UNDERW....
AND
UNDERGROUND
BASES

The Lost Science Series:

- THE ANTI-GRAVITY HANDBOOK
- ANTI-GRAVITY & THE WORLD GRID
- ANTI-GRAVITY & THE UNIFIED FIELD
- THE FREE ENERGY DEVICE HANDBOOK
- THE TIME TRAVEL HANDBOOK
- THE FANTASTIC INVENTIONS OF NIKOLA TESLA
- UFOS & ANTI-GRAVITY: PIECE FOR A JIGSAW
- THE COSMIC MATRIX
- MAN-MADE UFOS: 1944-1994
- THE BRIDGE TO INFINITY
- THE ENERGY GRID
- THE HARMONIC CONQUEST OF SPACE
- ETHER TECHNOLOGY
- THE TESLA PAPERS

Write for our free catalog of unusual
science, history, archaeology and travel books.
Visit us online at: www.wexclub.com/aup

Underwater and Underground Bases

Surprising Facts the Government Does Not Want You to Know!

by Richard Sauder, Ph.D.

Underwater and Underground Bases:
Surprising Facts the Government Does Not Want You to Know!

ISBN 0-932813-88-7

English language edition published by
Adventures Unlimited Press
One Adventure Place
Kempton, Illinois 60946 USA
Telephone (815) 253- 6390
Fax (815) 253-6300

Book design by Richard Sauder
Cover design by Harry G. Osoff
Cover photo by Carl Austin

Cover photo of Navaho Dam Tunnel, near Farmington,
New Mexico, USA

Printed in the United States of America

Dedicated to

Bill Hamilton

Contents

Acknowledgements .. 13
Preface .. 15

1. The Lowdown on the Secret Underground 22
 FEMA ... 23
 Central Intelligence Agency (CIA) 24
 Executive Office of the President 26
 Los Alamos National Laboratories 27
 U.S. Navy and National Security Agency (NSA) 29
 U.S. Air Force ... 29
 U.S. Army Corps of Engineers: The Really Secret
 Bases ... 34
 Classified Underground Bases 34
 Huge, Artificial Underground Caverns 35
 Secret Supercomputers Underground 39
 "Good Night Irene, I'll See You in My Dreams" -- Or
 Perhaps in a Secret, Underground Base? 39
 U.S. Army Subterranean Real Property 40
 A Day at the Archive 41
 U.S. Army Corps of Engineers Underground 42
 Giant, High-Tech Ice Cubes in the Subterranean
 Depths .. 46
 The Chillings Facts .. 52
 The Black Budget ... 53
 The Invisible Government 54
 The Secret Team ... 55
 What a Tangled Web 57
 Dulce, New Mexico and Sedona, Arizona 58

2. Secret Tunnel System in the United States:
 Reality or Disinformation? 61
 Secret Tunnels Full of Nuclear Missiles? 64
 Questions Remain .. 67
 Corporate Tunneling 69
 American Underground-Construction Association 69
 Robbins Co. .. 71

Traylor Bros. ... 71
Frontier-Kemper .. 72
Other Companies ... 73
Parsons Brinckerhoff 75
U.S. Federal Agencies That Like to Burrow 76
U.S. Bureau of Reclamation 77
U.S. Department of Energy 81
Yucca Mountain Exploratory Studies Facility (ESF) 82
Waste Isolation Pilot Plant (WIPP) 85
Possible Clandestine Use for WIPP and Yucca
Mountain Repositories? 87
Superconducting Super Collider (SSC) 89
The DOE's Genetic Research Program 91
U.S. Army Corps of Engineers 94
Passaic River Flood Protection Project 95
The United States National Committee on Tunneling
Technology ... 96
Need a Tunnel Boring Machine? 100

3. Secret Maglev Tunnel System? 102
National Maglev Initiative 103
Secret Maglev System? 104
Bechtel Maglev System 106
The Foster-Miller Maglev Concept 113
Grumman Team Maglev System 118
The Magneplane System 121
Could Clandestine Tunnel System Be Kept Secret? 128

4. How to Hide a Secret Underground Base 130
Construction Projects, Mining and Drilling as "Cover".. 131
Detecting Hidden Cavities 134
Secret Bases in Mines? 138
A Broad Hint ... 141
U.S. Government Underground in Rural Pennsylvania . 142

5. The Evidence for Secret Undersea Bases 143
Russian Tunnels -- For Submarines! 143
Tunneling the Continental Shelf 144

Evidence for Bases Beneath the Ocean Floor 145
The Undersea Base Paper Trail 148
Mine Tunnels Beneath the Sea 149
Modern Undersea Tunneling Technology in the U.S.A.,
Canada and Japan ...154
The Seikan Tunnel ...157
Ripple Rock Project158
South Bay Ocean Outfall Tunnel (San Diego) 160
Effluent Outfall Tunnel (Boston Harbor) 166
The Take-Home Message About Undersea Tunneling .. 169
U.S. Navy Underwater Construction Teams 170
Naval Facilities Engineering Service Center 171
Is the U.S. Army Corps of Engineers Undersea? 174

6. Undersea Bases: The Rock-Site Concept 182
Abstract ... 182
From the Sea .. 186
Cities Under the Ocean Floor? 202
Undersea Navy Base off Newfoundland? 204
Curiouser and Curiouser 205
The Glomar Explorer 206
Deep Sea Drilling Project 212
Further Official U.S. Navy Documentation 214

7. Submarine UFOs and Closing Thoughts 217
For Us, or Against Us? 218
Conclusion ... 220

Appendix A: A Note on the Source Data 223

Appendix B: Tunnels Built by United States Bureau of
Reclamation in Western States 226

Index .. 254

List of Illustrations

1. Brain Transmitter ... 18
2. Warrenton U.S. Army Training Station, Station B 25
3. Manzano Underground Base, Schematic View 31
4. Manzano Underground Base, Plant No. 1 32
5. Manzano Underground Base, Plant No. 2 33
6. Snettisham Project Profile 36
7. Snettisham Project Generator Deck 37
8. Snettisham Prtoject Power Turbines 38
9. U.S. Army Corps of Engineers Underground Manual 43
10. Underground heat Sink Document 47
11. Schematic of Heat Sink 49
12. Geometric Configuration of Heat Sink 50
13. U.S. Air Force Tunnel Boring Machine 63
14. Proposed Sites for Deep Missile Bases and Tunnels 65
15. Two Design Schemes for Deep Bases 66
16. Massive Sandstone Beds Near Green River, Utah 68
17. Construction of New York City Water Tunnel No. 3 74
18. Finished Section, New York City Water Tunnel No. 3 ... 74
19. Central Arizona Projects Tunnel, New Waddell Dam 78
20. Schematic of Yucca Mountain Nuclear Repository 83
21. Yucca Mountain TBM Receives Inspection 84
22. Yucca Mountain TBM Final Assembly 84
23. Yucca Mountain TBM, Underground View 85
24. Yucca Mountain TBM, Trailing Gear 85
25. Waste isolation Pilot Plant, Aerial View 86
26. Waste Isolation Pilot Plant, Schematic of Layout 86
27. DIABLO HAWK, U12n Tunnel Complex 88
28. Schema of Computer Controlled Maglev System 109
29. Sleek Maglev Train ... 121
30. Maglev Trough .. 123
31. Maglev Train with Vertical Rudders 125
32. Central Artery/Tunnel Project in Boston 136
33. Central Artery/Tunnel Project Work Area 137
34. Abandoned Iron Mine Near Cornwall, Pennsylvania 140
35. Robert W. Van Dolah Letter 150

36. Jussaro Iron Mine ... 152
37. Canadian Undersea Mine Entrance 155
38. Chunnel Tunnel Boring Machine 156
39. Schematic of San Diego South Bay Outfall 161
40. "Molita" Tunnel Boring Machine Fact Sheet 162
41. Lowering TBM Cutter Head Underground 163
42. Oceangoing Barge off of San Diego 164
43. Deep Sea Diver off of San Diego 165
44. Men in Tunnel Under Pacific Ocean 165
45. Schematic of Boston's Effluent Outfall Tunnel 168
46. U.S. Naval Facilities Engineering Service Center 172
47. Ocean Facilities Department, NFESC 173
48. Proposed Underground Base in Ohio 177
49. "Unique Military Facilities in Marine Environments" 180
50. The Rock-Site Plans .. 184
51. Placing Lock Tube in Sea Floor 187
52. Lock Tube in Place in Sea Floor 189
53. Heavy Equipment Lowered Down Shaft 194
54. Radial Rock-Site Layout 197
55. Undersea Submarine Port 197
56. Cross-Section View of Rock-Site Installation 198
57. Artist's Depiction of Rock-Site in Sea Mount 199
58. Atlantic Sea Mounts West of Gibraltar.................... 204
59. *Glomar Challenger* Deep Drilling Ship 212
60. *JOIDES Resolution* Deep Drilling Ship 213

Acknowledgments

I would like to particularly thank Bill Hamilton for contributing to my interest in this line of research. Back in the early 1990s I heard a talk he gave in Tucson, Arizona and it raised all sorts of questions in my mind. As it happens, the research I've done in the intervening years answered many of those initial questions, only to replace the original ones with even larger ones that seem still harder to resolve.

I also want to express gratitude to my family, especially my brother Rob Conrad, who laid out my first two books and designed the cover art for them, as well as lending helpful editorial advice and handling publishing details. I want to thank my mother, Grace Hall, for putting up the money for the first commercial print run of my first book. That first run was critical to the success of *Underground Bases and Tunnels: What is the Government Trying to Hide?* In the last few years it has turned into a genuine underground bestseller, going through one printing after another. The present work takes nothing away from the first book; on the contrary, it continues to build on the foundation that was laid down five years ago.

And finally, I want to thank the many people who have written me letters and sent research materials. I have received scores of cards and letters and clippings. I sift through them all and find the nuggets of information that are there. Many people have given me information; almost all of them have requested anonymity. So you won't find many names of my information sources in the pages that follow. That is what most people prefer and I respect their wishes.

Preface

You take the blue pill and the story ends. You wake in your bed and you believe whatever you want to believe. You take the red pill and you stay in Wonderland and I show you how deep the rabbit-hole goes.

(Morpheus, *The Matrix*)

In the late 1980s I moved to the American Southwest. Shortly after arriving in the Southwest I began to meet people who told me of purported, secret underground bases and installations where purported "Little Grey" extraterrestrials and covert elements of the United States military were hard at work on covert, Nazi-like genetic engineering experiments. The stories were highly strange, and persistent. As the years went by I continued to hear about these purported facilities and activities.

Finally, I did a little research and discovered that, indeed, there are underground bases and facilities run by the military and other agencies. Many of these (though by no means all) are in the eastern and mid-Atlantic states. In June of 1992 I made a trip to the East Coast and actually visited three of them, one then run by the Federal Reserve, but recently converted to a film storage vault for the National Archives and Records Administration (NARA), near Culpeper, Virginia; one run by the Federal Emergency Management Agency (FEMA), between Olney and Laytonsville, in Maryland; and still another, a CIA underground base, operating under the guise of the United States Army, just outside of Warrenton, Virginia. Later that summer, I wrote a short article for *UFO Magazine*, in Los Angeles. I identified the underground installations that I could document working from the public record. The article appeared in November 1992 and was well received. In the article I said that while I could neither prove nor

disprove the existence of alleged "Little Grey" aliens in secret underground facilities (or anywhere else), I *could* prove the existence of many, secure underground facilities. And that was that. The article appeared and I thought my research was over.

Little did I know. Less than two months later, I was awakened out of a sound sleep late one night. It was the Holiday period, during the last week of December 1992. Nothing seemed to be wrong and I could not determine a reason for having awakened so suddenly. I had been awake only a matter of seconds when I distinctly heard a voice in my right ear say very matter-of-factly, *"The underground bases are real."* At that point, let me assure you, I was all ears. The voice sounded to me as if it were that of an adult, male Caucasian, speaking normally accented, late 20th-century North American English. He went on to tell me that secret underground bases do exist; and that the general public little suspects, or suspects not at all, that these facilities exist. He added that there are people working and living underground and that the public would be astonished to know about these bases and what goes on in them, if they were to find out about them. He continued in this vein for maybe two or three minutes, giving me fairly general information, and then he stopped speaking as abruptly as he had started.

I would stress at this point that I do not use recreational drugs, and do not consume alcohol at all. In a lot of respects I lead an ordinary life. So I was completely flummoxed as to how I came to hear this unknown man's voice. I did not know who he was and why he talked to me. I quickly determined that I probably never would have answers to those questions. So I put them out of my mind.

I must say, however, that I was not persuaded that the voice necessarily had to have been telepathic. That is to say, the voice did not feel as if were an altogether interior,

mental phenomenon. Rather, it seemed to be in my inner ear. The sensation was something like the tiny voice that you hear over an earplug that is attached to a small transistor radio. In fact, I consider it entirely possible that a message was electronically transmitted to my inner ear or auditory cortex. Recently I have discovered that a patent was issued in 1989 for an electronic device that would make possible a radio frequency transmission directly into the auditory cortex of the brain.[1] (See Illustration 1.) The language of the patent describes a device that would produce an effect very similar to what I experienced. I now consider it possible that someone, perhaps in a covert United States government agency, electronically targeted my mind with a message about underground facilities.

Why would anyone do that? I am not sure. But maybe there is a faction within the government, or within the intelligence community, that would like to open up some of the government's underground bases to the light of day. Maybe the article I had written for *UFO Magazine* came to the attention of someone who felt that, with a little nudge, I might probe more deeply into the question of secret underground bases.

Though I had determined that I probably could not find out who had talked to me and why, I nevertheless felt that I ought to be able to find some kind of paper trail that would either prove or disprove the factual substance of *what* the voice had told me. Within a couple of days I began a careful, federal document search. I filed Freedom of Information Act (FOIA) requests. I riffled through card catalogues, electronic data bases and military publications. As time went by I gradually accumulated a literal foot and a half tall mound of documentation revealing a decades-

[1]See United States Patent No. 4,858,612. This patent describes a method for using microwaves to beam a radio transmission right into a subject's brain such that it can be audibly perceived.

United States Patent [19]

Stocklin

[11] Patent Number: **4,858,612**

[45] Date of Patent: **Aug. 22, 1989**

[54] **HEARING DEVICE**

[76] Inventor: Philip L. Stocklin, P.O. Box 2111, Satellite Beach, Fla. 32937

[21] Appl. No.: 562,742

[22] Filed: Dec. 19, 1983

[51] Int. Cl.⁴ ... A61N 1/36
[52] U.S. Cl. 128/422; 178/419 S
[58] Field of Search 128/419 R, 419 S, 422, 128/653, 771, 732, 741, 746, 791, 804; 340/407

[56] **References Cited**

U.S. PATENT DOCUMENTS

3,490,458 1/1970 Allison 128/421
3,751,605 8/1973 Michelson 128/1 R
3,951,134 4/1976 Malech 128/131
4,428,377 1/1984 Zollner et al. 128/419 R

FOREIGN PATENT DOCUMENTS

893311 2/1972 Canada 128/422
2811120 9/1978 Fed. Rep. of Germany ... 128/419 R
591196 1/1978 U.S.S.R. 128/419 R

OTHER PUBLICATIONS

Gerkin, G., "Electroencephalography & Clinical Neurophysiology", vol. 135, No. 6, Dec. 1973, pp. 652–653.
Frye et al., "Science", vol. 181, Jul. 27, 1973, pp. 356–358.
Bise, William, "Low Power Radio–Frequency and Microwave Effects on Human Electroencephalogram and Behavior", Physiol. Chem. & Physics 10 (1978).

Primary Examiner—William E. Kamm
Attorney, Agent, or Firm—Wegner & Bretschneider

[57] **ABSTRACT**

A method and apparatus for simulation of hearing in mammals by introduction of a plurality of microwaves into the region of the auditory cortex is shown and described. A microphone is used to transform sound signals into electrical signals which are in turn analyzed and processed to provide controls for generating a plurality of microwave signals at different frequencies. The multifrequency microwaves are then applied to the brain in the region of the auditory cortex. By this method sounds are perceived by the mammal which are representative of the original sound received by the microphone.

29 Claims, 7 Drawing Sheets

Illustration 1. Brain Transmitter. The patent is euphemistically entitled "Hearing Device". In reality, it describes an electronic device that transmits "multifrequency microwaves" into the auditory cortex of the human brain for "simulation of hearing". (*Source*: U.S. Patent and Trademark Office.)

18

long program of construction and operation of underground bases and installations by the United States government, all over the country. The scope of the plans and activities, as well as the technology for subterranean excavation and construction, was truly eye-opening. I understood that what the voice had told me was substantially true.

At the urging of an acquaintance, I compiled much of the information in book form. The book is entitled, *Underground Bases and Tunnels: What is the Government Trying to Hide?*. It has since become an underground best seller. I recommend reading it as a companion to this book. My second book, *Kundalini Tales*, deals with psychic, mystical and mind control topics, and contains an extensive appendix of actual patents for real electronic mind control technologies, including the patent for the microwave brain transmitter mentioned just above.

Just before *Underground Bases and Tunnels* appeared in commercial paperback I went on the air as a guest on the nationally syndicated Art Bell *Dreamland* radio show. The date of the show was 15 January 1995. As it happened, the night before doing the show I had a most interesting and unexpected out-of-body experience, as if to drive home to my conscious mind that the underground bases really, *really are there.* I awoke in the night to discover myself moving into an altered state of consciousness (it was spontaneous—I do not consume alcohol or other mind-altering substances). I have been consciously out-of-body many times, so I understood immediately what was happening. In front of me, in the middle of my visual field (with my eyes closed) I saw something that resembled a radar screen. Instead of a greenish trace that turned about a central axis, however, I saw a distinctly red line that scanned around in a clockwise direction. It rotated about a fixed center point. It left a reddish tinged trace that faded in the darkness as it swept

around in a circle, in just the same manner that the greenish trace on an ordinary radar scope fades as it rotates on the screen. I was riveted by this unusual, mental "radar scope". It was somehow extremely satisfying and intriguing to watch. I would even say that it was pleasurable. As I looked at it I very naturally and easily rotated out of my body, just like rolling over in bed, and found myself in the dark. I mentally gave myself a command to open my eyes (nonphysical eyes understood) and at once found myself hovering in mid-air in a vast, artificially constructed, underground cavern. The space was clearly lit, and I could see that it was maybe a couple of hundred feet wide and about one hundred feet high. All of the angles were rectilinear. The floor, ceiling and walls were bare rock. I saw no signs or adornment of any kind anywhere. Neither did I see any machinery, people or lighting source. I had no idea where I was.

So I mentally willed myself to turn around and look in the other direction. The cavern extended in front of me for maybe 1,000 feet-- about a fifth of a mile. It was impressively large. I began to move forward in space. After a bit I approached the far end of the gargantuan cavern. I still saw no machinery, no evident source for the lighting, no signs, no clue as to the purpose or function of this vast underground chamber. And then, as I neared the far end, looking down from a height of perhaps 50 feet I came upon a group of people sitting around at sidewalk café tables. It was all very incongruous, and yet so utterly and perfectly normal, to see this small group of 20 or 30 people, men and women, casually dressed, sitting at these tables with their little umbrellas, nibbling on snacks and sipping beverages. I didn't know what to make of it. Where was this place? What was its purpose? Who were the people? What were they doing there? Was this huge subterranean space, hewn out of the native rock at some unknown location, simply

their snack bar area? Was that its purpose? Simply to provide a wide-open space where they could get away from it all? Where they could sit down and take a break and gaze off into space-- albeit a rocky, somewhat confined, subterranean space?

To tell the truth, I could not tell. And I still don't know. Because that is where the experience ended. To this day I do not know if that facility really exists. However, in *Underground Bases and Tunnels* I documented Army and Air Force plans for similar, mammoth cavities to be excavated hundreds or thousands of feet underground. The plans are real, and the U.S. government assuredly has built many other subterranean installations. Strange as it may seem, there is a literal world under our very feet that we know virtually nothing about. If you doubt me, if you think that what I describe is simply the product of an overactive imagination, read on....

Your education is about to begin.

Richard Sauder, PhD
27 February 2001

Chapter 1. The Lowdown on the Secret Underground

Your biggest problem as an investigator is that you are looking for data in a never-never land of make-believe and incredible dishonesty.

(statement by insider interviewee)

As a direct result of the success *of Underground Bases and Tunnels: What is the Government Trying to Hide?* I have spoken to a number of groups across the country about my research. I have also appeared on radio and TV shows. When I talk to the public I like to mention that where secret, underground bases are concerned we are confronted with a literal, concrete, high-tech and oh-so-very-clandestine *political underground* that is severely at odds with the present-day myth of open government in the United States. In ordinary political discourse pundits sometimes refer to the political underground of the Far Left or of the Far Right. In the case of the secret underground facilities that I wrote about in my first book, and which are also the subject of this sequel, it is important to understand that there is a literal political underground that operates right out of the secretive guts of the established power structure. Covert elements of the military-industrial complex, comprising the alphabet soup of military and non-military federal agencies, intelligence agencies, and the so-

called "private" corporate sector are all represented underground. Just what do these agencies and organizations do underground? In some cases it is possible to know what goes on with some degree of certainty. Let me cite a few salient examples.

FEMA

For example, the Federal Emergency Management Agency (FEMA) operates a network of underground installations spread across the country. From personal observation and ongoing research these FEMA facilities appear to serve as regional communication and command centers. Interestingly, in the early 1990s, when I was researching *Underground Bases and Tunnels*, I was paging through a federal telephone directory when I found an "800" number for FEMA. I called the number and struck up a conversation with the woman who answered the phone. I asked her if she knew of any underground FEMA installations. She replied that she was talking to me from underground in northern Texas.[2] I asked her how far underground she was and she said, "Oh, about 30 feet." I then asked her if she knew anything about an alleged secret, underground tunnel system. She said that she did not. That was the gist of our brief conversation, but it served to emphasize to me the reality of a federal agency that routinely conducts at least part of its business from underground.

I subsequently mentioned my research on underground bases to a friend who told me of an important FEMA base in Maryland. Following her directions I found FEMA's back-up underground command center with ease. It is in Maryland, between the towns of Olney and

[2] I surmise that she was working in the FEMA facility near Denton, Texas. This is one of FEMA's known underground communications centers.

Laytonsville, on Riggs Road (not to be confused with yet another Riggs Road in the immediate Maryland suburbs of Washington, DC). Suffice it to say that FEMA is a known actor in the subterranean policy arena.

Central Intelligence Agency (CIA)

In his 1973 book, *The Secret Team: The CIA and Its Allies in Control of the World*, Fletcher Prouty mentions an "uniquely self-contained Army base near Washington" that was ostensibly shut down many years ago. In reality, says Prouty, the base was "reopened" using CIA funding and serves as a support base for the CIA. Prouty says that the base is very active and serves both "special CIA elements" and senior, retired military personnel in the region.[3]

When I read this passage in *The Secret Team* I knew immediately to which "uniquely self-contained", i.e., underground, base Prouty was referring. In my first book, *Underground Tunnels and Bases*, I discuss the United States Army Warrenton Training Center, just outside the small town of Warrenton, in northern Virginia. I knew from the open literature that an unknown federal agency has an underground bunker there.[4] In fact, when I visited the place in the early 1990s I found that the U.S. Army's Warrenton Training Center is actually comprised of two distinct parts: Station A and Station B. The first is on Rte. 802 and the other on Bear Wallow Road, on top of Viewtree Mountain. I have no idea where the underground bunker is. It may be under Station A or under Station B. (See Illustration 2.) Or perhaps it is somewhere between the two, and tunnels run

[3] L. Fletcher Prouty, *The Secret Team: The CIA and its Allies in Control of the United States and the World* (Englewood Cliffs, New Jersey: Prentice-Hall, Inc., 1973).

[4] William M. Arkin and Richard W. Fieldhouse, *Nuclear Battlefields: Global Links in the Arms Race* (Cambridge, Massachusetts: Ballinger Publishing Company, 1985).

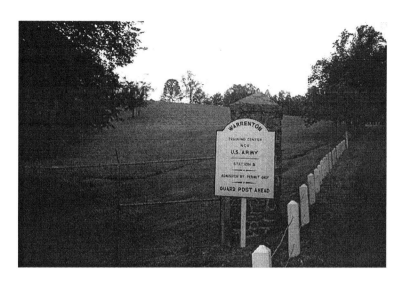

Illustration 2. This is the entrance area to Station B of the Warrenton U.S. Army Training Center, near the small, northern Virginia town of Warrenton. My research indicates this facility (and/or its neighboring twin, Station A) is probably not a normal U.S. Army base, but very likely serves as a cover for an underground CIA base. The profusion of antennae on the hill nearby suggests a sophisticated communications capability for Station B. (*Source:* Author's photo collection.)

from both stations to, and from, the underground facility. Neither do I know how extensive the underground facility is. My guess is that it is a sophisticated installation, but that is just a guess.

But what initially puzzled me was the fact that I was unable to find a mention of a U.S. Army Training Center in Warrenton, Virginia in any of the military encyclopedias or military base listings I consulted (this dual-station installation is not the much-discussed NSA installation, Vint Hill Farms, which lies several miles distance from Warrenton). I even thumbed through the listing of United States military installations at the rear of the Postal Service's national zip-code directory- but the U.S. Army Warrenton Training Center was not listed there either.

Suddenly, Prouty's book threw everything into perspective: the U.S. Army Warrenton Training Center is not an U.S. Army base at all! The signs out front are a fabrication and a lie. The U.S. Army Warrenton Training Center is a secret, underground CIA base! This conclusion is buttressed by information in an article that appeared in *Inquiry Magazine,* which plainly states that the U.S. Army Warrenton Training Center Station B, on Bear Wallow Road, is a CIA facility.[5]

Clearly, what the CIA does at Warrenton it can do elsewhere. I fully expect that the CIA, and other agencies and organizations such as the NSA (operating an underground facility under a U.S. Navy façade near Sugar Grove, West Virginia), routinely operate under false pretenses. I would hazard to guess that covert, underground facilities could operate as well under the guise of nonmilitary government agencies and private corporations and organizations, perhaps even including ostensibly charitable or religious organizations. Intelligence agencies do this all the time. They establish a so-called *cut-out operation* that has a legitimate, open side, and they use that as a front for the secret, clandestine project that they run covertly. I will have more to say about this later in the book.

Executive Office of the President

By complete chance, I happened to make the casual acquaintance of a gentleman who mentioned to me that he used to regularly perform work at Camp David (the presidential retreat in northern Maryland) for a company that had a contract with the federal government. I asked him if he knew anything about the bunker that is under

[5] Robert Walters, "Going Underground," *Inquiry Magazine* (February 1981).

Camp David. He said he certainly did. I asked if it were very sophisticated. His answer surprised me. He said that from what he saw there were literally miles of tunnels hundreds of feet beneath the mountains in northern Maryland, running from the vicinity of Camp David up into Pennsylvania. He described an elaborate installation with high speed computers, and an extensive underground system of tunnels, corridors and work areas. He said that there were guards posted periodically at blast doors and that, in his view, the entire complex was so large and elaborate that any one person would be unlikely to know the full layout of the place.

While I have no way of directly verifying every last particular of this man's story I believe it is true in broad outline. It is known from the public record that there is an underground facility at Camp David. It is also a matter of local lore in that part of the country that there are secret tunnels underground.

Los Alamos National Laboratories

In the spring of 1997 I unexpectedly received first-hand anecdotal information concerning the extent of the underground workings at Los Alamos National Laboratories, in northern New Mexico. In an earlier phase of my research I had filed a Freedom of Information Act request with the U.S. Department of Energy (DOE) seeking information about underground facilities at Los Alamos. After a protracted round of correspondence with the DOE I finally received some information about a comparatively small and shallow underground work area known colloquially at Los Alamos as the "Ice House". Judging from the information I saw the "Ice House" was used in the past for the storage of modest amounts of nuclear materials. The DOE eventually sent me some large blueprints of the climate control ductwork in the "Ice House". The

blueprints were really very ordinary. But the grudging manner in which the DOE had provided them raised questions in my mind. My thinking ran like this: if all that is underground at Los Alamos is the relatively insignificant "Ice House", and the available documentation consists solely of air conditioning duct work, then why the delays and grudging response to my simple request for information? I had a sneaking suspicion that my question about underground facilities at Los Alamos was closer to the mark than the DOE let on.

And then in the course of conducting some tangentially related research I happened to encounter a businessman who told me the following story. A number of years ago this gentleman visited Los Alamos in the company of an associate who had a high level security clearance. The businessman was privileged to go wherever his colleague went, without being questioned.

I specifically asked him about underground facilities at Los Alamos and he told me that judging from what he saw, fully 75% of the facilities at Los Alamos are underground. I expressed disbelief at this figure and he hastened to assure me that, indeed, most of the facilities at Los Alamos are underground.

I asked him how far underground the deepest levels go. He said that he could not be sure because his colleague had not shown him the deepest levels, but that it was his understanding that the deepest sections extended as far as one mile underground.

I frankly do not know what to make of this story. On the one hand, I concede the possibility that it is disinformation. On the other hand, I know that it is well within the state of the art in the underground construction industry to construct facilities one mile underground. In addition, the labs at Los Alamos are run by the U.S. Department of Energy -- an agency that is known to have

extensive tunneling and underground excavation experience. My guess is that the truth about what goes on in the subterranean depths beneath Los Alamos lies somewhere between the opposite poles of the businessman's story and the minimally small and shallow "Ice House" that the DOE presented to me as the extent of the Los Alamos underground.

U.S. Navy and National Security Agency (NSA)

Then there are the persistent stories of the U.S. Navy underground. From virtually the beginning of my research I have had people telling me that they have heard that the U.S. Navy is heavily involved in underground tunneling and construction. At first I thought these stories were highly improbable. Now I attach considerably more credence to them. I have a great deal more to say about the U.S. Navy later in the book. For now, I can tell you that the United States Navy operates a highly secretive underground facility in the mountains of West Virginia, near the tiny hamlet of Sugar Grove. Actually, the Navy runs the place for the National Security Agency as an electronic spying facility. Interestingly, Jim Schnabel mentions this facility in *Remote Viewers: The Secret History of America's Psychic Spies*. Schnabel says that it "...include(s) large subterranean facilities tucked into the base of Reddish Knob Mountain..."[6]

U.S. Air Force

For years, rumors have swirled about a mysterious underground base, immediately adjacent to Kirtland Air Force Base, in the foothills of the Manzano Mountains, near Albuquerque, New Mexico. I discussed this base in

[6] The entire book is well worth the read. Jim Schnabel, *Remote Viewers: The Secret History of America's Psychic Spies* (New York: Dell Publishing, 1997).

my first book, *Underground Bases and Tunnels*. Based on several conversations and communications I have had with people who have been in it, or with people who have spoken with or communicated with people who have been inside it, it appears that the base has gone through at least three, broad operational phases: 1) In the early years of the Cold War it was a nuclear weapons assembly facility, an atomic bomb factory, if you will. (The actual nuclear weapons themselves appear to have been stored in dozens of shallower bunkers that ring the periphery of the ridge under which the underground facilities lay.) 2) At a later date, it was used to back engineer classified and sensitive captured hardware and devices that were of interest to the military industrial complex. 3) Today, it is used by the Department of Energy, in part for the storage of low-level nuclear waste.

In the late 1990s I filed a Freedom of Information Act request for the plans to this underground facility and eventually did receive the floor plan for it.[7] The deep underground portions are actually comprised of two, separate facilities. There is a Plant 1 at the northern end of the site, and a Plant 2 at the southern end of the site. You can look at the illustrations and make of them what you will. The plans suggest a one level, two-part facility. But I would not be surprised if there is a great deal more to this installation than the Air Force has revealed in its FOIA reply. (See Illustrations 3, 4 and 5.)

In my first book, I also mention a second, brand new, state-of-the-art underground installation at Kirtland Air Force Base. This facility is reportedly a nuclear weapons storage area. Not long after it opened I spoke with one of the military guards who worked there. He informed me that anyone who enters the facility is subject to a voice

[7] Freedom of Information Act response, 2 December 1997.

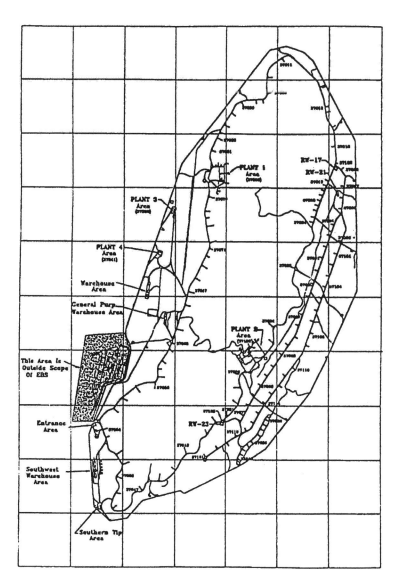

Illustration 3. Manzano underground base, on northeastern corner of Kirtland Air Force Base. Schematic view of mountain ridge, as seen from above. The underground base has at least two components: Plants No. 1 (upper left) and No. 2 (lower right). The location is just a couple of miles south of Interstate Highway 40 southeast of Albuquerque, New Mexico. (*Source*: U.S. Air Force.)

31

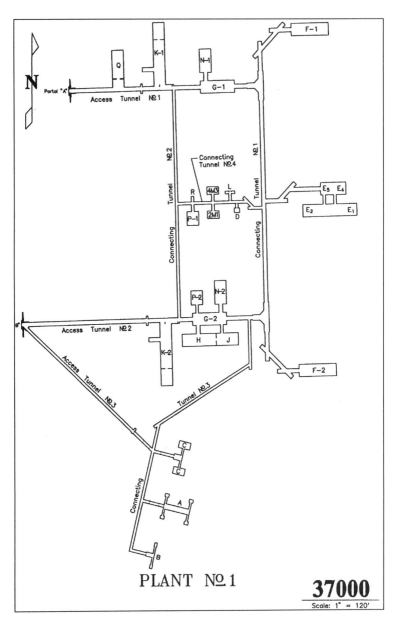

Illustration 4. Floor plan of Plant No. 1 of underground Manzano Base. Plant No. 1 measures approximately 1,200 feet on the longest dimension. Notice Portals "A" and "B" on the left. (*Source*: United States Air Force.)

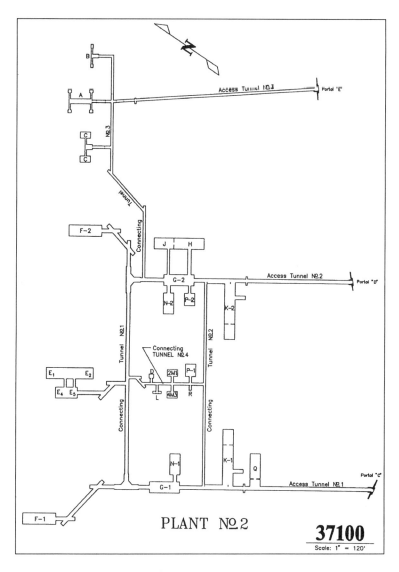

Illustration 5. Second part of underground Manzano Base. There are three separate entrances on the right side of the illustration. This component of the base measures about 1,300 feet on its longest dimension. Its depth is several hundred feet below the top of the ridge under which it lies. (*Source*: U.S. Air Force.)

print scan, a palm print scan, a retina scan and more prosaic methods of identification such as presenting a magnetically coded ID card. I believe this level of security is the norm for the new generation of underground facilities. Average people cannot just walk off the street and into secure underground bases. Entry is by authorized invitation (or perhaps abduction) only.[8]

U. S Army Corps of Engineers: The Really Secret Bases

And then there are the persistent rumors and second- and third-hand anecdotal stories of the really secret bases, tucked away underground in the American Southwest, in the Appalachians, and elsewhere. No one outside of the shadowy agencies that maintain these bases knows for certain what happens in these installations; few people on the outside even know precisely where they are. But even if we do not know what happens in them; even if we do not know how many of them there are or who runs them; and even if we do not exactly where they are, we most assuredly *do know* that they exist.

Classified Underground Bases

In the mid-1980s Lloyd A. Duscha, then Deputy Director of Engineering and Construction for the U.S. Army Corps of Engineers in Washington, D.C., delivered a talk at a conference on underground construction. In his introduction, Mr. Duscha mentioned that he had to modify his remarks a little for the conference because "...*several of*

[8] I am not joking about abductions. Dr. Helmut and Marion Lammer have done careful, but disturbing research that strongly indicates some people have been abducted to secret, military underground bases. The reasons for these reported abductions remain obscure, though clandestine mind control projects appear to be one possibility. Dr. Helmut and Marion Lammer, *MILABS: Military Mind Control & Alien Abduction* (Lilburn, Georgia: IllumiNet Press, 1999).

the most interesting facilities that have been designed and constructed by the Corps are classified." It is clear from the context that he is referring to underground facilities. He goes on to discuss the Corps' involvement in the construction of the large NORAD underground base beneath Cheyenne Mountain, in Colorado. And then he states: *"There are other projects of similar* scope (to the NORAD base- author's parentheses)*, which I cannot identify, but which included multiple chambers up to 50 feet wide and 100 feet high using the same excavation procedures* (as) *for the NORAD facility."* He then refers to the *"...critical and unusual nature of these projects..."*[9]

You will not find a more candid public admission by a military official that there are secret underground bases. At the same time that he baldly states that there are large underground facilities that he cannot identify he also alludes to their *"critical and unusual nature"*. It is all very puzzling and mysterious.

Huge, Artificial Underground Caverns

Needless to say, his statement agrees very well with what the mysterious voice told me in the middle of the night in December 1992. Of course, it is important to understand that impressively large openings can be excavated out of the solid rock, hundreds of feet underground. For example, hydroelectric power generating plants are frequently constructed deep underground. The various chambers that comprise these facilities can be quite large. These sorts of facilities are located all over the world, in the United States and elsewhere.

[9] Lloyd A. Duscha, "Underground Facilities for Defense—Experience and Lessons," in *Tunneling and Underground Transport: Future Developments in Technology, Economics and Policy*, ed. F.P. Davidson (New York: Elsevier Science Publishing Company, Inc., 1987).

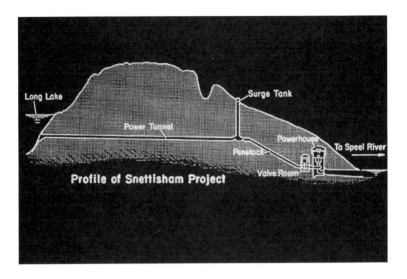

Illustration 6. Profile of the Snettisham Project, near Juneau, Alaska, USA. This hydroelectric project was completed in the 1970s. Notice the extensive tunneling and the huge, subterranean excavations at the right for the valve room and power house. (*Source*: U.S. Department of Energy.)

One example is the Chukha power plant in the Himalayan Mountains of Bhutan (in central Asia), which is contained in a huge cavern that is more than 750 feet underground. The cavern is 448 feet long, by 80 feet wide and 134 feet high.[10]

Another example is the powerhouse at the Portage Mountain Dam in British Columbia, Canada. The chamber is about 400 feet underground, and measures 66.5 feet wide, by 152.5 feet high and 890 feet long. It is gargantuan,

[10] R.L. Chauhan and R.S. Chauhan, "Design and Construction of Large Underground Caverns- A Himalayan Experience." In Tunnelling '85, *Proceedings of the Fourth International Symposium,* organized by the Institution of Mining and Metallurgy, with the cooperation of the British Tunneling Society and the Transport and Road Research Laboratory, Department of Transport, held in Brighton, England, from 10 to 15 March, 1985, ed. M.J. Jones (London, England: The Institution of Mining and Metallurgy, 1985).

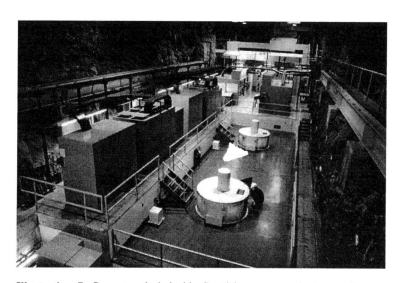

Illustration 7. Generator deck inside Snettisham power plant, near Juneau, Alaska. Hydroelectric projects, such as this one, provide ample evidence that it is entirely possible to carry out major industrial operations deep underground in huge caverns hewn out of the solid rock. (*Source*: U.S. Department of Energy.)

and carved out of solid rock, hundreds of feet below the surface.[11] This gives a rough idea of what conventional technology can do—both in North America and in a developing country in one of the poorest regions in the world. Note the great depth and the impressive size of these subterranean power plants in Bhutan and Canada. As a graphic example I have included a few illustrations of the Snettisham hydroelectric project near Juneau, Alaska. Its tunnels and underground workings are similar to those of the other projects cited above. (See Illustrations 6, 7 and 8.) I do not doubt that the secret government in the United States is capable of building underground facilities of at least comparable size and depth to those of these hydroelectric projects.

[11] Albert D. Parker, *Planning and Estimating Underground Construction* (New York: McGraw-Hill Book Company, 1970).

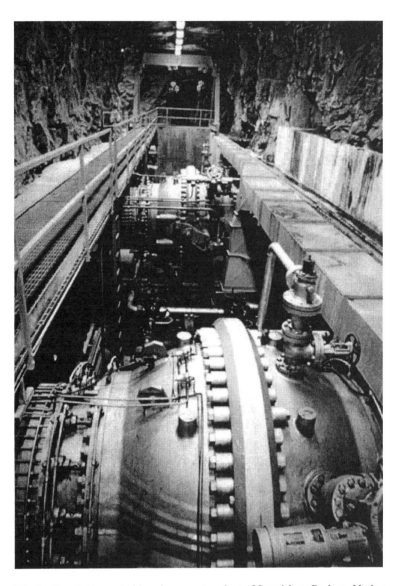

Illustration 8. Power turbines in generator plant of Snettisham Project. Notice the surrounding rock and the large size of the machinery. This photo shows very clearly the feasibility of locating powerful, complex equipment deep underground. This is a perfect example of a major, subterranean, industrial operation. (*Source*: U.S. Department of Energy.)

Secret Supercomputers Underground

As if to definitively drive home the idea that there truly are secret underground bases, I recently ran across an interesting book, *Trinity's Children*, by Tad Bartimus and Scott McCartney, in which an unnamed U.S. Air Force computer expert made precisely this same point. Bartimus and McCartney put it like this:

> There are more Cray supercomputers in New Mexico, an Air Force computer expert once said, than anywhere else. They're here at the weapons center (at Kirtland Air Force Base- *all parentheses by author*), they're across the street at Sandia (National Laboratories), they're at Los Alamos (National Laboratories) up the street, and they're at "underground places nobody knows about."[12]

"Underground places *nobody* knows about" (author's emphasis) in New Mexico. Equipped with Cray supercomputers.

"Good Night Irene, I'll See You in My Dreams" -- Or Perhaps in a Secret, Underground Base?

When I read these words I paused, put the book down and gazed across the room with my mind churning. In recent years, Bill Hamilton, another underground bases researcher, has told me of an ex-military officer who mentioned to Bill that he used to commute underground in a shuttle train from the White Sands Army Missile Base, in southern New Mexico, to an undisclosed underground location elsewhere in the American Southwest. According to Hamilton, the ex-military man, who was a computer

[12] Tad Bartimus and Scott McCartney, *Trinity's Children: Living Along America's Nuclear Highway* (New York: Harcourt Brace Jovanovich, Publishers, 1991).

specialist, alleged that the underground shuttle train would travel at a high rate of speed for an appreciable period of time before arriving at an underground installation where cutting-edge supercomputing research was carried out. The research centered on an incredibly sophisticated computer system named *Irene* that virtually thought like a human.[13] Of course, this is the kind of story that is very hard to either prove or disprove. In the absence of corroborating evidence, I have no idea whether it is true or not. But at the same time, it is very much like other stories that purport to describe clandestine, underground military installations where high-tech research is carried out in extreme secrecy, and which are connected with each other by a secret, underground tunnel system.

Nevertheless, I must say that anecdotal accounts like this, in tandem with public record quotes from military officials who directly refer to secret, underground facilities (see above), certainly suggest that there are things happening underground that we, the general public, do not know about.

U.S. Army Subterranean Real Property

Further evidence for underground military facilities appears on the internet website of the U.S. Army Corps of Engineers Construction Engineering Laboratories (CERL). Under the heading of *EO-12941: Building Category Codes*, CERL lists its many types of real property category codes.[14] Among the hundreds of codes listed, the following three are of particular interest: Code No. 62010 is *Underground Administrative Facility*. Code No. 44170 is *Underground Storage Facility, Depot Level*. And Code No.

[13] Personal communication with Bill Hamilton, 1996 and 1997.

[14] U.S. Army Corps of Engineers Construction Engineering Research Laboratories, *EO-12941: Building Category Codes*, on the WWW at http://www.cecer.army.mil/fl/seg/catcodes.htm, 1998.

44250 is *Underground Storage Facility, Installation.* How deep are these facilities? Where are they? What is administered from underground? And what does the Army store underground? All these questions are unanswered at this writing.

In recent years I have written a number of Freedom of Information Act requests to the U.S. Army seeking answers to questions about that agency's underground bases and activities. I am sorry to report that the Army has stonewalled me at virtually every turn; it has been unhelpful and substantively unresponsive.

A Day at the Archive

In October 1997 I even personally visited the U.S. Army Corps of Engineers historical archive in Alexandria, Virginia to research the agency's files. The staff was outwardly quite friendly and helpful—however, I found precious little information about the Army's underground activities. The archivist's assistant permitted me to search their electronic data base and I found a reference to a file entitled *"Underground Installations, Sites & Geological Formations, 1954."*[15] A document with a title like that could potentially be very informative as to the locations and engineering characteristics of underground bases. However, when I went to pull the file and look at it, I discovered that it was not there. It was missing! There was a marker indicating that the archivist had removed the file. I subsequently spoke to him and asked him for the file. He said that he did not know where it was. He claimed it had been misplaced somewhere. He promised to send it to me, at the Corps of Engineers' expense, when he found it. But he never sent it to me. So I called him and forthrightly

[15] *Underground Installations, Sites & Geological Formations, 1954* (XVII. Research & Development, Box 10, Folder 9). U.S. Army Corps of Engineers Library, Alexandria, Virginia.

expressed my profound dissatisfaction concerning the conspicuously missing file. I asked him if I should file a Freedom of Information Act request to obtain the file from him. He said, "I doubt that would do any good." And there the matter rests. The incident is a typical example of the frustrating bureaucratic stone walls that a determined underground bases researcher repeatedly encounters.

U.S. Army Corps of Engineers Underground

However, the U.S. Army does carry out a lot of underground construction. I presented documentation in my first underground bases book that demonstrates the Army's long time interests and activities underground. But there is more. For example, on 3 September 1996 the U.S. Army Corps of Engineers published a document entitled *Safety- Safety and Health Requirements*.[16] The document is an engineering manual for use by military personnel. The Corps of Engineers has published hundreds of these engineering manuals over the years, on a wide variety of topics related to the diverse missions that it carries out. (See Illustration 9.) One of the missions that the Army Corps carries out is the construction and maintenance of subterranean installations. I mentioned several Army engineering manuals in my first book that explicitly discuss the construction and maintenance of underground installations. *Safety- Safety and Health Requirements* also includes a chapter on underground construction. I will cite just a few interesting portions from *Section 26- Underground Construction (Tunnels), Shafts and Caissons*:

[16] U.S. Army Corps of Engineers, *Safety - Safety and Health Requirements*, Publication Number EM 385-1-1, 3 September 1996. On the WWW at http://www.usace.army.mil/inet/usace-docs/eng-manuals/em385-1-1/toc.htm, 1998.

D 103. 6/3: 1110 -345- 435

MANUALS – CORPS OF ENGINEERS
U. S. ARMY

EM 1110-345-435
1 JUL 61

ENGINEERING AND DESIGN
DESIGN OF UNDERGROUND
INSTALLATIONS IN ROCK

PROTECTIVE FEATURES AND UTILITIES

Illustration 9. The U.S. Army Corps of Engineers has been building underground for many years. This is just one of the many documents related to its subterranean activities that I have found. (*Source*: U.S. Army Corps of Engineers.)

43

26.A.01 Access

a. Access to all underground openings shall be controlled to prevent unauthorized entry.

26.A 17

Where underground openings are located adjacent to sources of water with potential for causing flooding in the underground work area, measures shall be taken to ensure that the underground area cannot be flooded.

Interestingly, passage 26.A 17 alludes to construction underground that is adjacent to sources of water (of course this could include being under bodies of water). The following passages concerning caissons and compressed air work hint at subterranean construction beneath bodies of water:

26.H Caissons

26.H.01

In caisson work in which compressed air is used and the working chamber is less than 3.3 m (11 ft) in length, whenever such caissons are at any time suspended or hung while work is in progress so that the bottom of the excavation is more than 2.7 m (9 ft) below the deck of the working chamber, a shield shall be erected for the protection of the workers.

26.H.06

In caisson operations where employees are exposed to compressed air working environments, the requirements of Section 26.I shall be complied with.

26.I Compressed Air Work

.

26.I.02

The compressed air work plan shall include the following considerations:

a. requirements for a medical lock and its operation;
b. an identification system for compressed air workers;
c. communications systems requirements;
d. requirements for signs and record keeping;
e. special compression and decompression requirements;
f. man lock and decompression chamber requirements;
g. requirements for compressor systems and air supply;
h. ventilation requirements;
i. electrical power requirements;
j. sanitation requirements;
k. fire protection and fire protection considerations; and
l. requirements for bulkheads and safety screens.[17]

My dictionary provides six definitions for the word, caisson, one of which is: *a watertight enclosure inside which men can do construction work underwater.*[18] Based on this evidence it appears possible that the U.S. Army Corps of Engineers is carrying out construction work at the bottom of bodies of water, and perhaps *beneath* the bottom

[17] U.S. Army Corps of Engineers, on the WWW at: http://www.usace. army.mil/inet/usace-docs/eng-manuals/em385-1-1/s-26.pdf, 1998.

[18] David B. Guralnik, ed. *Webster's New World Dictionary of the American Language, Second College Edition* (New York: William Collins + World Publishing Co., Inc., 1974).

of bodies of water; hence the need for compressed air caissons and decompression chambers, as befits a deep sea working environment. I will have more to say later in this book about military documentation that indicates the possibility of constructing manned installations beneath large bodies of water.

Giant, High-Tech Ice Cubes in the Subterranean Depths

And then there is the 1979 U.S. Army Corps of Engineers technical manual that forthrightly discusses how to dissipate waste heat from a subterranean base at a depth of 4,000 ft. below the surface.[19] (See Illustration 10.) That's right- three-quarters of a mile underground! The problem is that when complex installations and other sorts of facilities are constructed deep underground, getting rid of excess heat is crucial. Electronic equipment such as computers, machinery of all kinds, underground nuclear power plants and even human bodies generate heat. That heat must be dissipated or it can build up to dangerous levels. In addition, at great depth the surrounding rock itself is warmed due to the pressure of the overlying rock. The U.S. Army Corps of Engineers manual cited above assumes that the surrounding rock is at a temperature of 90°F. So the rock itself that surrounds a deep underground facility must also be cooled down, in order that that the installation will not overheat and fail.

There are two main ways of cooling an underground installation: 1) using surface cooling facilities or 2)

[19] John M. Stubstad, William F. Quinn, Marcus Greenburg, Walter C. Best and Mounir M. Botros, *Design Procedures for Underground Heat Sink Systems*, Special Report 79-8, Report No. FESA-TS-2032, Prepared for U.S. Army Facilities Engineering Support Agency, United States Army Corps of Engineers, Cold Regions Research and Engineering Laboratory, Hanover, New Hampshire (April 1979).

FESA-TS-2032

Special Report 79-8

April 1979

DESIGN PROCEDURES FOR UNDERGROUND HEAT SINK SYSTEMS

John M. Stubstad, William F. Quinn, Marcus Greenberg,

Walter C. Best and Mounir M. Botros

Prepared for
U.S. ARMY FACILITIES ENGINEERING SUPPORT AGENCY
By

UNITED STATES ARMY
CORPS OF ENGINEERS
COLD REGIONS RESEARCH AND ENGINEERING LABORATORY
HANOVER, NEW HAMPSHIRE, U.S.A.

GB
2405
.C6
8R
79-8

Illustration 10. The existence of this document strongly implies the reality of underground heat sinks for deeply buried, underground bases. (*Source*: U.S. Army Corps of Engineers.)

using cooling towers (whose basic operation is analogous to that of an automobile radiator). In the case of an underground nuclear power plant, cooling with surface water sources can also be achieved in the following way:

> Local water sources such as rivers, lakes, water wells, aquifers or even the ocean for coastal sites can be used for cooling the power plant. Cool water would be drawn from the source, circulated through a heat exchanger and then either returned to the source or wasted at a remote location.[20]

I have also been advised that in some cases waste heat can be dissipated through large piles of boulders, or through boulder fields and other large masses of broken rock. In these cases, air conduits are carefully drilled from the underground facility to the bottom of the piles of boulders or other broken rock. The presence of the facility can be disguised more easily in this way, because the presence of heat vents is concealed by the boulders or piles of rock.[21]

Facilities for cooling an underground installation may also be located deep underground, in the form of huge, subterranean "heat sinks". Water chilling plants cool the water in the heat sinks; if necessary the water may be further chilled by the addition of ice, creating an ice-water heat sink. Under some conditions, the entire heat sink system may be composed of ice. The "sinks" themselves are described as huge, vertical, cylindrical reservoirs excavated in the rock deep underground, measuring about 250 ft. tall by 50 ft. in diameter. The tops and bottoms of the reservoirs would be hemispherical, while the walls would be covered with 2 solid feet of concrete and special

[20] Ibid.
[21] According to anonymous sources, these rock piles may be either artificially constructed or natural features.

tar-like sealant. (See Illustrations 11 and 12.)

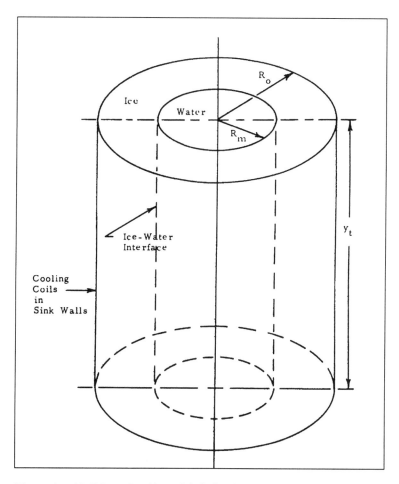

Illustration 11. Schematic of heat sink during freezing of ice. The refrigeration coils would be in the walls of the cavity. (*Source*: U.S. Army Corps of Engineers, Cold Regions Research and Engineering Laboratory, *Analysis and Conceptual Design of Practical Ice-Water Heat Sinks*, Special Report 221, authored by Edvard Grande, March 1975.)

Illustration 12. Basic geometry of the heat sink reservoirs. The drawing is not to scale. Keep in mind that the heat sinks would have the vertical orientation depicted here, would be very deep underground, and would be full of ice-cold water, an ice and water combination, or ice. (*Source*: U.S. Army Corps of Engineers, *Design Procedures for Underground Heat Sink Systems*, April 1979.)

What kind of refrigeration capacity would be needed to provide the requisite cooling power? The U.S. Army Corps of engineers 1979 study anticipated a 125 ton refrigeration unit would be needed to cool the rock surrounding a deeply buried installation; while a 40 ton refrigeration unit would be needed to cool the water used to maintain a deep base 4,000 ft. underground.[22] Starting from the time of completion of excavation, approximately three years would be needed to chill the surrounding rock at that depth and to bring the entire cooling system down to a comfortable and safe operating temperature. The Army Corps study discusses several different underground cooling systems, using various numbers of heat sink reservoirs, up to as many as a total of ten, for a deeply buried underground facility.

There may even be hybrid cooling systems for an underground facility. To wit, a subterranean facility could make use both of:

> ...an underground ice reservoir and a hardened cooling tower located in an underground cavern.[23]

There need be no cooling apparatus visible on the surface at all. It can all be very cleverly concealed in underground chambers and caverns. As mentioned above, coolant water can even be drawn underground directly from the bottom of lakes, rivers, bays or the ocean itself (more about undersea facilities later). So you see, there need be no surface indication whatsoever of the cooling apparatus for a sophisticated, deeply buried underground facility.

[22] John M. Stubstad et al. One ton of refrigeration represents a cooling capacity of 12,000 Btu/hr.
[23] Ibid.

The Chilling Facts

Are there really deep underground secret bases cooled with chilled water plants? I am inclined to think that there may be at least one, and perhaps more. While searching through military construction appropriations bills, I discovered that in October 1989 the United States Congress budgeted $4.5 million dollars for a "chilled water plant." The "chilled water plant" was to be constructed by unnamed "defense agencies" at a "classified location" somewhere in the continental United States. At the same time, the Congress authorized the United States Army to spend $7.5 million for an unspecified, classified "operational facility" to be constructed somewhere in the continental United States. The Congress also allocated to the Army a total of $7.3 million for two "classified projects" to be carried out at "classified locations," again in the continental United States. Finally, the Congress awarded the Army $600,000 for "land acquisition" at "classified locations" somewhere in the continental United States. [24]

All of this information appears under the heading "CONUS CLASSIFIED," in the middle of the same page in the 1989 military construction appropriations report. Because this information is classified it is impossible to say with total confidence why the military was purchasing land at "classified locations," or why the Pentagon wanted a classified "chilled water plant," or what the Army's classified "operational facility" was. However, if the military were building secret, underground bases that require large refrigeration facilities for cooling, this is exactly the kind of documentation that one would expect to

[24] U.S. Congress, House of Representatives, *Making Appropriations for Military Construction for the Department of Defense for the Fiscal Year Ending September 30, 1990, and For Other Purposes*, 101st Cong., 1st sess., 1989, Rept. 101-307.

find. The military would need to purchase the land for the facility, if they did not already own it; they would need to construct the facility; and they would need to build a refrigeration plant to cool it and keep it cool. I have combed through a lot of government information and data from disparate sources looking for proof of the construction of secret underground bases. In my view, these cryptic references in a 1989 congressional report come the closest to fitting the profile of what I would expect funding for such facilities to look like. If these references to classified projects, classified land acquisition and a classified chilled water plant refer to funding for a secret underground base, then it means that within the last decade, or so, the United States Army has built at least one clandestine, deeply buried subterranean facility. Based on my research, my "guesstimate" is that various U.S. federal agencies have constructed multiple, highly secret, high tech, deeply buried facilities.

The Black Budget

At this point, the uninitiated reader must be scratching his or her head in bewilderment and wondering how so many secret plans and underground installations can exist. After all, the money to construct them must come from somewhere. Many billions of dollars must have been lavished on making these facilities. So why have there been no budget hearings for underground base construction? Why hasn't there been conspicuous mention in the national press of these facilities and their funding?

The answer to this understandable question is really very simple: the secret underground facilities are part of the *black* budget. The black budget is comprised of all of the secret, covert, clandestine programs and projects that federal agencies carry out. When an activity is illegal or unconstitutional federal agencies simply fund it through the

black budget. The project is not reported publicly and the funding for it does not go through the constitutionally mandated process for federal spending in the United States Congress. Tim Weiner discusses this process in his Pulitzer Prize-winning book, *Blank Check: The Pentagon's Black Budget*.[25] According to Weiner, at one point during the Reagan years the Pentagon's black budget ranged as high as $36 billion per annum. It appears likely that tens of billions of dollars are still lavished on the black budget each year.

The Invisible Government

Just who oversees the black budget to which I have been referring, and who administers secret projects like clandestine tunnels and underground bases? Why, *The Invisible Government* of course! The invisible government has been around for decades now. It is nothing new. Insiders, that is to say, those who understand how government, intelligence (spy) and military agencies, and large corporations really work, have known this simple truth all along:

> There are two governments in the United States today. One is visible. The other is invisible.

> The first is the government that citizens read about in their newspapers and children study about in their civics books. The second is the interlocking, hidden machinery that carries out the policies of the United States in the Cold War.[26]

[25] Tim Weiner, *Blank Check: The Pentagon's Black Budget* (New York: Warner Books, Inc., 1990). This is an excellent book that provides an insightful analysis of just how unconstitutional many of the Pentagon's activities are.

[26] David Wise and Thomas B. Ross, *The Invisible Government* (New York: Random House, 1964).

These words were written by David Wise and Thomas Ross in the 1960s, at the height of the Cold War. More than 30 years have passed, the Cold War is now over (at any rate that is what the newspapers tell us), but the invisible government remains. And the secret underground bases fall within its clandestine domain. Out of sight, out of mind. Funded from the black budget, stealthily constructed, operated by known and unknown, highly secretive agencies that carry out hidden agendas, without our knowledge, deep underground.

The Secret Team

In 1973, L. Fletcher Prouty, a retired U.S. Air Force Colonel, published an eye-opening book entitled, *The Secret Team*.[27] Prouty held a unique position in the United States government. From 1955 to 1963 he was the liaison between the Central Intelligence Agency (CIA) and the Department of Defense (DOD) for military support of what he calls *Special Operations*. In this position he had access to a wide range of political, intelligence and military operatives—all the way from Washington, D.C. and the Pentagon to the far corners of the globe. He saw the full gamut of secret operations and policy making.

The *Secret Team* which gives Prouty the title for his book, is a powerful, brutally violent and treacherous international *octopus*. It has operatives in the academic world (scholars), in intelligence agencies (spies), in the military (both officers and enlisted personnel), in private industry (businessmen and businesswomen), in the world of corporate and public sector high finance (bankers, financiers and stock brokers), in the news media (electronic and print journalists), in the publishing industry in the

[27] L. Fletcher Prouty, *The Secret Team: The CIA and its Allies in Control of the United States and the World* (Englewood Cliffs, New Jersey: Prentice-Hall, Inc., 1973).

United States and abroad (book publishers). It has powerful connections in dozens of countries all over the world. According to Prouty, the Secret Team overthrows and influences governments almost at will, all over the globe. At the core of the Secret Team are members of the CIA, the National Security Council (NSC) and various and sundry other military and civilian officials, intelligence operatives, business people and academics.

Prouty characterizes this Secret Team as the "real power structure." Far from being a tight, coherently focused group it is in actuality more like a hugely violent, murderously out-of-control, sprawling octopus that has the world, and the United States, in its deadly grasp. Of course, the Secret Team is completely unconstitutional. But I am sure that many readers of this book understand by now that the constitutional government of the United States has already fallen long ago—and it fell from within! Who are the perpetrators? Why, they are the CIA, the NSA, the FBI, the IRS, the federal courts, the White House, the Congress, the Pentagon, the Democratic and Republican Parties, and a host of fellow travelers from the academic world, the business community, organized crime and the world of high finance. How ironic that the Secret Team, which has made a 50 year crusade out of (ostensibly) fighting Communism, has ended up doing precisely what the Communists never could or did do: subvert constitutional government in the United States! Which begs the question: are these cutthroat CIA kooks and Secret Team anti-Communist zealots really Communists in disguise? In this regard, Walt Kelly's famous line, uttered by his cartoon character, Pogo, comes to mind: "We have met the enemy, and they is us!"

Prouty's book is a classic work and well worth reading. (Unfortunately it is out of print, so you must look for it in a good used bookstore or library, or order it via

interlibrary loan.) Even though it was published 25 years ago it is as relevant today as when it first appeared. One of the things that Prouty does is to clarify that there are literally hundreds of clandestine CIA units operating from within the armed forces of the United States, wearing Air Force, Army, Navy and (presumably) Marine Corps uniforms. These CIA units appear outwardly to be regular military units- but they are not. In other words, what we know as the Pentagon is actually a hybrid CIA-military organization in unknown, and unknowable, measure.

What a Tangled Web

Permit me to briefly recapitulate what my research suggests. At the bare minimum: 1) There are definitely secret underground bases (and possibly secret undersea bases too, but more about that later). 2) In particular, there are secret, underground installations in New Mexico. 3) The black budget is truly huge, running conservatively into the tens of billions of dollars yearly. 4) The Pentagon has been massively infiltrated by the CIA, such that military officers do not always fully understand the things that go on in the very agencies they ostensibly command. 5) As a direct result of the combination of many billions of dollars of black money, CIA cut-out projects, classified military projects, and the all pervading secrecy that covers the whole morass, the entire, obscure field of black operations and underground bases and tunnels is so wonderfully confused by a thickly tangled welter of disinformation that even the most seasoned investigators have difficulty making sense of it all.

I can best illustrate what I mean by talking about the alleged underground bases near Dulce, New Mexico and Sedona, Arizona.

Dulce, New Mexico and Sedona, Arizona

Two locations in the Southwest that have been prominently mentioned by many people as sites for large, secret, deep underground government bases are the Dulce, New Mexico and Sedona, Arizona areas. The little town of Dulce, New Mexico is on the northern end of the Jicarilla Apache Indian Reservation, near the Colorado-New Mexico state line. For years, the area near Dulce has been the subject of unsubstantiated rumors and stories about a purported, top-secret, underground base. As the rumors go, the secret underground base is a cutting edge, genetic engineering laboratory that clones humans and creates human-animal genetic hybrids. The base allegedly is (or was) jointly run by covert elements of the United States military and purported "Little Grey" aliens.

Reality check: I twice visited the Dulce area and did not see anything that indicated to me that there was an underground base there. Neither have I seen any hard, unimpeachable evidence or documentation from other researchers definitively demonstrating that there is a secret underground base there.

Similarly, the red rock country in and around Sedona, Arizona is widely rumored to be the site of a sprawling complex of secret underground bases and tunnels. The New Age community in the Southwest has been positively atwitter in recent years about alleged, clandestine, subterranean happenings in and around the Sedona region's craggy cliffs and canyons. Some of the stories I have heard prominently feature heavily armed soldiers who warn hikers away from the area.

Well. I lived in nearby Flagstaff, Arizona for a year and a half and visited the Sedona area on several occasions to hike in the outlying areas and look for evidence of a possible underground facility. As happened when I visited Dulce, New Mexico, I saw nothing that looked out of place.

To my eye, there was no indication of an underground labyrinth of tunnels and secret bases. I never saw any armed, menacing soldiers.

But the rumors about underground bases at Dulce, New Mexico and Sedona, Arizona are so persistent that they have to be dealt with. I can see two possibilities: 1) there really are secret underground bases at Dulce and/or Sedona; or 2) there really are *not* secret, underground bases at Dulce and/or Sedona. If the first possibility is correct, then it is possible that we will one day have hard evidence proving the existence of these facilities. Indeed, I encourage anyone having such hard evidence to forward it to me, in care of my publisher. But if the second possibility is correct, then the rumors of secret, underground bases at Dulce and Sedona are part of an elaborate disinformation campaign.

What would be the goal of such a campaign, if that is the case? The answer is simple: by falsely directing the attention of researchers and others to places where underground bases do *not* exist, attention is diverted from other places where they *do* exist.

Let me be clear on this point: I do not know if there are, or if there are not, secret underground bases at Dulce and Sedona. I have searched and have found no hard evidence to substantiate the many rumors and sensationalistic claims that have been made on talk radio, on the internet, and in various magazines and books. However, I do not rule out the possibility that a secret, underground facility could be at either location.

But whether secret, subterranean installations lie underground in the immediate vicinity of Dulce, New Mexico and/or Sedona, Arizona, or not, does not alter the fact that there certainly are secret underground bases in the American Southwest, and elsewhere as well. How many of these facilities are there? Precisely where are they? Just

who works in them? And what exactly is done in them? Unfortunately, these are questions for which firm answers are difficult to obtain. Other researchers and I have been searching for reliable information, but it seems like every time one question is answered, a host of new ones arise to take its place.

Chapter 2. Secret Tunnel System in the United States: Reality or Disinformation?

The stories of a secret, underground tunnel system that is purported to exist in the United States have been swirling for years now. I first heard these stories in the late 1980s. At first I thought they were highly entertaining, but very unlikely to be true. They invariably involved a secret network of tube-shuttle trains operated by the United States military and alleged *Little Grey* aliens that went careening through a clandestine tunnel system that supposedly sprawled under the western states. I have not yet found any solid proof that *Little Grey* extraterrestrials exist, in secret underground bases and tunnels, or anywhere else. But I have learned enough about the massive funding of black budget projects and the power and sophistication of modern tunneling machinery that I do not automatically dismiss the possibility of secret tunnels. For all I know, there might be secret tunnels deep beneath our feet. (See Illustration 13.)

One federal bureaucrat who spoke to me hinted that an extensive, secret system does exist. The conversation went like this:

> *Sauder*: What about the rumors of a secret tunnel system in the United States?

Official: I would pay attention to those rumors.

Sauder: Well, are there secret tunnels or not?

Official: There might be.

Sauder: O.K. Assuming there might be secret tunnels, are there 400 miles of tunnels? 4,000 miles of tunnels?

Official: I would say hypothetically that there might be more than the smaller figure, but less than the larger figure.

Of course, there is the very real possibility that this bureaucrat was simply feeding me disinformation. Anyone can put on airs and pretend to possess secret knowledge. Maybe what the official told me is just a lie.

On the other hand, I am also willing to consider the possibility that secret tunnel systems may really exist. After all, various federal intelligence agencies spend tens of billions of black budget dollars every year on all kinds of covert activities.[28] So the money to undertake secret construction projects is available. Untraceable and unaccounted for. Ready to be shoveled by the bushels into literal, high-tech holes in the ground. The requisite infrastructure of secrecy is also in place- courtesy of David Wise's and Thomas Ross's *Invisible Government* and Fletcher Prouty's *Secret Team*. And finally, the technology to make sophisticated underground installations and tunnels

[28] On 15 October 1997 the Director of the CIA admitted, in response to a Freedom of Information Act lawsuit, that the budget of the CIA and other federal intelligence agencies was $26.6 billion for fiscal year 1997. World Wide Web: http://www.abcnews.com/sections/us/cia1015/index.html, 1997.

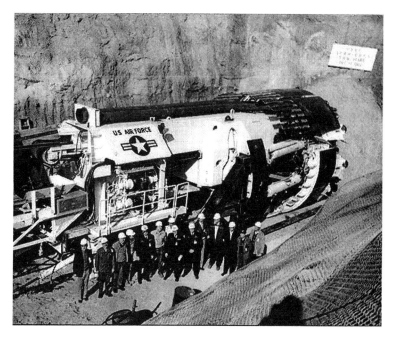

Illustration 13. United States Air Force tunnel boring machine at Little Skull Mountain, Nevada, December 1982. There are many rumors of secret military tunnels in the United States. If the rumors are true, machines such as the one shown here are used to make the tunnels. (*Source: U.S. Department of Energy.*)

exists. Powerful tunnel boring machines and other excavation equipment have been in use since the 1950s. The state of the art in subterranean excavation technology makes possible the construction of underground installations literally anywhere in the world: under swamps, deserts, glaciers, large cities, small towns, farm land, mountains, forests -- even under the open sea!

In the words of the U.S. Army Corps of Engineers:

> Since adequate technology is available to construct hardened underground facilities under virtually any ground conditions, the main constraint in construction

projects remains economic viability rather than technical feasibility.[29]

Of course, as I have shown, money is really no obstacle. There is plenty of it in the black budget. And we have documentation that the military has made secret underground bases. That much we know.

Secret Tunnels Full of Nuclear Missiles?

In *Underground Bases and Tunnels* I also showed plans by the Pentagon to make a hundreds of miles-long tunnel system somewhere in the western states to shelter deeply buried nuclear missiles and their crews, who would burrow out from thousands of feet underground in the event of nuclear war, and fire off the missiles. Through the Freedom of Information Act, I have recently uncovered more documentation for this plan. I obtained a lengthy, 1980 Defense Nuclear Agency (DNA) document produced by the Boeing Aerospace Company, that plainly indicates two possible locations for such a clandestine, deeply buried tunnel system: a) western Colorado, in the vicinity of Grand Mesa; and b) southern Utah.[30] It also blocks out a huge area for possible MX Missile deployment in central Nevada that extends into western Utah. My research over the last several years definitely indicates all three of these states as potential candidates for clandestine underground

[29] U.S. Army Corps of Engineers, Construction Engineering Research Laboratory, *Literature Survey of Underground Construction Methods for Application to Hardened Facilities*, Report No. CERL TR M-85/11 (April 1985).

[30] Report received via the Freedom of Information Act from the United States Defense Threat Reduction Agency, 10 September 1999. D.M. Armitead, H.G. Leistner, J.J. McAvoy and J.A. Wooster, *Investigation of Deep Missile Basing Issues*, Federal Document No., DNA 6284F, Contract No. DNA 001-79-C-0297, Prepared by Boeing Aerospace Company for the Defense Nuclear Agency (30 December 1980).

Illustration 14. Possible sites for the proposed deep base in Grand Mesa, Colorado and southern Utah. (*Source*: U.S. Defense Nuclear Agency, *Investigation of Deep Missile Basing System Issues*, 30 December 1980.)

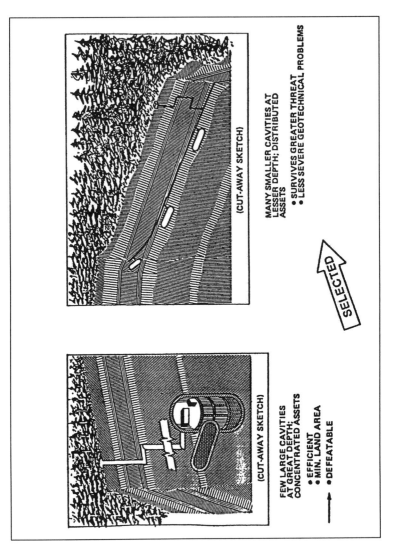

Illustration 15. Two schemes for deep bases: a) a few, large bases at very great depth; or b) many, smaller bases at comparatively shallower depth. Notice that the entrance shafts to both types of bases are depicted as relatively simple structures situated in coniferous forests of the type that are common in many areas of the western United States. (*Source*: U.S. Defense Nuclear Agency, *Investigation of Deep Missile Basing System Issues*, 30 December 1980.)

66

facilities and tunnels. (See Illustration 16.) The Boeing/DNA report provides hard numbers for the estimated number of personnel needed to construct, operate and maintain a deeply buried, hundreds of miles-long tunnel system filled with nuclear missiles. One of the illustrations within the report suggests the tunnels could range up to 600 miles or more, at depths of up to 4,000 feet. The report estimates that a tunnel system at 2,600 foot depth would require 8,692 support and operating personnel; a system at 3,360 foot depth would require less personnel -- about 7,871. The estimated cost over a ten year period would be about $17 billion.[31] Clearly, both the required number of personnel and the cost are well within the capabilities of the modern military-industrial complex. (See Illustrations 14 and 15.) Tim Weiner's book, *Blank Check*, shows how the Pentagon's "creative accounting" can make these sorts of sums of money "vanish" into thin air.

Questions Remain

But the question remains: what about secret, underground tunnels? Do they exist or not?

I could easily play the absolute skeptic and deny any possibility of secret tunnels. But such an approach has a potential drawback. To wit: if secret tunnels really do exist and I summarily dismiss them as impossible without carefully weighing the evidence, then I would have unnecessarily blinded myself to an objective, if obscure, truth. Since I don't want to run that risk, I will carefully weigh as much relevant evidence as I can find. Based on the evidence I collect I will then judge the likelihood that the stories of secret tunnels are true- or perhaps false.

So let's have a look at the available evidence. First of all, to make tunnels of any variety, whether secret or not,

[31] Ibid.

Illustration 16. Jurassic Age Wingate Sandstone. Massive sandstone beds in the vicinity of Green River, Utah, near the Delta Mine. This type of sandstone formation is ideal for tunneling by boring machines. The southwestern U.S.A. has many, many miles of this kind of geologic formation. (*Source*: Carl F. Austin.)

there must be companies, organizations and agencies with tunneling capability and expertise. Are there organizations, agencies and companies with the demonstrated capability to construct deep underground tunnels? In point of fact, there are many, many such companies, organizations and agencies. I will present several of them for your consideration in the pages that follow; private sector companies first, followed by some of the major United States federal agencies involved in underground tunneling (so far as is known from the open record), and finally concluding with an obscure quasi-governmental tunneling organization. Bear in mind that the list that follows is not exhaustive; it is merely illustrative of the sort of tunneling capabilities that have existed over the last few decades in the private and public sectors in the United States.

Corporate Tunneling

American Underground-Construction Association

Many corporations possess the technology, personnel and expertise to make deep underground tunnels. In fact, there is an industry trade association, the American Underground-Construction Association (AUA), that counts literally dozens of private companies among its members (as well as the U.S. Bureau of Reclamation). Interestingly, when I first browsed the AUA website in 1998 it stated:

> The American Underground-Construction Association (AUA) is an organization of professionals involved in the planning, design, development, construction and use of underground facilities...AUA is the official United States member-nation representative to the International Tunneling Association. Think deep.[32]

[32] On the WWW at http://www.auca.org/, 1998.

No doubt, if you are reading this book you already *are* a deep thinker. And no doubt your deep thoughts are leading you to ask just who belongs to the AUA. It turns out that the American Underground-Construction Association (AUA) membership roster includes (but is by no means limited to):

- Al Mathews Corporation
- Frontier Kemper Constructors, Inc.
- Lovat Tunnel Equipment, Inc.
- Parsons Brinckerhoff Quade & Douglas, Inc.
- Bechtel Corporation
- EG&G Reeco
- Kiewit Construction
- Harza Engineering Company
- Morrison Knudsen Company, Inc.
- Perini Corporation
- Jacobs Associates
- Wirth Maschinen und Bohrgeräte
- Atlas Copco Robbins, Inc.

> (*Source*: the WWW at http://www.auca.org/aua/directory.html, 1997.)

This abridged list of AUA member corporations includes many of the biggest names in the underground construction and tunneling industries. There are many more corporations that belong to the AUA, any and all of which are capable of consulting on, or providing expertise, materiel and equipment to help construct underground installations and tunnels. I might add that virtually all of the AUA member corporations in the list above have worked on underground construction or tunneling projects for various agencies of the United States government in the past.

In the discussion of various corporations that follows below, I would like to point out that I am merely demonstrating the capability that exists on the part of private industry to construct lengthy tunnels. I have no proof that any of the companies mentioned have made secret tunnel systems. I mention them merely to show that the technology exists, and has existed for decades, to make lengthy, large diameter, deep underground tunnels.

Robbins Co.

Let's consider the Robbins Company of Kent, Washington. Between 1952 and 1990, The Robbins Company used tunnel boring machines (TBMs) on 409 separate projects to construct 1,236 total miles of tunnels. To complete these projects it constructed some 153 new TBMs. However, during that same 38 year period the record also shows that the Robbins Company carried out 11 more tunneling projects for which the distances are not known.[33] Where are these eleven other tunneling projects? For whom did Robbins make the tunnels? At present Robbins TBMs are boring an 11 mile, approximately 16 ft. diameter tunnel for the new MetroWest Water Supply Tunnel near Boston, Massachusetts. The tunnel ranges between 200 ft. and 500 ft. below the ground surface.[34]

Traylor Bros.

Then there is Traylor Bros., Inc. based in Evansville, Indiana. Traylor Bros., Inc. has excavated more than 50 miles of tunnels, including tunnels for subways in

[33] *Underground Structures: Design and Construction*, ed. R.S. Sinha (New York: Elsevier Science Publishing Company Inc., 1991).
[34] "Two Robbins TBMs to Bore Boston Water Tunnels," *Breakthrough: Project and Product News From Atlas Copco Robbins*, No. 4, 1996.

Los Angeles, Portland, Buffalo, Baltimore, San Francisco, the District of Columbia and Singapore. Traylor Bros. employs a variety of equipment and methods for tunneling in subaqueous, soft ground and hard rock conditions. The company carries out compressed air tunneling using "sand hogs", hard rock tunneling with TBMs, conventional drill and shoot tunneling using hydraulic drills and high explosives, soft ground tunneling with mechanical shields, and subaqueous tunneling using earth pressure balance.[35]

Frontier-Kemper

Another tunneling company, Frontier-Kemper Constructors, Inc. is also located in Evansville, Indiana. Frontier-Kemper has excavated almost 55 miles of hard rock tunnels and slopes. Frontier-Kemper has sunk over 50,000 vertical feet of shaft, including a 572 foot vertical elevator shaft for the U.S. Bureau of Reclamation at Hoover Dam, in Boulder City Nevada, and three 270 foot vertical elevator and vent shafts for the "deepest subway station in North America" for the Tri-County Metropolitan Transportation District in Portland, Oregon. Frontier-Kemper has also raise bored over 56,000 feet of vertical shafts ranging in diameter from 4'0" to 20'3". One of these was a 2,150 foot shaft for the U.S. Department of Energy's Waste Isolation Pilot Project near Carlsbad, New Mexico (designed to store nuclear waste in deep caverns carved out of rock salt formations).[36]

[35] On the WWW at: http://www.traylor.com/, 1997 and http://www.traylor.com/tunnels/, 1997.
[36] On the WWW at: http://www.frontier-kemper.com/, 1997 and http://www.frontier-kemper.com/fkc_tunneling_and_shaft_sinking.html, 1997.

Other Companies

Of course there are many other companies which make tunnels and tunnel boring equipment. For instance, during the years 1965 to 1989, Atlas Copco Jarva, and the Demag and Wirth Companies carried out 300 projects which accounted for about 500 miles of tunnels.[37] The Canadian company, Lovat Tunnel Equipment, Inc., is notable for making tunnel boring machines with a cutting head up to 46 ft. in diameter.[38] Needless to say, TBMs of this size are capable of making impressively huge tunnels.

This is probably the appropriate place to mention New York City's Water Tunnel No. 3, which has been under construction since 1970. Among the companies at work on this massive project are the Grow Tunneling Corporation, Perini Corporation and Skanska JV.[39] The tunnel network has been described as one of the "most complex and intricate" projects of its kind in the world. Dozens of miles of tunnels, and multiple shafts and huge chambers have been bored and hewn out of the solid rock hundreds of feet beneath the Bronx, Queens and Manhattan. (See Illustrations 17 and 18.)

The information presented here simply reflects the state of the art in the tunneling industry. I have cited the work of the companies above merely to demonstrate what can be, and what has been, done. The fact of the matter is that the technology and the expertise to bore lengthy, deep underground tunnels through the solid bedrock have existed for several decades. I reiterate that I have no information that any of the companies mentioned here have helped

[37] *Underground Structures: Design and Construction*, ed. R.S. Sinha (New York: Elsevier Science Publishing Company Inc., 1991).
[38] On the WWW at: http://www.industrylink.com/kuhn/cs4.htm, 1997.
[39] "New York City Tunnel No. 3, USA." On the WWW at http://www.water-technology.net/projects/new_york/, 2000.

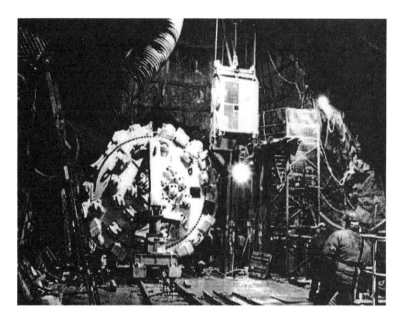

Illustrations 17 and 18. Water Tunnel No. 3, deep below New York City. **Above:** underground construction area. **Below:** finished tunnel. The rail track and utility lines will be removed prior to use of the tunnel as an aqueduct. The complex, 60-mile project is slated for completion in 2020. (*Source*: New York City Department of Environmental Protection.)

construct clandestine tunnels for the United States military or for any other organization or agency.

Parsons Brinckerhoff

And then there is Parsons Brinckerhoff. The following information is on the corporate website:

Tunnel/Underground Design and Engineering

As the premier underground engineering firm in the U.S., PB has long been a leader in the planning, study, design, permitting and construction management of underground facilities. PB is involved in all areas of underground design and construction including: immersed tube tunnels, cut-and-cover tunnels, mined and bored tunnels in rock and soft ground; and oil and gas storage caverns. These underground facilities are designed for a variety of applications, including rail and transit tunnels, highway tunnels, tunnels for military facilities, high energy physics tunnels, water and wastewater tunnels, and nuclear waste storage.[40]

Here is a very large, technically competent company that plainly states that it is the *"premier underground engineering firm in the U.S.,"* that it makes *"mined and bored tunnels in rock and soft ground,"* as well as *"rail and transit tunnels,"* and also *"tunnels for military facilities."* Does this information bear any relation to the many, so far unsubstantiated rumors of a purported subterranean labyrinth of clandestine tunnels through which the United States military allegedly, covertly operates shuttle trains deep beneath the United States? I simply do not know.

[40] This material comes verbatim from the Parsons Brinckerhoff website, at http://www.pbworld.com/Services/T-Z/TunUnDeE/TunUn DeE.htm, 1998.

In the next section I will discuss the tunneling abilities of several federal government agencies.

United States Federal Agencies That Like to Burrow

The following federal agencies are not the only ones involved in tunneling. I mention them simply to demonstrate the extensive federal capacity for subterranean tunneling. My purpose throughout this book is to factually demonstrate what *can* be done, by factually documenting a small part of what *has* been done, and by whom, in order to gauge to what degree the many stories of secret underground bases and tunnels are true. As you will see a little later on, I even open the discussion to the possibility of undersea bases. But were I to mention every agency that has ever dug a tunnel anywhere, what to speak of every tunnel that has been dug, my research would never end, and this book would be so long that you would drop it in boredom. The simple reality is that many, many government agencies have engaged in tunneling projects, for all kinds of reasons. The tunneling work is carried out at all levels of government: local, state and federal. Tunnels are made for subways, sewers, highways, railroads, aqueducts, hydroelectric projects—for a wide variety of purposes.

If secret tunneling activity has been carried out there are assuredly many government agencies that could conceivably take part in such activities. This is true even (or maybe even especially) at the local level. Many cities have successfully bored lengthy subway systems, for example. Think about this: if you are 500 feet underground, and access to the tunneling project is carefully controlled, who could possibly know, outside of the personnel working on the project, if a clandestine tunnel veered off from the main tunnel?

Here, then, are a number of U.S. federal agencies that have substantial tunneling expertise.

U.S. Bureau of Reclamation

The United States Bureau of Reclamation is a relatively low profile agency within the United States Department of the Interior that is the lead agency for carrying out hydroelectric and water projects all over the western region of the country. One of its major functions during the 20th Century was tunneling. For decades this agency has been blasting, building, excavating and tunneling all over the West, all the way from Alaska to California, from Nevada to Nebraska, from Washington to Montana to New Mexico and many points in between. Over the decades, it has excavated well over 200 miles of tunnels (see Appendix B for a detailed listing of individual tunnel locations, length, size and shape). The tunnels range in length from hundreds of feet to more than 13 miles; their diameters vary from 4.75 ft. to 28.5 ft.[41] The tunneling methods have included the use of TBMs, conventional drill and blast technologies that are in wide use in the mining and tunneling industries, and hand excavation.[42] (See Illustration 19.)

What is the intended use of these hundreds of miles of tunnels? Well, according to the Bureau of Reclamation's official internet website the tunnels serve four functions:

- Conveying water over long distances.
- Allowing passage of automobiles and trucks.
- Working around dams and powerhouses associated with dams.

[41] World Wide Web at http://www.usbr.gov/wcg/tunnels/tdata.html, 1997.
[42] World Wide Web at http://www.usbr.gov/wcg/tunnels/texc.html, 1997.

- Providing passage underground for other reasons.[43]

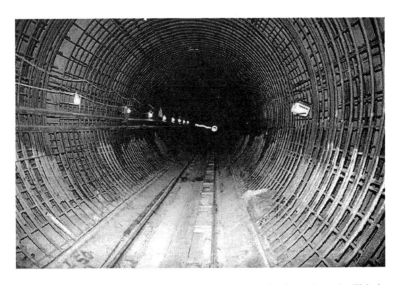

Illustration 19. New Waddell Dam, Central Arizona Projects Tunnels. This is a good example of the tunnel work that the Bureau of Reclamation does. (*Source*: U.S. Bureau of Reclamation, 1990.)

Of these four points, numbers one and three correspond very well to the work for which the agency is best known, constructing aqueducts, dams and hydroelectric plants. Numbers two and four, however, are a little more obscure. With regard to the second point, it is easy to understand that there may be times when alternate routes for ground transport would need to be provided when a major construction project disrupts local roads. But the fourth point is interesting: "providing passage underground for other reasons." I contacted the Bureau of Reclamation to find out just what those "other reasons" for tunneling might be. The prompt reply was that "other reasons" is a "catch-

[43] On the WWW at http://www.usbr.gov.wcg/tunnels/, 1998.

all phrase" that includes "adits for construction, drainage tunnels, etc." I found out that the Bureau of Reclamation "also aided DOE in oversight of the design and construction of the Superconducting Super Collider". (I discuss the Superconducting Super Collider later in this chapter.) In addition, the Bureau of Reclamation's response informed me that tunnels can be used for "sewer outfalls."[44]

All of which is interesting, but I still cannot help but wonder if "providing passage underground for other reasons" might not include the construction of clandestine tunnels. I say this because I have been told by a number of people that some of the tunnels, dams and hydroelectric projects that the Bureau of Reclamation has constructed in the western states double as a cover for other, clandestine underground projects.

One insider put it to me in this hypothetical, what-if manner: "From a hypothetical point of view, what is to stop a tunnel boring machine (TBM) from tunneling off of an aqueduct tunnel deep underground and striking out secretly to make a clandestine tunnel? It takes about ten men to operate a TBM and in good rock you can count on as much as 15 miles of tunnel per year."

I responded: "But how would you hide the muck (the ground up rock) that the TBM would excavate?"

The answer was: "Hypothetically you could just flush it away in the nearest river during the spring floods when the snow pack melts and the spring rains come. You could just hypothetically bore out a slurry pipe to the river bottom, from underground, and flush the debris away with all the other sediment and gravel coming down river."

It does make sense, doesn't it? If secret tunnels have been made, that would certainly be one way to secretly get rid of the muck the tunneling would generate.

[44] E-mail from Bureau of Reclamation, 29 January 1998.

In my view, the Bureau of Reclamation is just the sort of low profile federal agency that would be perfectly suited to carrying out secret underground construction projects. It usually receives little attention in the news media. For that reason, it is generally not very well known outside of sparsely populated regions of the rural West. At the same time, its decades of experience in underground construction and tunneling in remote areas of the West would make it ideally suited to involvement in "hypothetical" secret tunneling projects of the sort described above.

Perhaps the Bureau of Reclamation's most famous project is Hoover Dam, not far from Las Vegas, Nevada. To make the dam and the associated hydroelectric facility the Bureau had to make more than 5 miles of tunnels in the canyon walls that line the Colorado River.[45] More than three miles of the tunnels had a diameter of 56 feet, an impressive tunnel diameter in 1931 (or today!).[46] The dam is a massive 726.4 feet tall, 45 feet across on top and 660 feet thick at the base. It took 3.25 million cubic yards of concrete to build -- enough to make a 1935-standards, two lane highway from San Francisco to New York City.[47]

To be sure, many other dams and hydroelectric projects span the West, some of them comparable in size and complexity to Hoover Dam. Do some of these facilities really serve as an overt cover for covert projects that operate clandestinely, side-by-side with the publicly acknowledged operations that the Bureau of Reclamation carries out? To tell the truth, I don't know, but a handful of

[45] "Hoover Dam, The Virtual Tour", on the WWW at http://www.hoover dam.com/service/virtur/vurtoura.html, 1997.
[46] "A Hoover Dam History, Diverting the River", on the WWW at http://www.hooverdam.com/History/essays/tunnels.htm, 1997.
[47] "Hoover Dam, The Virtual Tour", on the WWW at http://www.hoover dam.com/service/virtur/vurtoura.html, 1997.

people have told me that there is more to some of these projects than meets the eye.

U.S. Department of Energy

The United States Department of Energy has a long-time, ever growing presence underground. For years it was closely involved in the miles of tunnels beneath the desert at the Nuclear Test Site (NTS) in Nevada. And quite apart from the stories and conjectures about purported underground facilities at the DOE's National Laboratories in Los Alamos, New Mexico, the DOE is now constructing two major underground facilities under Yucca Mountain, Nevada and near Carlsbad, New Mexico for the long-term storage of nuclear waste. Both projects have been under construction for years and have met with heated political and environmental opposition. However, both projects have forged ahead, in spite of the opposition, benefiting from a supportive and lenient federal bureaucracy and judiciary. The nuclear power and weapons industries are very well funded and politically well connected. They, and the long-lived, radioactive poisons they generate are not easily countered.

The DOE was also the responsive agency for the politically contentious Super-Collider -- a long, sub-atomic particle accelerator that was to be installed beneath Waxahatchie, Texas in mile upon mile of tunnels bored deep underground. However, after boring some 14 miles of tunnels 250 feet underground in the Texas bedrock, the project was abandoned by a skeptical U.S. Congress that decided to withdraw funding support. So the miles of tunnels lie there, abandoned, in the vicinity of Waxahatchie, Texas. At least that is the story that has been presented to the public by the United States government. The story might be true; it might be false. I haven't been underground at Waxahatchie to walk every one of the 14

(alleged) miles of tunnels, so I am reserving judgement. The subterranean activities of major government agencies and large corporations are so well funded, and so much of what happens underground is concealed from public view that I have to admit to a smidgen of suspicion as to a possible clandestine agenda in the deep tunnels at Waxahatchie, Texas.

Yucca Mountain Exploratory Studies Facility (ESF)

In recent years, the DOE has bored miles of tunnels deep beneath Yucca Mountain, Nevada[48] to determine the site's suitability for a long-term repository for nuclear waste. According to public statements, the Yucca Mountain site was chosen because the geological formations there are very dry and pose less of a problem for radioactive contamination of groundwater than most other locations in the United States. The region is a desert, and the water table is extremely deep. Therefore, the DOE reasons that placing the nuclear waste 1,000 feet underground will still leave it 800 feet above the water table. In that way, the DOE plans to prevent radioactive contamination of the region's groundwater.[49] (See Illustration 20.)

Between March of 1994 and 25 April 1997, five miles of 25 foot diameter tunnel were bored by a 720 ton tunnel boring machine (TBM),[50] built by Construction Tunneling Services.[51] The five miles of tunnels contain

[48]Yucca Mountain is about 100 miles northwest of Las Vegas, Nevada. See "Tests in the Exploratory Studies Facility," on the WWW at http://www.ymp.gov/reference/photos/esfcon/default.htm, 2000. Also, "Welcome to the Las Vegas Exploratory Studies Facility", on the WWW at http://ees13.lanl.gov/!esf-lv.htm, 1998.

[49] "Geology Overview," on the WWW at http://www.ymp.gov/ reference/photos/geology/geology.htm, 2000.

[50] "Tunnel Boring Machine Comes Through in a Crunch," on the WWW at http://www.rw.doe.gov/pages/current/ent-5-97/art01.htm, 1999.

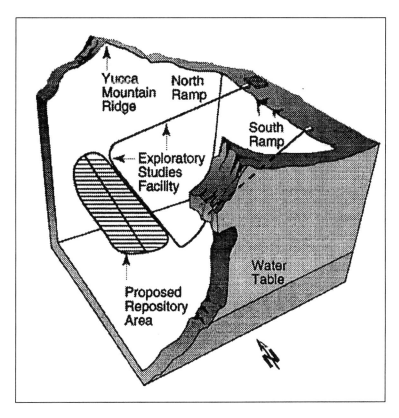

Illustration 20. Schematic of the underground area of the new Yucca Mountain nuclear waste repository in Nevada. (*Source*: On the WWW at http://www.ymp.gov/general/facts/e_sci/ render.htm, 1998.)

seven research alcoves where scientists study the underground geology and hydrology to determine the suitability of the site for long-term nuclear waste storage. [52] (See Illustrations 21 and 22.) More recently, another 1.7 mile, 16 foot diameter tunnel has been excavated by TBM,

[51] "The Yucca Mountain Mapping Group", on the WWW at http://www.usbr.gov/geo/ymp.htm, 2000.
[52] "The Exploratory Studies Facility", on the WWW at http://www. ymp.gov/general/facts/e_sci/ymp0395.htm, 1998.

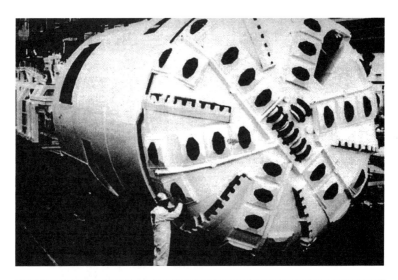

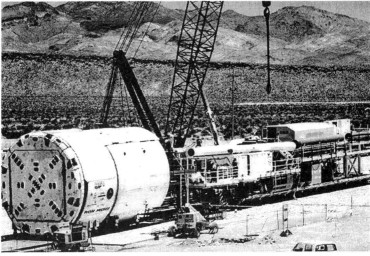

Illustrations 21 and 22. Two tunnel boring machines used to excavate the ESF under Yucca Mountain, Nevada. **Top:** one of the machines receives a factory inspection in Seattle, Washington. **Bottom:** final assembly of the cross-drift TBM and its trailing gear before entering the mountain. (*Source*: U.S. Department of Energy.)

cutting across the ESF from northeast to southwest.[53] (See Illustrations 23 and 24.)

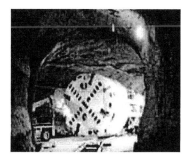 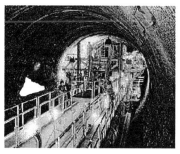

Illustrations 23 and 24. Two views underground in Yucca Mountain. **Left:** TBM used to excavate the cross-drift was moved forward on rails to begin excavating the tunnel. The excavation started in December 1997 and ended in October 1998. (*Source*: U.S. Department of Energy, on the WWW at http://www.rw.doe.gov/homejava/cdinfo/cdinfo.htm, 2000.) **Right:** A special section of the trailing gear of the TBM was constructed to allow geologists to perform geologic studies and mapping as part of the tunneling operation. (*Source*: "The Yucca Mountain Mapping Group", U.S. Bureau of Reclamation, on the WWW at http://www.usbr.gov/geo/ymp.htm, 2000.)

Waste Isolation Pilot Plant (WIPP)

The DOE's Waste Isolation Pilot Plant in southeastern New Mexico is 26 miles east of Carlsbad. The WIPP facility will store transuranic waste from the research and production of nuclear weapons. Transuranic waste includes "protective clothing, tools, glassware, equipment, soils, and sludge that have become contaminated with radioactive materials..." It is the first such facility in the world.[54] The actual waste storage area lies 2,150 feet underground.[55] After many delays, the WIPP

[53] "Cross-drift Excavation Confirms Earlier Site Assessments", on the WWW at http://www.rw.doe.gov/homejava/cdinfo/cdinfo.htm, 2000.
[54] "WIPP Facility", on the WWW at http://www.nsc.org/ehc/wipp/facil.htm, 2000.
[55] "Waste Isolation Pilot Plant", on the WWW at http://www.wipp.carlsbad.nm.us/wipp.htm, 2000.

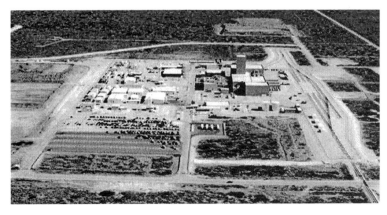

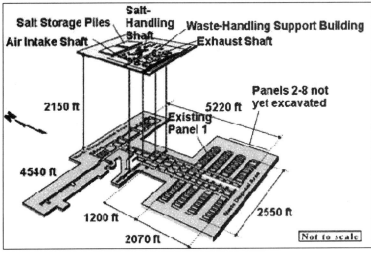

Salt Storage Piles, Salt-Handling Shaft, Waste-Handling Support Building, Air Intake Shaft, Exhaust Shaft

2150 ft

5220 ft — Panels 2-8 not yet excavated

Existing Panel 1

4540 ft

1200 ft

2550 ft

2070 ft

Not to scale

Illustrations 25 and 26. Top: Aerial view of WIPP's surface facilities is instructive. There is a parking lot for 300 cars and a couple of dozen industrial buildings of various sizes and shapes. The facility is very similar to the sort of medium sized industrial complex you can see anywhere in the industrialized world. Only, in this case, the industrial operation concerns storing transuranic radioactive waste in a very large facility that is very deep underground. (Source: U.S. Department of Energy.) **Bottom:** Layout of WIPP. Transuranic waste is stored 2,150 feet underground, about four-tenths of a mile beneath the surface. The underground portion of the facility spreads out over almost a full square mile. (*Source:* U.S. Department of Energy, on the WWW at http://www.nsc.org/ehc/wipp/facil.htm, 2000.)

began receiving transuranic nuclear waste in 1999.[56] (See Illustrations 25 and 26.)

Possible Clandestine Use for WIPP and Yucca Mountain Repositories?

Before leaving the topic of WIPP and the Yucca Mountain nuclear waste repositories, I must note that the possibility of dual use for nuclear waste repositories has been raised elsewhere in the literature that I have reviewed. Earlier, I mentioned a Defense Nuclear Agency report, *Investigation of Deep Missile Basing System Issues*,[57] that I received via the Freedom of Information Act. The report detailed potential plans for a highly secure, hundreds-of-miles-long, nuclear missile equipped, deeply buried tunnel system, somewhere in the American West. The report states that, "...protracted nuclear war, requiring enduring strategic forces, is a realistic probability." It chillingly alludes to the possibility of a nuclear war lasting for "many months or even years". The nuclear system recommended by the report is called the Future Secure Reserve Force (FSRF). The report further states that, "...the concept of alternate or shared uses of deep based facilities can enhance the utility of such a facility."

In other words, a deeply buried tunnel system could do more than house a wing of clandestine nuclear missiles and its accompanying fleet of post-attack, dig-out TBMs. In fact, the report specifically mentions a possible dual use FSRF tunnel system that could also accommodate

[56] "WIPP Milestones", on the WWW at http://www.wipp.carlsbad.nm. us/fctshts/milestones.pdf, 2001.

[57] D.M. Armitead, J.J. McAvoy, H.G. Leistner and J.A. Wooster, *Investigation of Deep Missile Basing System Issues*, Prepared by Boeing Aerospace Company for the Defense Nuclear Agency, Report No. DNA 6284F, Contract No. DNA 001-79-C-0297 (30 December 1980).

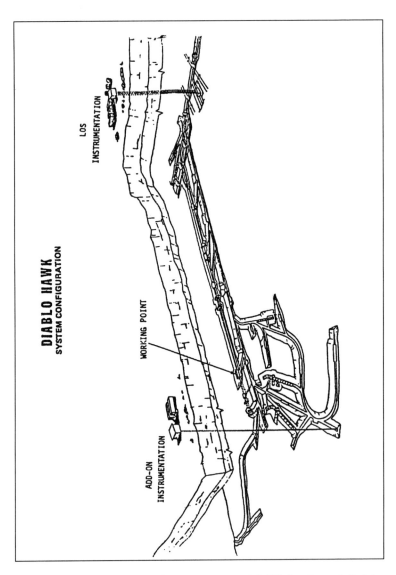

Illustration 27. Part of tunnel system excavated 1,400 feet beneath Rainier Mesa, at Nevada Test Site. This part of the U12n tunnel complex was used for the DIABLO HAWK underground nuclear test. A deeply buried tunnel system can underlay the landscape, with little indication of its presence. In this case, there are some trailers with electronic equipment to monitor the nuclear test. Vertical scale is greatly compressed. (*Source*: U.S. Defense Nuclear Agency, *Investigation of Deep Missile Basing System Issues*, 30 December 1980.)

the storage of nuclear waste. It states: "Collocation of a military facility and a monitored repository for hazardous waste deep underground may be an attractive deployment option."[58] It cautions that this would only be the case if political issues related to the underground storage of nuclear waste are resolved. However, with the recent opening of the WIPP facility for nuclear waste, and the continuing work at the planned Yucca Mountain nuclear waste repository, the possible implications of this statement for both of these monitored nuclear waste repositories are self evident.

When would such a system be built? Maybe right now, in the first decade of the 21st Century. According to the Boeing authors: "The required I.O.C. date for the system is assumed to be 1990, or later; i.e., at least ten years are available for development and deployment."[59]

If such a clandestine tunnel system existed, perhaps in tandem with the Yucca Mountain or WIPP nuclear waste repositories, or elsewhere, would the public-at-large know about it? Not necessarily. The report underscores that, "The unobtrusive character of a deep based system is a result of its minimal public interface." And it further refers to such a system being an "unobtrusive neighbor in the host area."[60] (See Illustration 27.)

Superconducting Super Collider (SSC)

Initial plans for the SSC called for a 54 mile-long loop of deep, underground tunnels to be carved beneath Waxahatchie, Texas. Tunneling began in January 1993. The Robbins Company, of Kent, Washington supplied one new tunnel boring machine, and two rebuilt ones for the

[58] Ibid.
[59] Ibid.
[60] Ibid.

tunneling work. The companies that contracted for the actual tunneling operations were Traylor Bros., Frontier Kemper Constructors, Obayashi/Dillingham, and Gilbert Texas and J.F. Shea. The project management team was lead by Parsons Brinckerhoff and Morrison Knudsen.[61] The companies involved in this project read like a veritable "who's who" of the underground excavation and tunneling industry in the United States. If you are observant, you will notice that the names of a number of these companies pop up more than once during the course of this book. The amount of money involved was impressive too: $8.25 *billion*.[62] That works out to almost $153 million per mile. Not bad work, if you can get it.

Yet by the end of the year, the SSC was dead. At least that is what the United States Congress and the U.S. DOE announced. In a letter at year's end, U.S. Secretary of Energy Hazel O'Leary and U.S. Congressman George E. Brown, Jr. proclaimed: "The superconducting super collider as we know it is now dead..."[63] And they set forth a variety of political and funding factors that contributed to its demise.

In subsequent years, the surface real estate holdings and buildings have been sold off by the Texas General Land Office. The main laboratory facility was sold to GVA Texas Waxahatchie Ltd. The company is controlled by George Ablah, of Wichita, Kansas. The linear accelerator facility went to International Isotopes

[61] "Collider Construction Pace Accelerates," *Civil Engineering*, Vol. 63, No. 3 (March 1993).
[62] Ibid.
[63] Hazel O'Leary and George E. Brown, Jr., "The Future of the Superconducting Super Collider", 10 December 1993. Their letter is archived on the WWW at http://www.lbl.gov/ScienceArticles/Archive/ssc-and-future.html, 2000.

Inc., of Denton, Texas.[64] Thousands of acres of land have been sold to yet others.[65]

It is, therefore, abundantly clear that the United States DOE has plenty of expertise in tunneling and underground construction. It also has a huge infrastructure of classified programs, by virtue of its long association with the Pentagon's nuclear weapons programs. In my view, the DOE has all the political, economic, scientific and engineering infrastructure elements necessary for carrying out highly secretive underground projects.

The DOE's Genetic Research Program

The DOE's years-long underground excavation and tunneling experience cannot be questioned. Its subterranean activities span decades now. But many people do not realize that another area in which the DOE is heavily involved is genetic research. Many people are not aware that the DOE is one of the lead agencies in the entire world in cutting-edge genetic research. It conducts its own research, and also coordinates its efforts with a wide variety of other governmental and scientific organizations around the world. The DOE is placing a huge emphasis on decoding human DNA, at present.

From an intuitive standpoint this makes little sense. At least it didn't to me. So I wrote to the DOE and asked for literature on their genetic research. I wanted to understand why the DOE would be so heavily involved in researching human genetics.

[64] Readers of my first book, *Underground Bases and Tunnels: What is the Government Trying to Hide?*, will recall that Denton, Texas is the site of one of FEMA's underground installations.

[65] Information about the sale of real estate related to the SSC is from the following source, "Super collider lab sold by state", on the WWW at http://www.texnews.com/1998/texas/lab0516.html, 2000.

It didn't take long to discover at least part of the answer: the DOE is concerned about the potential for genetic mutations as a result of nuclear radiation! I found the following, revealing quotation in a recent DOE publication:

A Logical Consequence: The Human Genome Project

A surprising but cogent thread links the atomic bombs that ended World War II with today's most ambitious health research effort, the Human Genome Project. One of the unanswered questions of radiation research is the extent to which the descendants of bomb survivors harbor DNA mutations as a legacy of their parents' exposure to radiation. Indeed, the Radiation Effects Research Foundation maintains a precious resource of frozen white-blood cells from almost a thousand families of survivors and children, awaiting the day when their DNA can be analyzed for telltale mutations. But that day awaits new tools for genetic analysis and a far more detailed knowledge of the human genetic makeup. Thus the tie to the genome project.[66]

What could be clearer? The agency that, along with its predecessor, has done more than any other to foist the nuclear menace off on the world, is aware of nuclear radiation's destructive potential, and is monitoring it -- even going so far as to decode the human genome itself, the better to determine how nuclear radiation damages it. I am reminded of the information in my first book, *Underground Bases and Tunnels: What is the Government Trying to Hide?*, that shows a decades-long,

[66] United States Department of Energy, The Office of Biological and Environmental Research, *A Vital Legacy: Biological Research and Environmental Research in the Atomic Age*, September 1997.

environmental radiation monitoring program carried out by the DOE and its predecessor agency, the Atomic Energy Commission, that included extensive sampling of animal tissues and organs for radioactive contamination. But reading the documentation I received shows that the DOE has been in the genetic research business for many, many years at laboratories scattered across the United States: including Los Alamos, in New Mexico; Brookhaven, on Long Island, in New York; Oak Ridge, in Tennessee; and Lawrence Livermore, in California.[67]

Reading through the documentation on the DOE's extensive genetic research and its extensive underground excavations and facilities caused me to reflect anew on the reason for my becoming interested in this line of research in the first place: unsubstantiated rumors of clandestine genetic engineering research being carried out in secret, underground facilities, by alleged "Little Grey" aliens and covert elements of the United States military. The rumors focused most heavily on an alleged underground facility in northern New Mexico, near the small town of Dulce.

I certainly have seen no clear proof of "Little Grey" aliens underground at Dulce, or anywhere else for that matter. However, I have seen plenty of evidence of underground tunnels and facilities constructed and operated by a wide variety of government agencies, including the DOE. There are also reams of documentation for the years-long involvement of the DOE in human genetic research.[68] There are presently many internet websites which link to a myriad of government and nongovernment resources and information about the human genome project. It is easy to use appropriate keywords such as DOE, human genome, DNA, genetic

[67] Ibid.
[68] For example, see: United States Department of Energy and the Human Genome Project, *To Know Ourselves*, July 1996.

research, etc. and the major search engines to identify these many websites. My purpose here is not to offer a thorough treatment of the human genome project and the role that the DOE plays in it, so if this topic interests you, please browse the internet websites that are available, and their associated links, for more information. Or go to a good research library and use the government and scientific documents there to find more information.

But I do find it interesting that the rumors of clandestine, subterranean genetic engineering center on northern New Mexico, a region with two known underground bases (at Kirtland Air Force Base) and other, reported, secret government underground facilities (see above), and the location of a major genetic research effort by the DOE (at Los Alamos). Is it possible that there is some truth to the rumors, that there is, indeed, secret genetic engineering experimentation occurring in covert subterranean installations-- albeit carried out *not* by "Little Grey" aliens, but by covert government agencies? I do not know, but the prevalence of black budget funding (especially for secret military programs), technological and engineering expertise in the Pentagon and DOE, operational compartmentalization, and geographic proximity do raise questions.

U.S. Army Corps of Engineers

The U.S. Army Corps of Engineers also has demonstrated expertise in constructing large, long, deep underground tunnels. In addition, as mentioned above, an Army Corps official has referred on the public record to the Army Corps' role in constructing an unknown number of large, classified underground bases of a "critical and unusual nature".

In my view the Army Corps of Engineers would be entirely capable of constructing secret tunnels. The

following example demonstrates very well the tunneling capabilities of the Corps of Engineers.

Passaic River Flood Protection Project

In 1992 the New York District of the U.S. Army Corps of Engineers advertised for contractors to construct tunnels for the Passaic River Flood Protection Project in New Jersey. The Corps sought engineering services to design:

> ...a main tunnel approximately 40 feet in diameter, about 20 miles long and a spur tunnel approximately 22 feet in diameter, about 1.2 miles long. Both tunnels are to be constructed in hard rock at depths ranging between 150 and 485 feet.[69]

The Corps solicitation goes on to spell out in detail exactly what kind of company the Army was looking for:

> Due to the large size and technical complexity of the project, broad experience and technical capability are required to design this project. (1) Experience. Extensive specialized experience is required in the design and construction of: (a) pressure tunnels and hydraulic appurtenances. In addition, experience is required in the design and construction of: (b) channels, (c) deep and shallow foundations, (d) levees and embankments, and (e) slopes and retaining walls. (2) Technical capability. Extensive technical expertise is required in the following engineering and supporting disciplines: (a) all facets of

[69] Commerce Business Daily | RFP, *Design of Underground Diversion Tunnels, Appurtenant Structures And Related Surface Elements, Passaic River, N.J., NY District, Army COE*, Solicitation 026 92, Reference 0572PRC0002, issued 12-APR-92, Department of the Army, U.S. Army Engineer District New York, 26 Federal Plaza, New York, NY 10278-0090. Commerce Business Daily accessed via the World Wide Web at http://www.fedmarket.com/, 1998.

geotechnical engineering, (b) geology, (c) structural, civil, mechanical and electrical engineering, (d) cost engineering, and (e) design and construction scheduling. In addition, capability is required in: (f) hydrology and hydraulics, (g) value engineering, (h) architecture, (i) water quality, (j) chemical engineering, and (k) environmental science, (l) industrial hygiene and health physics, (m) real estate, (n) site planning, and (o) safety. Special Qualifications: The following special qualifications apply: (1) design experience by prime applicant on large diameter, deep-rock tunnels utilizing tunnel boring machines ... [70]

You get the idea. The take home message is that the U.S. Army Corps of Engineers works closely with tunneling contractors and geotechnical firms with underground construction experience in building huge, miles-long, deep underground tunnels. To build large tunnels hundreds of feet underground, boring through the solid bedrock, is an expensive process and it takes time, equipment and know-how. But it can be done, and is done all of the time, by real government agencies working closely with real, nuts-and-bolts corporations.

The United States National Committee on Tunneling Technology

And then there is the United States National Committee on Tunneling Technology (USNC/TT). The USNC/TT was a quasi-governmental, interagency task force that served for several years as a focal point for United States tunneling policy and technology. It was formed in the late 1970s under the aegis of the National Research Council, but has since disbanded. One of its major projects was to research the feasibility of

[70] Ibid.

constructing a massive, deeply buried, hundreds-of-miles-long tunnel system for the U.S. military somewhere in the western states. The tunnel system was to have contained numerous, deeply buried nuclear missiles, as well as tunnel boring machines and resident military crews.[71] In the event of a shooting nuclear war, the crews would burrow out from deep underground and fire off the nuclear missiles -- as much as *one year or more* after the start of hostilities.[72] The popular conception of nuclear war in the public mind is that it would all be over in a few hours or a few days. However, my research reveals quite clearly that the Pentagon was (and probably still is) planning on nuclear war continuing for a prolonged period of time, in which irregular salvos of nuclear missiles would be exchanged at intervals of months *or years*. The prospect is hellish.

The membership of the USNC/TT was drawn from a wide variety of government agencies (federal, state and local), corporations, universities and scientific and engineering research institutes, engineering and scientific professional organizations, labor unions and from the ranks of private consultants.[73] The membership roster makes for

[71] See Richard Sauder, *Underground Bases and Tunnels: What is the Government Trying to Hide?* (Kempton, Illinois: Adventures Unlimited Press, 1995).

[72] D.M. Armitead, J.J. McAvoy, H.G. Leistner and J.A. Wooster, *Investigation of Deep Missile Basing System Issues*, Prepared by Boeing Aerospace Company for the Defense Nuclear Agency, Report No. DNA 6284F, Contract No. DNA 001-79-C-0297 (30 December 1980).

[73] See *Report for 1979 and 1980, U.S. National Committee on Tunneling Technology, A Summary of the Work Conducted During Calendar Years 1979 and 1980,* Assembly of Engineering, National Research Council (Washington, DC: National Academy Press, 1982); and *Report for 1981 and 1982, U.S. National Committee on Tunneling Technology, A Summary of the Work Conducted During Calendar Years 1981 and 1982,* Commission on Engineering and Technical

quite a listing of just "who's who" in the United States tunneling industry. Although there are certain individuals who are prominent in this specialized field, and whose names repeat frequently and conspicuously in the underground construction and tunneling literature, I will not list their names here. My objective is not to call attention to any particular individual; rather I simply aim to give the reader an idea of some of the agencies, organizations, corporations, universities, associations and institutes that provided members to the USNC/TT.

Government and Quasi-Governmental Agencies
Federal Highway Administration
U.S. Bureau of Reclamation
U.S. Bureau of Mines
U.S. Army Corps of Engineers
Sandia National Laboratories
National Science Foundation
Urban Mass Transportation Administration
Washington Metropolitan Area Transit Authority
Defense Nuclear Agency

Academic and Scientific Research Organizations
Colorado School of Mines
Battelle Memorial Institute
Department of Civil Engineering, Stanford University
Department of Civil Engineering, University of Illinois
Department of Civil Engineering, University of California at Berkeley
Department of Civil Engineering, Massachusetts Institute of Technology

Systems, National Research Council (Washington, DC: National Academy Press, 1983).

Department of Mining and Geological Engineering, University of Arizona

Corporations
Parsons, Brinckerhoff, Quade and Douglas
Dillingham Construction
Exxon Mineral Company
Harza Engineering Company
Morrison-Knudsen Company
Daniel, Mann, Johnson and Mendenhall
Underground Technology Development Corporation
Lachel Hansen and Associates, Inc.
Traylor Brothers, Inc.
Freeport Mining Company
Tudor Engineering Company

Professional and Scientific Associations
American Underground-Space Association
Geological Society of America
American Institute of Mining, Metallurgical, and Petroleum Engineers
Association of Engineering Geologists

Labor Unions
Compressed Air and Free Air Tunnel Workers Union

The reader should get the idea. The USNC/TT drew many of its members from positions in major government agencies, prominent universities, powerful corporations and well established scientific and engineering professional associations. I tried, and failed, to obtain the records of the USNC/TT's meetings. I went around and around on the phone with the archivist at the National Research Council, and never succeeded in having a look at the committee's

notes and records of its meetings. Is there something there to hide, or did I just run into the bureaucratic tendency to keep secret all information within the organization, no matter how insignificant and trivial it may be? I truly cannot tell.

Need a Tunnel Boring Machine?

Of course, building a clandestine tunnel system can be downright expensive. You have to pay skilled tunneling crews and swear (or scare) them to secrecy; you have to pay the architects and engineers who design the labyrinth; you have to pay for ongoing maintenance and operation of the system; and, of course, you need to purchase a fleet of tunneling machines.

But where to find a good buy on a TBM? As it turns out, you can do all of your compartmentalized "need-to-know", black budget shopping on-line, right on the internet. TBM Exchange International® offers for your discriminating consideration a complete line of perfectly serviceable, used tunneling machines from Robbins, Wirth, Lovat, and Jarva ranging in price from $175 thousand to $2 million.[74] You can see that TBMs are a little pricey, so be sure to have your check book close at hand as you browse the inventory. TBM Exchange International® can even assist in finding machine operators to run the TBM for you.[75]

But perhaps you are a little wary of buying such a large, complex, expensive machine over the internet, as if it were just another music CD or paperback book? No problem, in that case you can go directly to the seller -- in this instance Spie Batignolles, a French company, which in 1994 completed a 35 mile tunnel system for *The Lesotho*

[74]On the WWW at http://www.tbmexchange.com/tunnel_boring_machines.htm, 1999.

[75] See the WWW, http://www.tbmexchange.com/, 1999.

Highlands Water Project (LHWP), in South Africa.[76] But that was just Phase 1A of the project. By project's end in the year 2010 some 120 miles of tunnels will have been bored to "export water from the Lesotho Highlands to the industrial area of Transvaal in South Africa." At a cost of $5.2 billion this is positively a gargantuan civil construction project.[77]

Though the project is not yet finished, Spie Batignolles is advertising for sale three TBMs used on the preliminary stages of the LHWP. Two Robbins Model 167 machines and one Atlas-Copco Jarva M.K. 15 hard rock tunnel boring machine are available for purchase.[78] All three excavate an approximately 16 foot diameter tunnel (a little over 5 meters).

So, there you are. If you have a few hundred thousand dollars, or better yet, a couple of million dollars, buying a used TBM in working order is practically a done deal! However, you may incur a hefty shipping bill to transport such a heavy, bulky, expensive machine out of South Africa to another part of the world. But for the garden variety covert agency with billions of "black budget" dollars to use, that is probably not such a big problem.

[76] See the WWW, http://www.spiebatignolles.fr/equipment/default.htm, 1999.

[77] See the WWW, http://www.spiebatignolles.fr/equipment/lesotho_ highlands_water_project.htm, 1999.

[78] See the WWW, http://www.spiebatignolles.fr/equipment/atlascopco_ jarva_mk_15.htm, 1999; and http://www.spiebatignolles.fr/equipment/ 2_ robbins_model_167_for_sale.htm, 1999.

Chapter 3. Secret Maglev Tunnel System?

In 1985, Robert Salter, of Litton Industries, presented a paper for a tunneling, underground transport, and macro-engineering conference sponsored by the Massachusetts Institute of Technology, in which he forthrightly advocated the construction of a deep underground transcontinental tunnel system.[79] Salter advocated constructing these tunnels as routes through which high speed, magnetic levitation trains would travel at supersonic speed, crossing the continent in less than an hour. His paper included an illustration that depicted a system of underground maglev[80] tunnels stretching from coast-to-coast, spanning the North American continent. He advocated constructing the underground tunnels in 25 mile segments, such that 100 individual segments would be excavated and joined together to form one continuous 2,500 mile long tunnel.

[79] Robert Salter, "Planetran Today: Prospects for the Supersonic Subway", in *Tunneling and Underground Transport: Future Developments in Technology, Economics and Policy*, ed. F.P. Davidson (New York: Elsevier Science Publishing Company, Inc., 1987).

[80] Maglev, i.e., "magnetic levitation". Maglev trains would zoom along suspended on a magnetic field, thus permitting extremely rapid travel without friction from rails, as is the case with conventional trains.

Interestingly, this approach is well within the state of the art for the tunnel boring industry. Using existing technology it is entirely possible to construct a lengthy tunnel system, using just such a construction plan. Moreover, it is striking that the system Salter describes strongly resembles a system that rumor alleges to already exist. Are the rumors simply disinformation? Or did Salter know more than he revealed in his 1985 conference report?

National Maglev Initiative

It is interesting that Salter recommends a system of maglev trains for his projected, transcontinental, supersonic, subterranean transportation network. As it happens, in the early 1990s there was a very interesting, multi-agency National Maglev Initiative (NMI). The NMI was a joint effort of the Federal Railroad Administration, The U.S. Army Corps of Engineers and the Renewable Resources Division of the Department of Energy. The objective of the NMI was to "define the role MAGLEV could play in the U.S. transportation system, to assess the potential for MAGLEV in the domestic market, to recommend a strategy for the introduction of MAGLEV technology, and to identify the most appropriate federal role." [81]

Of course, technology developed for public works projects could easily be transferred to clandestine projects. The participation of the U.S. Army Corps of Engineers

[81] Rolland D. King, Presiding, "MAGLEV", John T. Harding, "MAGLEV: National Overview and Federal Program", In *National Conference on Advanced Technologies in Public Transportation, Conference Proceedings*, The Westin St. Francis Hotel, San Francisco, California, Presented by the Transportation Research Board, National Research Council, In Cooperation with the Federal Transit Administration, U.S. Department of Transportation, August 16-19, 1992.

(USACE) in the NMI is especially intriguing, in light of the USACE's well documented involvement in underground excavation and tunneling.

Secret Maglev System?

The National Maglev Initiative yielded the following, lengthy report which appeared on the U.S. Bureau of Transportation Statistics website on the internet. The report, entitled *Compendium of Executive Summaries from the Maglev System Concept Definition Final Reports*,[82] is an abbreviated report of studies conducted by major corporations and universities in the United States for a proposed, high speed Maglev train system. The Maglev system described in the report was to be operational by the year 2000. The year 2000 has come and gone, but of course no such system is publicly operational in the United States. Nevertheless, the United States government awarded more than $8.6 million to design such a system.

Is it possible that a Maglev system really was built, perhaps by one or more of the corporations who took part in this design project -- but that the system was built secretly, underground? Or perhaps even undersea?

I'll return to these questions, but first, here are some lengthy excerpts from the document that give a sense of the plans advanced by some of the United States' most powerful corporations:

**Compendium of Executive Summaries from the
Maglev System Concept Definition Final Reports**

Preface

Four 11-month system concept definition (SCD) studies, totaling more than $8.6 million, were awarded in late

[82] On the WWW at: http://www.bts.gov/ntl/DOCS/CES.html, 1999.

October 1991 to determine the technical feasibility, performance, capital, operating and maintenance costs for a maglev system that would be available by the year 2000. Due to the extensive nature of the final reports, the limitations on distribution of proprietary information and the difficulty of presenting consistent detailed cost and performance information it was decided not to publish all of the material delivered under these SCD contracts. This compendium of Executive Summaries of the SCD Final Reports presents the essence of the studies representing the information supplied to the US Government as part of its evaluation of the potential of maglev as a future transportation system. The four industry teams were:

Bechtel (San Francisco, CA) with Hughes Aircraft; END Division of General Motors; Massachusetts Institute of Technology (MIT); and Draper Labs. The concept features repulsive superconducting levitation, tilting vehicle, a ladder track, and a box beam girder guideway partially reinforced with Fiber Reinforced Plastics (FRP).

Foster-Miller, Inc. (Waltham, MA) with DeLeuw Cather; Boeing Aerospace and Electronics; Morrison Knudsen; Bombardier; General Dynamics; General Atomics and AYA & Associates. Concept features repulsive superconducting levitation which integrates lift, guidance and a locally commutated linear synchronous motor (LCLSM) propulsion in a tilting vehicle. The guideway employs null flux levitation coils and a unique vertical switch with no moving structure.

Grumman Corporation (Bethpage, NY); with Parsons, Brinckerhoff, Inc.; Gibbs & Hill; Battelle Labs; Intermagnetics General; PSMTechnologies; Honeywell; and NY State University at Buffalo. Concept features attractive levitation using controlled superconducting

magnets, tilting vehicle, and V-shaped guideway
supported by a central spline girder with outriggers.

Magneplane International (Wayland, MA) with MIT
Plasma Fusion Center; MIT Lincoln Labs; Raytheon;
Bromwell and Carrier; Failure Analysis Associates; and
Koch Process Systems. Concept features repulsive
superconducting magnets with a semi-circular sheet
guideway which permits self banking. Stability is
provided by a "magnetic keel".

These projects were jointly funded by the US Army
Corps of Engineers and the Department of
Transportation with support from the Department of
Energy.

It is interesting that several of the federal agencies and
large corporations involved in the national Maglev train
system design are well known to be involved in
underground construction and tunneling projects: The
Army Corps of Engineers, the U.S. Department of
Transportation, the U.S. Department of Energy, Bechtel
Corporation, Morrison Knudsen, and Parsons Brinckerhoff,
Inc. The first system to be discussed is from the Bechtel
group.

Bechtel Maglev System
Concept Definition Final Report- System Overview

Prepared for U.S. Department of Transportation Federal
Railroad Administration

A. GENERAL SYSTEM OVERVIEW

This section provides an overview of the operation of the
entire system, with later sections used to elaborate on

details of the design and operation. All technical issues mentioned here are discussed in more detail elsewhere in this report.

1. INTRODUCTION

Maglev is a transportation system that uses vehicles which are levitated a short distance from a dedicated guideway by magnetic forces. These vehicles also use magnetic forces for non-contacting guidance and propulsion, and will travel safely at speeds greater than 150 m/s (540 km/h or 336 mph). Maglev has many similarities to high speed rail. It depends upon mechanical guidance from a guideway, and can carry people directly into regions of high population density. It employs electric propulsion and is capable of operating in almost all weather conditions. It can provide comfortable travel with greater safety than either air or highway modes. But unlike high speed rail, the vehicles can accelerate and decelerate rapidly and bank steeply for turns. This allows the route to have much steeper grades and follow the interstate highway right-of-way where appropriate. The proposed maglev design uses smaller vehicles and off-line loading and unloading so that passengers do not need to make many unnecessary stops. This necessitates short headways and demands completely automated control. Maglev also has many similarities with air travel. The suspension system is non-contacting and the proposed operating mode uses airline size vehicles and point-to-point scheduling. Unlike air travel, the operation is not as sensitive to weather conditions, and vehicle control is completely automated. It is expected to be as safe as high speed rail, which is safer than any other passenger carrying system, because there is no guideway encroachment and much less chance for human error. In this section we present an overview of the principal concept characteristics of the maglev system being developed by the Bechtel

Team. Some features are based on requirements imposed by our statement of work, and others have been created by members of the Team based on studies conducted before and during this project. Important innovative features of the concept include: A high efficiency electrodynamic suspension system that can suspend the vehicle down to very low speeds and thereby reduce power consumption. A box-beam guideway that reduces structural cost and environmental impact while providing a high degree of safety and longevity. A linear motor propulsion system that provides high acceleration and braking and can operate at reduced speed in the presence of many types of failure. An automated and fault tolerant control system that allows highly reliable fail-safe operation with short headway and high availability. Use of air bearings for low speed stop/start in lieu of wheels, for emergency situations. This overview emphasizes what the system does rather than how it does it. Subsequent sections describe the technical details of how we expect to achieve these objectives.

2. SYSTEM PARAMETERS

2.1 SPEED

The maximum design speed is 150 m/s (540 km/h or 336 mph), but in most cases the top operational speed will be 135 m/s (486km/h or 302 mph). By providing safe operation at higher than normal speeds, we help ensure outstanding safety at normal speeds. In addition, we allow full speed operation against head winds of 18 m/s (40 mph) and in the presence of minor variations in the performance of subsystems. At times of high demand the maximum operational speed may be reduced somewhat. A reduced speed allows shorter headway and higher system capacity, with no reduction in safety margins or increase in total system power consumption. The

operational speed that provides maximum system
capacity will be determined by simulation for each
section of guideway, and the Central Control will never
reduce speed below this point unless required for safe
operation in the face of unusual conditions. (See
Illustration 28.)

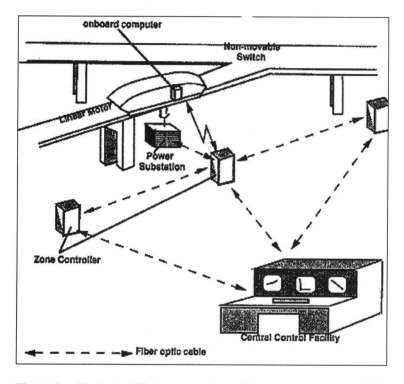

Illustration 28. A simplified representation of how a computer controlled,
high-speed maglev transportation system would operate. In this schema the
maglev system is depicted on trestles, an important difference from the
unsubstantiated, popular tales of a purported maglev train system that allegedly
runs through a secret underground tunnel system. (*Source*: U.S. Bureau of
Transportation Statistics, on the WWW at http://www.bts.gov/ntl/DOCS/
images/CESMAG/CES10.GIF, 2000.)

2.2 ACCELERATION

Acceleration is limited by the thrust available from the linear motor, but it is also limited by passenger comfort and safety constraints. For U. S. applications it is expected that major sections of the guideway will follow interstate highway rights-of-way, and vehicles will frequently have to slow in order to negotiate turns with acceptable banking angles. Without relatively high rates of acceleration there will be considerable time lost negotiating turns, but it is not practical to require passengers to be seated during numerous speed changes. Hence, it is necessary to limit vehicle acceleration to values that are compatible with passengers standing and walking. There is some uncertainty as to what steady acceleration limits are acceptable to standing passengers, but the upper limit for normal operation seems to be about 2.0 m/s^2 (0.2 g). We believe that the advantages of uniformity of design and flexibility of control make it warrant the cost of providing sufficient thrust to achieve 2.0 m/s^2 acceleration almost everywhere on the guideway and at almost all speeds. The maximum thrust is the maximum motor thrust reduced by the drag produced by aerodynamic and magnetic forces. Aerodynamic drag force increases as the square of the speed, and magnetic drag force decreases inversely as the speed, so over a wide speed range the drag force is surprisingly constant. For the baseline vehicle the deceleration from these forces is about0.4 m/s^2. In order to achieve a net acceleration of 1.6 m/s^2 we need about 2 N of motor thrust for every kilogram of vehicle mass. For comparison, the proposed maximum acceleration is more than three times the value that can be achieved by a Transrapid maglev vehicle or any existing high speed train when they are operating near the top of that speed range. It is also less than half the accelerations commonly encountered in automobiles and rapid transit vehicles.

2.3 DECELERATION AND BRAKING

Under normal conditions, and allowing standing passengers, the deceleration limits are the same as those for acceleration, or 1.6 m/s^2. Normal braking is regenerative with most of the vehicle's kinetic energy being converted to electric energy that is made available for propulsion of nearby vehicles. For mild emergency conditions the vehicle is regeneratively braked with reverse thrust up to the motor limits, or 2.0 m/s^2 deceleration. The regenerative braking, coupled with aerodynamic and magnetic drag, provides about 2.4 m/s^2 of net deceleration. This exceeds normal comfort levels but is not considered hazardous to standing passengers. This mode will be used whenever unexpected events require rapid but not extreme stopping action. For extreme emergency conditions it is imperative to stop rapidly and even limited injury is preferable to a low deceleration rate which would result in a more damaging situation. For this "hard stop" condition the linear motor is capable of providing 2.0 m/s^2 deceleration, and when the aerodynamic and magnetic drag is added, the total deceleration can exceed 25 m/s^2 (sic). Where possible the passengers would be given a few seconds warning before being subjected to this level of deceleration, but the hard braking is assumed to be acceptable where necessary to avoid catastrophic accidents. Still faster braking is possible with the use of aerodynamic forces, such as from speed brakes or a drag chute. These have been added to ensure the highest possible levels of redundancy and safety.

2.4 HEADWAY AND CAPACITY

The minimum allowed headway is a function of speed, with guideway capacity determined by this minimum headway. There are three possible limits to headway: a

headway distance minimum due to linear motor zone length; a headway time minimum due to control related issues; and a safety limit determined by the ability to stop in the clear distance ahead, the so-called "brick wall" criteria ... The nominal maximum speed is 135 m/s, but many routes will require turn negotiations at substantially slower speeds. Extreme weather or minor malfunctions may also dictate a need for slower speeds. The design is based on die (sic) ability to handle 100 vehicles per hour at an average speed of 125 m/s (450 km/h or 280 mph), and 90 vehicles per hour at average speeds from 100 m/s (360 km/h or 224 mph) to 135 m/s (386 km/h or 302 mph).[83]

Notice that the Bechtel plans are for a maglev system that travels at speeds as great as 300 mph, or more. Furthermore, the Bechtel plans anticipate that ...(f)or U. S. applications it is expected that major sections of the guideway will follow interstate highway rights-of-way."[84] Of course, such a plan makes perfect sense from a policy standpoint, since the land has already been condemned for use by the United States government. Moreover, most interstate highways have a median strip in which a maglev rail line could be constructed. This plan reminds me of completely unsubstantiated rumors, that I have on rare occasions heard over the years, that describe an alleged, secret, interstate tunnel system that purportedly follows the rights-of-way of the interstate highway system. Notice, too, that the Bechtel plan refers to "U.S. applications" of their plan. This implies that there also might be *non*-U.S. "applications". Could such *non*-U.S. "applications" perhaps include high speed tunnels beneath the open sea? I do not categorically rule out this admittedly unusual possibility. (Read Chapters 5 and 6 very carefully for my reasoning.)

[83] Ibid.
[84] Ibid.

The Foster-Miller Maglev Concept

Foster-Miller along with a team of subcontractors which includes Boeing, Bombardier, General Atomics, General Dynamics, Morrison Knudsen, and Parsons DeLeuw, has developed a Maglev system concept that meets all goals for speed, capacity, safety, reliability and comfort and it has done so by innovatively using state-of-the-art technology. As a result of this work Foster-Miller can, with high confidence, deliver a cost-effective, operational, high performance Maglev system before the year 2000. This confidence is based on many ideas and innovations which are covered in detail in the concept definition report. Of most significance is Foster-Miller's invention of a high speed, all electric switch made possible by a robust twin beam guideway and a sidewall coil controlled levitation and propulsion system. This switch along with multicar consist capability permits a low cost, two-way operational, single guideway Maglev system that can serve all but the densest corridors in the U.S. For these heavy traffic corridors the base system can be expanded to well over 12,000 passengers per hour capacity in each direction by adding a second guideway when needed and when revenues warrant. The Foster-Miller Maglev system definition is based on numerous rational engineering trade off studies. There is no perfect solution to a system definition - a design optimized for the best performance in a highly specific application is likely to suffer in applications with different parameters. A design tuned to rely heavily on very specific technologies may not be easily or acceptably modified if those technologies become obsolete in a few years. The most desirable system effectively balances the attributes contributing to overall system performance against flexibility for further growth and improvement. In the development of the Foster-Miller system, an extensive literature search has been performed which critically evaluated both the German electromagnetic system

(EMS) and the Japanese electrodynamic system (EDS). The EDS operates with a large gap between guideway and vehicle, achievable by well developed superconducting magnet technology. The majority of researchers in the U.S. have accepted the EDS as the preferred approach since it can accommodate larger guideway irregularities and leads to an economical guideway structure. Japan is aggressively pursuing an EDS Maglev and has demonstrated fundamental concepts, some of which (such as the null-flux principle) are originally from the U.S. Foster-Miller proposes an advanced El;)S (sic) Maglev taking maximum advantage of proven systems and technologies and providing major performance and cost advancements.

1.1 SYSTEM GOALS

The first task addressed by Foster-Miller was the formation of a set of goals and requirements for the Maglev system. Some of these requirements were clearly dictated prior to this work, others were the result of collective engineering judgments. Some of the goals and requirements are summarized below:

Capacity - The system will be configurable to handle a maximum capacity of 12,000 passengers per hour in each direction. The goal is to develop a system which could be configured to also cost-effectively accommodate much lower capacities.

Speed - The system will operate at design maximum speed of 134 m/sec.

Costs - The Maglev system must be competitive with aircraft and very high speed rail. Passenger safety will be integral with all aspects of the system design.

Reliability - The system must have reliability on par with high speed trains. This translates to MTBM's (mean time between maintenance) of 1,000 hr for the vehicle, 10,000 hr for the super-conducting magnets and 1,2S0 (sic) hr for wayside components. The system should make the maximum use of existing rights of way (ROW). The system should function in both inter and intramodal capacities with freight transport capability. Operational noise and vibration levels will be consistent with ride comfort criteria. Aerodynamic efficiency will be maximized and the overall power consumption minimized. Magnetic field exposure will be consistent with specified requirements.

1.2 EMERGING TECHNOLOGIES

Since much of the existing Maglev examples are rooted in designs from the 1970s, a key issue is the consideration of the best and most current technologies that can be brought to bear today on Maglev. During the last 20 years there have been dramatic advances in a number of technologies which can directly impact Maglev. Probably the most significant advancement has been in computing capability. Cost, size and power requirements for computing hardware have drastically diminished while capability has expanded. Today's embedded microprocessor controllers match the computing capabilities of the main frames of two decades ago. Virtually every area of the Maglev system: safety, performance, operating and capital costs, etc., can benefit from the availability of vastly improved control and computing performance. Recent developments in high strength to weight materials can improve Maglev design. The higher strength, lighter weight materials make for a lighter Maglev vehicle with no reduction in safety or strength. It is clear that minimizing the Maglev vehicle weight per passenger is beneficial to virtually every aspect of the system. The lower vehicle weight

eases guideway loading, making for reduced guideway costs. Lower vehicle weight also translates into reduced propulsion, lift and guidance requirements. This means that the initial costs of these systems are less and the energy costs in operation are less. Power handling semiconductors is another technology area which has seen tremendous advances in recent years. Like computers, power semiconductors have seen big advances in capabilities and significant reduction in cost. The Insulated-Gate Bipolar Transistor (IGBT) was introduced in 1983. The IGBT offers higher current densities than bipolar transistors, high input impedance, reverse voltage blocking and good high temperature performance. Commercial IGBT capabilities are constantly improving, but current devices can handle 1400V and 800A. In higher powers, Gate-Turn-Off Thyristors (GTO) have seen big advancements in the past 10 years. Commercial GTOs currently can handle 4500V and 4000A (with a single device). On the near horizon U. S. manufacturers are developing special power handling hybrids like the metal-oxide semiconductor controlled thyristor (MCT). These devices will combine the best respective characteristics of IGBTs and GTOs and will be directly interfaceable with microcomputer I/Os. The impacts on Maglev of these developments in power devices are increases in reliability, safety and system flexibility. The increased power capabilities of single devices means that fewer devices can be used for the same function - translating directly into increased system reliability. The flexibility really comes from the combination of more capable computing and control hardware and the more capable power devices. The computers provide the faster control, the power devices provide the means to implement that control. There are many more technologies that will impact the direction of Maglev in the 90s and beyond. Fiber optic communication, virtually nonexistent 20 years ago, provides a high bandwidth communications

medium which is inherently immune to EM disruptions. Sensor technologies continue to grow in both capability and cost-effectiveness. Manufacturing techniques for concrete structures, composites, superconducting magnets, and non-ferrous materials have seen and will continue to see steady improvements. These and many more advancing technical areas will positively impact Maglev system design. During development of a system concept an important question is whether a particular technical concept is too risky or too immature to employ. Tradeoff analyses evaluate these questions. If technical concepts are rated on a scale of risk and maturity, at one end of the scale are mature, hardware proven technologies and methods with negligible technical risk for implementation in a Maglev system. Near the middle of the scale are concepts that are well understood, but demonstrated in scaled-down hardware or laboratory conditions only. These concepts would require some investment in development and would carry some associated risk, to reach a level of maturity sufficient for implementation in a Maglev system. Finally, at the other end of the scale are concepts with no real hardware demonstration history and needing much development to be applied to Maglev. These concepts would require significant investment to bring them up to a level of development suitable for application to real systems. These technology concepts would also carry a significant risk of never reaching a state in which they could be used in a real Maglev system. Foster-Miller's approach has been to avoid high risk concepts, but to examine moderate risk concepts for potential benefits to the overall system and to tradeoff (sic) against the potential development cost and the associated risk of that technology never reaching viability. The baseline system utilizes many new technologies in ways in which these applications have much system benefit and little technical risk associated with them. If moderate risk concepts do offer potentially significant system

mprovement, system flexibility has been deliberately built in to permit future modifications and enhancements. The envelope of future system needs has also been considered. If the costs (economic and performance) or risk associated with building in system expandability was small compared to the potential future benefits, that flexibility was included in the design.

Notice the repeated reference to developing and *delivering* a functioning maglev train system by the year 2000: "Foster-Miller can, with high confidence, deliver a cost-effective, operational, high performance Maglev system before the year 2000."[85] The plain message that U.S. government agencies and major corporations are delivering in this report is that an interstate maglev train system *can be built* with state-of-the-art technology, and that it can be built *before the year 2000*. Look around, the year 2000 has come and gone and you do not see such a system available for public use for surface transportation. Has it perhaps been built underground, in great secrecy? Or maybe even undersea?

Grumman Team Maglev System

Prepared for National Maglev Initiative
Contracting Administration: U.S. Army Corps of Engineers
Huntsville, AL 35807-4301

EXECUTIVE SUMMARY

Grumman, under a U.S. Department of Transportation and Army Corps of Engineers contract, has completed a System Concept Definition (SCD) study to design a high-speed 134 m/s (300mph) magnetic levitation

[85] Ibid.

(Maglev) transportation system. The primary development goal was to design a Maglev that is safe, reliable, environmentally acceptable, and low-cost. The cost issue was the predominant one, since previous studies have shown that an economically viable Maglev system (one that would be attractive to investors for future modes of passenger and/or freight transportation) requires a cost that is about $20 million per mile. The Grumman Corporation assembled a team of seven corporations and one university that were exceptionally qualified to perform this study. The Grumman team members and associated responsibilities include:

Grumman Corporation - system analysis and vehicle design.
Parsons Brinckerhoff - guideway structure design.
Intermagnetics General Corp. (IGC) - superconducting magnet design.
PSM Technologies - linear synchronous motor (LSM) propulsion system design.
Honeywell - communication, command, and control (C3) design.
Battelle - safety and environmental impact analysis.
Gibbs & Hill - power distribution and system control design.
NYSIS - high temperature super conductor (HTSC) and magnetic shielding analysis.

As a result of the team's efforts, a unique high-speed Maglev system concept has been identified. If implemented, this design would meet all of the objectives specified above and would satisfy U.S. transportation needs well into the 21st century. The design is based on the electromagnetic suspension EMS system concept using superconducting (SC) iron cored magnets mounted along both sides of the vehicle. The Grumman team selected an EMS design instead of an electrodynamic suspension (EDS) design because of the

following significant advantages that the EMS offers over the EDS design: Low magnetic fields in cabin and surrounding areas (this eliminates or minimizes the need for magnetic shielding). Uniform load distribution along the full length of vehicle (minimizing guideway loads and vibrations in the cabin and contributing to the elimination of a secondary suspension system). Small pole pitch (results in smoother propulsion). Magnetically levitated at all speeds (needs no supplemental wheel support). Wrap-around configuration (safer operation). Existing EMSs like the German Transrapid and the Japanese High Speed Surface Transportation (HSST) systems use copper coils on the vehicle's iron cored magnets instead of SC coils. This results in a number of basic disadvantages: Small gap clearance (1 cm (0.4 in.)), which results in tighter guideway tolerance requirements. Heavier weight with limited or no tilt capability to perform coordinated turns and maximize average route speed. Limited off-line switch speed capability (56 m/s maximum). Large number of magnets and control servos (~100 total). The Grumman team design has retained all of the advantages of an EMS system. At the same time it has succeeded in eliminating, or significantly improving, every aspect of the identified EMS disadvantages.

...........

Our total system cost which includes guideway, electrical and communication, vehicles, stations buildings etc. is estimated at $12.4M/km ($20M/mile).[86]

To me, the most interesting part of the Grumman plans is the projected cost for a high speed maglev train system: approximately US$20 million per mile. That is to say, a

[86] Ibid.

1,000 mile segment would cost about US$20 billion. This amount of money, and much, much more, certainly is available in the "black" budget of the military-industrial complex. (See Grumman design in Illustration 29.)

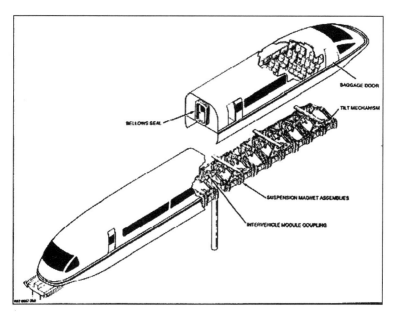

Illustration 29. Proposed design for a planned maglev train. Notice the sleek, aerodynamic appearance. A design such as this would appear suitable for possible use in a tunnel environment. (*Source*: U.S. Bureau of Transportation Statistics, on the WWW at http://www.bts.gov/ntl/DOCS/images/CESMAG/CES40.GIF, 2000.)

The Magneplane System

CONCEPT RATIONALE

The Magneplane system achieves continuous traffic flow similar to highways, rather than the batch flow process of railroads. Magneplane utilizes magnetic levitation to gain two crucial advantages: individually targeted vehicles can operate safely at 20 second headways, and

stop at off-line stations without slowing traffic; vehicles are supported resiliently at 6 inch clearance, and are free to self-bank in turns, with airplane comfort. Because guideways carry only individual vehicles, they can be significantly lighter and less expensive to build and maintain than railroad type guideways. They need to carry only 1/20th the live load, and can be compatible with the curves, grades and overpass requirements of highways. Because of the large clearances possible with the Magneplane concept, guideways do not require high stiffness and accuracy of alignment or banning (super elevation), and are aesthetically more graceful. (See Illustration 30.) Less energy is needed because individually targeted vehicles travel non-stop. This eliminates the need to accelerate passengers who did not want to stop at every station, and reduces the cruising speed required to match airline trips. Individual Magneplanes can transport a continuous stream of 25,000 passengers/hour, five times more than railroads, and can provide non-stop service at high frequency along multi-station corridors. Magneplane was developed in the seventies to the level of a fully operational superconducting, scale model with initial support by MIT, Raytheon, Avco, Alcoa, and 3M, and with subsequent support from the National Science Foundation under the RANN program. The program was terminated in 1975 for political reasons. Many Magneplane innovations have since been adopted by the Japanese and Germans, who both failed to capitalize on the full potential advantages of the original concept, which remains the most advanced concept, and the one best suited to American needs in the 21st century. A Next Generation team has been formed by Magneplane International, Inc. in collaboration with the MIT Plasma Fusion Center, MIT Lincoln Laboratory, Raytheon Equipment Division, United Engineers and Constructors, Inc., Beech Aircraft Corp., Failure Analysis Associates, Inc., Process Systems International, Inc., and Bromwell

& Carrier, Inc. The first system is planned to be ready for construction beginning in 1997.

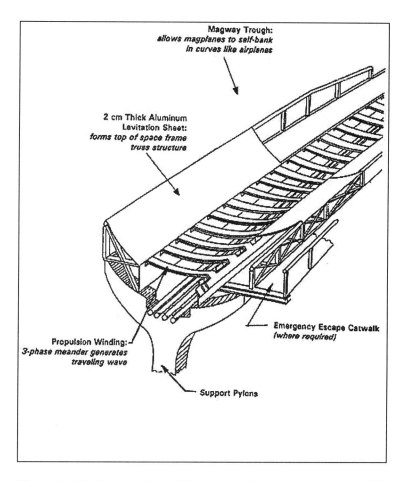

Illustration 30. Representation of the magnetic levitation trough over which the proposed maglev trains would zoom. Note the proposed support pylons for an implied elevated system, by stark contrast with the rumored, clandestine, underground maglev train system. (*Source*: U.S. Bureau of Transportation Statistics, on the WWW at http://www.bts.gov/ntl/DOCS/images/CESMAG/ CES52.GIF, 2000.)

1.0 DESIGN OVERVIEW

1.1 MAJOR MAGNEPLANE DESIGN GOALS

Existing transportation technology is nearing saturation and cannot meet projected demands. Airlines have saturated the airspace at major hubs. Automobiles will require 40-lane interstate highways in a decade. Railroads, whether wheel borne or maglevitated, can handle about half as many passengers as one single highway lane; the faster they go, the less their capacity, and the less often they can stop. Radically new technology is needed. The next revolution in transportation technology has begun, and will become the largest technology venture for several decades. Our economic security requires that we play a leading role in this venture, world-wide. Magneplane International is designing the only transportation system proposed thus far that can meet projected demands, and help solve the problems of existing technology: congestion, pollution, environmental destruction, dependence on foreign off (sic), and unnecessary loss of lives. Magneplane therefore offers the only technology which can restore US leadership in transportation. Magneplane's objective is not only to replace short-haul airlines, but primarily to reduce highway traffics (sic) which carries more than 90 percent of passengers and freight along most corridors. This means providing a cost-effective, attractive alternative that people will actually use instead of their cars. If the automobile is partially displaced by a faster, safer, cheaper means for traveling and commuting, driving will be fun again, and we can better protect our health and environment. Magneplane systems will permit measures like the establishment of green-belt zones to revitalize urban centers by reduced congestion, frustration and lost productivity. Maganeplane (sic) technology will also enable the United States to develop world leadership in high-speed ground transportation,

thereby restoring our balance of trade, our industry, and our jobs. (See Illustration 31.)

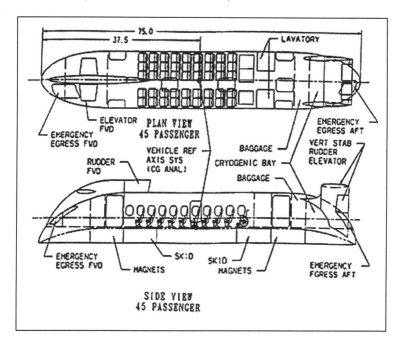

Illustration 31. One conception of a possible maglev train. Notice the dual, vertical rudders,in the front and in the rear. (*Source*: U.S. Bureau of Transportation Statistics, on the WWW at http://www.bts.gov/ntl/DOCS/images/CESMAG/CES53.GIF, 2000.)

Our principal design goals are the following:

1. cruising speed of 300 mph, high average speed, low waiting time, non-stop service when possible.

2. capacity of up to 25,000 passengers per hour on a single magway (equal to three highway lanes).

3. transportation alternative to both cars and planes for trips as long as 400 miles.

4. ride quality as good or better than airplanes.

5. safe, reliable, and operational under all weather conditions.

6. no new corridors - should be built along existing highways.

7. flexibility in upgrading capacity and service.

8. points of access where people live and work, lower use of Intermodal connections than required by airplanes.

1.2 HOW OUR DESIGN MEETS THESE GOALS

We propose a computer-controlled continuous flow system. We will build small magports at shopping malls, industrial parks, city centers, and any other place where people go in great numbers. There is no reason to limit maglev use to a few huge hubs. Small off-line magports will be served without interrupting the flow of magplanes along the principal corridor. We will connect the stations with a network of magways built along existing highways. New land for straight routes is simply not available in places where maglev is needed most. The Magneplane system allows magplanes to bank in curves like airplanes to provide a comfortable ride at high speeds. We will run single magplanes, not trains. Magplanes will be dynamically scheduled: A central computer will plan the routes of each vehicle in response to ticket purchases, so that passengers will get fast service directly to their destination with as few stops between as possible. With long trains, small magports are not possible, nor is dynamic scheduling. Trains

cannot stop often enough to be useful. The magplane is propelled by a powered magway; vehicles ride a traveling wave, like surfboards; they can follow at close headways without colliding. Superconducting magnets on board the vehicle interact with the magway to produce both lift and thrust.

1.3 LEVITATION

Superconducting levitation magnets at the bow and stern produce strong magnetic fields underneath the vehicle. When the magnets move, their fields induce image currents in a 2cm thick aluminum sheet in the magway. These image currents behave exactly like mirror images moving with the vehicle magnets, and therefore repel them, producing a lift force. Sheet levitation (as the effect has been called) can produce a smooth ride at a height of several inches above the magway, even when the magway is rough. This magnetic spring is very soft, but becomes very stiff as the vehicle is pushed toward the magway and thus prevents contact.[87]

The Magneplane concept presents a radical concept: maglev trains everywhere! At the shopping mall, the industrial park, anywhere people go in large numbers. There would be a network of local lines to feed into a larger, high speed network that would carry people for hundreds of miles. Here again, this is reminiscent of the stories about the much rumored, but as yet unsubstantiated, clandestine underground maglev tunnel system. The rumors also describe local, or regional branch lines (albeit underground) connecting military bases and Fortune 500 company research installations in Southern California and Nevada, for example, with facilities in other states.

[87] Ibid.

It is all most peculiar: the stories and rumors on the one hand, that seem so unlikely and bizarre, that one can occasionally find on obscure internet websites, in small circulation pulp magazines, and sometimes hear on late night radio shows or in conversation with acquaintances and friends; and the hard facts on the other hand, that just do admit of the possibility of a factual basis for at least some of the stories and rumors.

I go back and forth between these two poles. One day I will believe that the whole idea of a clandestine, military tunnel system is utter hogwash, the improbable fruit of a disinformation campaign that is being conducted for unknown reasons; but on other days, I can conceive of the reality of such a covert tunnel system, and see the stories and rumors as an indication of its existence.

Could Clandestine Tunnel System Be Kept Secret?

But could such a large, sophisticated construction project be kept entirely secret? Of course, the answer has to be, "no", it could not be kept entirely secret. The obvious objection to the existence of such a secret tunnel system then becomes: "If it can't be kept secret, then why hasn't word leaked out?" The just as obvious rejoinder to the preceding objection is: "But maybe word *has* leaked out." Many rumors and stories are out there in the culture, in books, in magazines, on internet web sites and on radio talk shows, and they are persistent enough that I am addressing them in this book. I am even presenting evidence demonstrating that there are grounds to suppose that such a secret maglev train tunnel system *is* within the realm of feasibility and possibility. Given what we know of technological and industrial capabilities, of compartmentalized secrecy in the military-industrial complex, and the huge size of the black budget it is

thinkable to construct such a system, and keep it comparatively (though not absolutely) quiet.

Thanks to an obscure report I obtained via the Freedom of Information Act, we even have hard numbers from the military-industrial complex of the estimated number of total personnel needed to build and operate a deeply buried, hundreds of miles-long tunnel system: on the order of 7,800 to 8,700 people. And we have a hard estimate for the total expense associated with constructing, operating and maintaining such a system: in the neighborhood of $17 billion over a ten year period. As an example, the estimated, one-time construction cost of an approximately 300 mile-long, deeply buried tunnel system under Grand Mesa, Colorado was estimated at about $4.28 billion.[88] Clearly, the requisite number of people with security clearances, and the requisite amounts of money, are all potentially available within the military-industrial complex, on Fletcher Prouty's *Secret Team* and in the black budget. The conclusion that comes into focus is that it is within the realm of possibility that a secret, underground tunnel system (or perhaps undersea tunnel system -- see Chapters 5 and 6) has been built.

[88] Monetary figures are 1978 and 1980 constant dollars, respectively. The report cited here was obtained via FOIA. D.M. Armitead, H.G. Leistner, J.J. McAvoy and J.A. Wooster, *Investigation of Deep Missile Basing Issues*, Federal Document No. DNA 6284F, Contract No. DNA 001-79-C-0297, Prepared by Boeing Aerospace Company for the Defense Nuclear Agency (30 December 1980).

Chapter 4. How to Hide a Secret Underground Base

What about hiding an underground base? Or concealing its actual construction? Both are simpler than you might think. A clandestine, subterranean installation can be concealed under the guise of other industrial activities. One of the most useful documents on this subject that I have come across, issued by DARPA, the Defense Advanced Research Projects Agency, discusses the topic in some detail, but from the standpoint of nuclear arms control.[89] The manual is written for nuclear weapons inspectors who must go out in the field in countries around the world and try to detect evidence of violations of nuclear test ban treaties. The basic premise of the report is that when a nuclear power, or aspiring nuclear power, wants to test a nuclear device, and wants at the same time to keep the fact of the test secret, it may stealthily construct a secret underground test complex, and detonate a low yield weapon in it, endeavoring to mask both the underground

[89] Dwayne C. Kicker, primary author (UTD, Incorporated), *Development of Inspection and Detection Techniques for Hidden Cavities*, Sponsored by Defense Advanced Research Projects Agency (DOD), Defense Small Business Innovation Research Program, ARPA Order No. 5916, Issued by U.S. Army Missile Command, Final Report 15 July 1991.

test complex and the detonation of the weapon under cover of heavy industrial activities. The report lists a variety of ways in which such clandestine underground workings can be secretly constructed and concealed, in order to better equip nuclear weapons inspectors to detect their presence, and hence to prevent secret, underground nuclear detonations.

Construction Projects, Mining and Drilling as "Cover"
I want to cite extensively from the document itself, because it shows so clearly how an underground complex can be concealed by seemingly normal industrial activity. On the first page the report states:

> This research addresses the need to develop operational on-site field procedures and systems to detect large, hidden underground cavities suitable for nuclear decoupling, located near mining, drilling or construction sites (sites which can best mask both the construction of the cavity and the detonation of the explosion).[90]

There are a couple of things to mention here. First, the report suggests that mining, drilling and construction sites can hide underground cavities. And second, it suggests that a secret, underground nuclear explosion can feasibly be hidden under the rumble of heavy industrial activity (such as by the detonation of large quantities of mining explosives).

Mining and quarrying operations can provide the cover for secret excavations. The report makes the following point with respect to strip mining:

> ...it is conceivable that a discrete underground excavation at a large surface mine would not be noticed

[90] Ibid.

by an untrained observer, as massive earth-moving equipment is continuously in use. The material excavated from an underground operation could be blended with the large amounts of material being moved daily. The generated waste material is disposed of in a variety of ways, such as fill for haul road construction or fill for reclaimed areas.[91]

What could be clearer? At a major strip mining operation, there is so much hustle and bustle, so much heavy machinery, and so much rock and soil being excavated and moved around that a secret, underground excavation can just get lost in the shuffle.

The report further explains that underground mines may contain mined out areas, or abandoned areas that can be used for secret nuclear testing (and by implication for other purposes, as well). For example, the report states that:

> Large mines...could contain several kilometers of openings, thus providing numerous opportunities to isolate a large room or stope for use as a decoupling chamber.[92]

A "decoupling chamber" is simply a large, underground space in which a nuclear device can be detonated, i.e., muffled and concealed from seismic detection. But of course such a hidden chamber or chambers could be just as easily used for a wide range of other purposes as well. Stopes are simply massive, steplike underground excavations that miners make in an ore body or mineral deposit (be it iron, aluminum, copper, diamonds, gold, silver, or any other mineral or ore), as they excavate a mine.

[91] Ibid.
[92] Ibid.

The report continues:

> When the ore is completely drawn off, the stopes may either be left empty or filled with waste material. Again, numerous opportunities exist for large isolated cavities.[93]

And:

> In block caving, a large block of ore is undercut to initiate caving. As the ore is drawn off from the haulage level beneath the ore body, both the ore and the waste will cave. Because the caving process itself is the means of excavation, the method is relatively inexpensive. Conditions for this method require a massive deposit with fairly weak strength for both the ore and the rock. While caving methods are less likely suspect environments, a caved area overlain by competent rock could be excavated or drawn off to develop a large isolated cavity.[94]

The report also mentions that large cavities can be excavated underground in drilling operations and civil construction projects.

> In addition to...mining operations..., heavy construction operations may give similar opportunities for developing hidden cavities. Large road cut operations involve the extraction of large amounts of material which may require the use of large blasts. There are many civil tunneling projects which, depending on the size of the excavation, may require large, heavy equipment, the movement and disposal of large amounts of material, and the use of explosives. Large caverns may be

[93] Ibid.
[94] Ibid.

constructed for use in pumped storage hydroelectric plants.[95]

Note well what the report's author is saying here: civil engineering projects such as major highway construction, tunnel excavation and hydroelectric plants may present opportunities for developing hidden cavities. (See Illustrations 32 and 33 for a hypothetical example.)

Detecting Hidden Cavities

But how does the investigator determine whether a hidden cavity exists or not? Well, s/he must obtain:

- Satellite data (Landsat or similar satellite imagery) which depict changes occurring over the past 5 to 10 years;
- Geologic data;
- Mining/construction reports; and
- Intelligence data.

In other words, the investigator must do his/her homework, obtaining as wide a variety of data as possible, including satellite data and talking with people close to the project, if possible. Available documentation should be located and reviewed.

O.K. Suppose that the investigator suspects that a given industrial operation is a cover for a clandestine underground cavity -- what next?

The report recommends:

For each of the suspect type sites, the depth and extent of workings should be noted. The depth can give indications of the equipment type or site as well as type

[95] Ibid.

and size of ground support. Considering that the likelihood of hidden cavity activity increases with the size of the operation, the extent of workings provides useful information.

All surface buildings should be inspected for their contents and purpose. Buildings could be used to store supplies for the hidden cavity, such as long roof bolts and cables, scaffolding, instrumentation, etc. Buildings could also serve as cover for a shaft or other underground access.

The number and type of personnel should be noted, including management, engineering, skilled and unskilled labor. Personnel should be commensurate with the type of operation and with the traditional labor mix.

The primary operations of drilling, blasting, excavating and hauling should be inspected for each suspect site as applicable. These operations should be closely sized and matched for maximum efficiency. Any excesses, such as additional drilling or excavating equipment, or oversized haulage equipment, could indicate hidden cavity equipment. Any additional equipment on the site should also be inspected, which could provide clues for suspicious activity. Nearby activities, such as road construction, should be examined as possible "dumps" for excavated material.

Auxiliary operations, such as power supply and water drainage, should be inspected. The power supply should be matched to the given equipment and facilities. Water color, chemical content, and flow can be matched to the geologic conditions, giving an indication of its origin. Also, water temperature can give an indication of its original depth, thus providing clues of the presence of hidden cavities.[96]

Do you have your notebook out? These are all the clues you need to look for. Notice the report says that buildings

[96] Ibid.

could provide a cover for shafts or other openings to a secret underground cavity. What sort of buildings? Well, conceivably *any and all* buildings -- one would suppose that if the intent is to hide something, the more unlikely looking the building in question, the better.

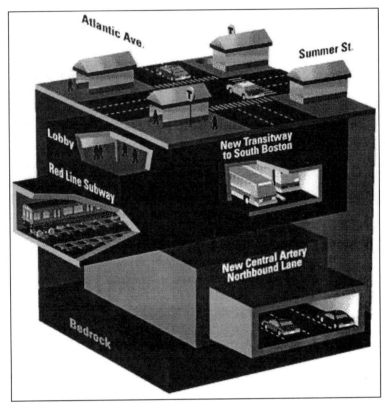

Illustration 32. Boston's "Big Dig". The Central Artery/Tunnel Project in Boston, Massachusetts. *The largest, most complex and technologically challenging highway project in American history.* It entails miles of underground tunnels, highway interchanges and complex underground, urban infrastructure work. Construction is by Bechtel/Parsons Brinckerhoff, a joint venture of Bechtel Corporation of San Francisco, and Parsons Brinckerhoff Quade & Douglas, Inc., of New York. This graphic depicts the complexity of multiple, stacked, underground tunnels in a modern city. (*Source*: Massachusetts Turnpike Authority, on the WWW at http://www.masspike. com/digframe.html, 2000.)

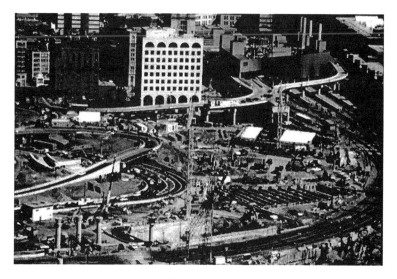

Illustration 33. Surface view of one "Big Dig" work area, on the Central Artery/Tunnel Project in Boston, Massachusetts. Project planning began in 1982, and construction started in 1991. Completion is scheduled for December 2004. The total cost is projected to be a staggering $13 billion. The project will excavate a total of 15 million cubic yards of dirt. About two-thirds of the dirt will be trucked to landfills and other sites, more than 541,000 truckloads in all. If all those trucks were lined up end to end, they'd back up 4,612 miles. That's all the way to Brasilia, capital of Brazil, as the crow flies, or to the Panama Canal, strictly over land. The rest of the dirt, more than 4,400 barge loads, is being taken to Spectacle Island, in Boston Harbor, where an old dump has been capped to make way for a new park. About 2.5 million cubic yards of clay will be made available to cities and towns to cap landfills that have reached capacity. The project will replace that dirt with 3.8 million cubic yards of concrete, enough to build a sidewalk three feet wide and four inches thick from Boston to San Francisco, and back three times. These figures give a good idea of the incredibly huge quantities of soil and concrete that major civil engineering projects handle. (*Source*: Massachusetts Turnpike Authority, on the WWW at http://www.masspike.com/digframe.html, 2000.)

Secret Bases in Mines?

The report very explicitly mentions that secret cavities might be found in conjunction with either surface or underground mines. In the case of surface mines,

> The construction and maintaining of slopes and shafts would likely be detectable by aerial photos.[97]

Moreover,

> Surface mining operations are often developed into underground mines, and this scenario provides a greater potential for hidden cavity activity.[98]

Where underground mines are concerned,

> Suggested means for hiding a cavity included developing the cavity in a "sealed" area of the mine and using leakage air to ventilate the opening. The excavated material could be blended into the run-of-mine product, transported to abandoned areas of the mine, or used as backfill material.[99]

Finally,

> Field observations should check for traffic patterns or other activity in the direction of mined-out, unused areas of the mine. Large mining operations can best conceal the presence of these salient characteristics because the percent difference in mine characteristics as a result of the hidden cavity will be much less in comparison to a small mine. Also...the salient characteristics may not be evident if the cavity was created at some time in the past

[97] Ibid.
[98] Ibid.
[99] Ibid.

or is planned for some time in the future. Perhaps the most striking finding from the discussions with ... mine operators was a consensus that it would be extremely difficult to locate all suitable cavities in old, large underground workings. [100]

So there you have it, from DARPA and the U.S. Army Missile Command. A virtual "how-to" manual for detecting the presence of clandestine, underground facilities. I can't help but wonder if the many recommendations and observations in the report don't arise from actual practices employed right in the United States itself to conceal government and corporate underground facilities from *us*.

The report makes clear that civil construction projects, such as highway, tunneling and/or hydoelectric plant construction can mask the excavation of secret underground cavities. Even drilling operations (as for mineral deposits) can mask excavation of underground cavities. And perhaps most interesting of all, routine mining operations provide a perfect cover for concealing clandestine underground cavities.

Of course, not every road, not every highway or tunnel, and not every strip mine, quarry or underground mine is a cover for clandestine subterranean activity. However, this document makes abundantly clear that *some* of those construction and industrial activities *could* provide a cover for surreptitious subterranean activities and installations. (See Illustration 34.)

[100] Ibid.

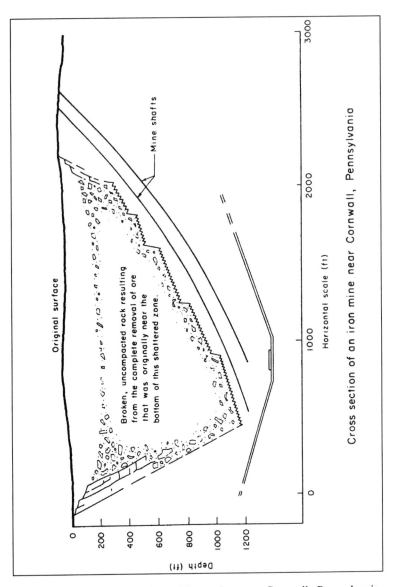

Illustration 34. Cross section of iron mine near Cornwall, Pennsylvania. RAND Corporation planners contemplated burying an underground base deep beneath this abandoned iron mine. The planned base lies at the bottom of the sketch. (*Source*: S.M. Genensky and R.L. Loofbourow, *Geological Covering Materials for Deep Underground Installations*, RM-2617, U.S. Air Force Project RAND, 4 August 1960.)

A Broad Hint

Interestingly, during the course of my research a couple of sources broadly hinted to me that both abandoned and active mines could serve as a cover for clandestine, underground bases. Both of them said essentially the same thing to me, so I will liberally combine and paraphrase their comments:

> You know, there are many thousands of active and abandoned mines in the United States. It would be an interesting project, albeit a bit tedious and time consuming, to go state by state, inquiring of the appropriate state agencies, mining companies and mining schools about the total active and abandoned mining sites, and the total mileage (linear and square) for each state and each individual mine. Once you do that you would have a good idea of the potential underground space available for possible use by the military or others.[101]

Based on conversations such as these, and my own hunches as I pursued the evidence, I consider it entirely possible that there are secret underground bases in some deep mines (whether active or abandoned) in the United States and elsewhere. And judging by the material elsewhere in this report I consider that quarrying, open pit mining operations, deep drilling projects, major highway construction, and aqueduct and other tunneling, as well as hydroelectric plant construction, may also be occasional covers for secret underground activities and installations.

[101] This is a combined paraphrasing of conversations with distinctly different insiders, who each told me very much the same thing. Notice that they didn't say that there *are* clandestine underground bases in old, abandoned mines, or in active mines, for that matter. But they certainly dropped a broad hint.

U.S. Government Underground in Rural Pennsylvania

To be sure, there is precedent in the open literature for the United States government employing deep underground mine space for federal agency use. In Boyers, Pennsylvania, to the north of Pittsburgh, two U.S. government agencies operate underground: the Retirement Operations Center and the Federal Investigations Service operate out of a retired limestone mine formerly operated by U.S. Steel. The two federal agencies employ 360 people in the 252 foot deep converted mine, that contains 70 miles of tunnels. Eight mammoth rooms contain 300 million records. The records are stored in 100,000 drawers in filing cabinets stacked 10 high. There is also a main frame computer room. "Much of the labyrinthine tunnel system... is developed into a street system, with stop signs, yellow-striped walkways and parking spaces for the lucky few allowed to drive in." And there are other agencies and corporations who share space in the converted mine, such as the World Bank, Westinghouse, Universal Pictures and BMG.[102]

All of this takes place 252 feet underground, in a countryside of rolling hills and fields full of dairy cattle and corn. Driving along through the rural Pennsylvania scenery, who would think that deep underground "workers tap away at computers"? And please do take note: "The mine is unmarked and invisible from the road."[103] Clearly, other government agencies and corporations can do covertly elsewhere what two government agencies, along with other corporations and non-government agencies, are doing openly (albeit deep underground) in the vicinity of Boyers, Pennsylvania.

[102] Linda Perlstein, "Their Offices Are the Pits, But These Workers Don't Mine," *The Washington Post*, 4 August 1998.
[103] Ibid.

Chapter 5. The Evidence for Secret Undersea Bases

Stories of underground tunneling by the United States Navy are very persistent. When I first started my research, people began telling me that the United States Navy was involved in clandestine tunneling and secret underground base construction. Over the years, I have encountered bits and pieces of information suggesting that there may be undersea naval facilities. A former associate of mine who had been in the Navy told me that there are tunnels on both coasts of the United States that submarines enter when they are at sea, and then travel through to secret, underground submarine bases that are inland from the coast. I have been told, time and again, about purported submarine tunnels in the Long Beach, California area that allegedly bore inland from the ocean.

Russian Tunnels -- For Submarines!

In fact, there is precedent in the open literature for such tunnels -- albeit in Russia. In their excellent book, *Blind Man's Bluff: The Untold Story of American Submarine Espionage*, Sherry Sontag and Christopher Drew relate that in the 1980s:

The Soviets also were building four large underwater 'tunnels' at a new submarine base at Gremikha near the tip of the Kola Peninsula, about 150 miles from Murmansk. Blasted out of the adjacent hillside, the granite tunnels were large enough to accommodate the Typhoons...[104]

Have similar underwater tunnels been built by the United States Navy to secretly accommodate its submarines, perhaps in the Long beach, California area, and elsewhere? I consider it possible.

Tunneling the Continental Shelf

I have been given hints that there may be lengthy, secret tunnel systems beneath the continental shelf, off both coasts of the United States. I have spoken to a few insiders in recent years and I plainly asked one of them: "What about the stories of highly secret naval installations beneath the ocean floor, to which submarines secretly come and go? And what about the stories of secret, undersea bases, and hundreds of miles of secret tunnels deep beneath the sea floor along the Atlantic and Pacific coasts of the United States?"

The answer was intriguing: "I would carefully consider those stories."

And so I am paying attention to the stories. I will tell you candidly that I do not know whether the stories are true or not. They are interesting. If they are true, then there are sophisticated, clandestine, undersea bases and tunnels that the United States government operates – and which it has kept secret from the American people.

[104] The Typhoons are extremely large submarines. Sherry Sontag and Christopher Drew, with Annette Lawrence Drew, *Blind Man's Bluff: The Untold Story of American Submarine Espionage* (New York: Public Affairs, 1998).

Evidence for Bases Beneath the Ocean Floor

It is important to understand that the technology for constructing manned, undersea bases hundreds, even thousands, of feet below the sea floor exists. Brand that simple fact on your brain. The experience, the expertise, the machinery, the trained personnel and the financial means for constructing manned bases beneath the ocean floor have been in place for at least 35 years. Bear in mind that the petroleum industry routinely carries out major industrial operations in deep water, well out to sea. The petroleum industry also routinely bores down into the deep rock beneath the ocean floor. It is a major industrial operation and it occurs frequently.

A recent news item on CNN's website profiled one of the deep sea divers involved in recovering bodies of drowned sailors from the sunken Russian submarine, *The Kursk*. The diver works for the giant, multinational, petroleum conglomerate, Halliburton Co. According to the article, the diver has worked on unspecified undersea projects which have included a range of construction activities including "welding, concrete work -- whatever jobs can be done undersea." [105]

Let me relate a personal anecdote. In 1976, while hitchhiking through Scotland I caught a ride with an ex-diver for the British Navy. He was working at that time in the oil fields in the North Sea, and described his work routine to me as follows: he would put on a diving suit and travel down to the sea floor, where he would carry out major construction work, which involved strenuous work on pipelines and valves, and the assembly of structural components. The simple point I am making is that the offshore petroleum industry has had the capability for

[105] "For Missouri-born diver, Russian sub mission was like no other." Associated Press news article, on the WWW at http://www.cnn.com/ 2000/US/12/04/kursk.diver.ap/index.html, 2000.

decades to carry out heavy industrial activities on the sea floor. This capability could easily be extended to constructing airlocks and openings for undersea bases. (And don't forget the example of the Soviet underwater submarine tunnels above.)

Where tunneling is concerned, operating a tunnel boring machine (TBM) in solid rock hundreds of feet below the ocean floor really presents no greater a technical challenge than operating a TBM in solid rock hundreds of feet below the surface of solid ground. In both cases the machine and its operators are in an enclosed environment.

Indeed, one source mentioned to me that "in principle" there is nothing to stop a tunnel boring machine (TBM) from tunneling out beneath the sea bed, from onshore. Once offshore, beneath the sea, there is nothing to stop the TBM from tunneling along the coastline, miles out to sea- *beneath the sea floor.* And no one would be the wiser. The state-of-the-art progress for a TBM in good rock is several miles per year.[106] With just one machine, and one

[106] For example, the Pacific Gas and Electric Company used a Robbins Company TBM to bore a 24' 1" diameter, 22,000 foot-long tunnel during construction of the Kerckhoff 2 Underground Hydroelectric Power Plant in the early 1980s. The power plant is about 30 miles northeast of Fresno, California. Typical rates of progress were anywhere from 60 to 100 feet per day. Assuming 365 days of work per year, the machine should average about 5.5 miles of tunnel annually. (Edward R. Kennedy, P.E., "The Kerckhoff 2 Underground Hydroelectric Power Plant Project, A State-of-the-Art Application of a Tunnel Boring Machine", U.S. National Committee on Tunneling Technology, *Tunneling Technology Newsletter,* Number 38, June 1982). An 18 mile tunnel through fractured rock in Greece yielded extrapolated TBM net average advance rates of about 4.5 miles per year. [G. Dolcini, S. Fuoco and R. Ribacchi, "Performance of TBMs in Complex Rock Masses," in *North American Tunneling '96, Vol. 1,* ed. Levent Ozdemir (Rotterdam, Netherlands and Brookfield, Vermont: A.A. Balkema, 1996)]. Another study projects rates up to 10 miles of tunnel per year or more "to be feasible within the possible level of

crew, a one hundred mile tunnel system could certainly be secretly constructed in ten to twenty years. If just five machines were employed, five hundred miles (or more) of secret tunnels could be excavated in the same period of time.

This is well within the state of the art of tunnel boring technology. Indeed, at a recent meeting between the heads of state of Japan and South Korea, Japanese Prime Minister Yoshiro Mori proposed constructing a 108 mile-long undersea rail tunnel between Japan and South Korea. The purpose of the tunnel would be to facilitate trade and to provide a rail link between Japan and the Eurasian land mass. In the words of Prime Minister Mori, "The construction is technically possible, but the problem is money."[107]

What could be clearer? Here the head of state of one of the most technologically advanced countries in the world is baldly stating that a 100+ mile undersea tunnel is technically feasible -- the sticking point is not whether it can be done (because it can), rather the problem is finding the money to do it. In other words, the engineering aspects

attainment using today's machines in moderate conditions and without any further advance in machine technology." D.B. Parkes, *The Performance of Tunnel-Boring Machines in Rock*, CIRIA Special Publication 62, (London: Construction Industry Research and Information Association, 1988). And the extrapolated annual rate of advance for the TBMs boring the Chunnel underneath the English Channel between France and England, ranged from about 8 to 13 miles, assuming the machines' best monthly rates of progress ("Tunnel Boring Machines," Eurotunnel on the WWW at http://www.eurotunnel.com/eurouk/etplc/tbm.htm, 1999. The available evidence indicates that for contemporary tunneling machines an average rate of 5 miles per year is attainable even in fractured rock. In better conditions, tunnel boring machines can make advances of 10 miles or more per year. This is well within the state of the art in today's tunneling industry.

[107] "Japan proposes undersea tunnel to link S. Korea," on the WWW at http://www.indiatimes.com/221000toi/22worl15.htm, 2000.

of the proposed project are not the problem; rather, the financing is.

At the risk of over repetition I will stress once again that the money to carry out a secret project of this sort certainly exists in the Pentagon's black budget. The requisite infrastructure of secrecy to carry out such a project has been in place in the military-industrial complex for decades now. And there is even a paper trail that shows U.S. Navy interest in building manned bases deep beneath the ocean floor.

The Undersea Base Paper Trail

The paper trail begins in 1966 with a letter on 18 April 1966, from Robert W. Van Dolah of the U.S. Bureau of Mines, to Dr. William B. McLean, Technical Director for Research and Development at the U.S. Naval Ordnance Test Station at China Lake, California.[108] (See Illustration 35.) In the letter, Mr. Van Dolah alludes to Dr. McLean's interest in "deep underwater exploration." Mr. Van Dolah specifically refers to tunneling at great depth under the ocean bottom. His letter says:

> In talking with some of our mining experts here, I find a consensus that sinking a shaft to 10,000 feet and driving a shaft horizontally from this presents no severe problems (other than money perhaps) if the rock is competent and not faulted. One of the most difficult problems in deep mines is a sealing off of aquifers. It would seem that even if the rock were competent throughout the tunnel and drift, there might be rather difficult problems in breaking through to the bottom of

[108] Letter from Robert W. Van Dolah, Research Director, Explosives Research Center, United States Department of the Interior, Bureau of Mines to Dr. William B. McLean, Technical Director, Research and Development, U.S. Naval Ordnance Test Station, China Lake, California, 18 April 1966.

the ocean and maintaining a seal against the high water pressure.

In other words, Mr. Van Dolah is saying that the only serious constraints against sinking a shaft two miles deep[109] and tunneling under the ocean are financial. Breaking through to the ocean bottom presents potential problems, but actually tunneling beneath the ocean does not. Of course, Mr. Van Dolah is absolutely correct. There are many tunnels beneath the sea.

Mine Tunnels Beneath the Sea

All over the world there are mines that extend offshore beneath the sea; in many cases the mines were first excavated many decades ago, even one hundred years ago

[109]The question as to the feasibility of deep shafts, i.e., large shafts that extend thousands of feet underground, has been definitively answered in the affirmative by the mining industry. I will cite just two examples from the many that can be found in the mining engineering literature; they suffice to prove the general point. In the early 1980s, the Wyoming Mineral Corporation and Conoco Inc. bored a 10 foot diameter shaft to a depth of 2243 feet in Crown Point, New Mexico. They also bored a couple of other six foot diameter shafts to a depth of 2188 feet at the same location, with the objective of developing a uranium mine at about 2180 feet below the surface. Russel E. Hunter, "Drilled Shaft Construction at Crownpoint, New Mexico," in *Proceedings, 1983 Rapid Excavation and Tunneling Conference, Chicago, Illinois, 12-16 June 1983*, ed. Harry Sutcliffe and John W. Wilson (New York: The American Institute of Mining, Metallurgical, and Petroleum Engineers, Inc., 1983). Twenty years earlier a 9673 foot shaft was sunk at the Western Deep Levels mine in South Africa. This shaft, which extends to virtually the 10,000 foot level mentioned by Van Dolah has a lined diameter of 20 feet. "World's Deepest Single Shaft," *The South African Mining and Engineering Journal* (19 October 1962). It is clear that shafts with diameters of ten and twenty feet, that extend for thousands of feet underground, have been the state of the art in the mining industry for decades.

**UNITED STATES
DEPARTMENT OF THE INTERIOR**
BUREAU OF MINES
4800 FORBES AVENUE
PITTSBURGH, PENNSYLVANIA 15213

April 18, 1966

Dr. William B. McLean
Technical Director, Research and Development
U. S. Naval Ordnance Test Station
China Lake, California 93557

Dear Bill:

I missed you at Colorado Springs. The meeting was fairly interesting but essentially a rehash of the discussions that we had at Ramey without too much new coming out.

I enclose a few reprints of things that might be of interest to you in your thoughts about deep underwater exploration. In talking with some of our mining experts here, I find a consensus that sinking a shaft to 10,000 feet and driving a drift horizontally from this presents no severe problems (other than money perhaps) if the rock is competent and not faulted. One of the most difficult problems in deep mines is a sealing off of aquifers. It would seem that even if the rock were competent throughout the tunnel and the drift, there might be rather difficult problems in breaking through to the bottom of the ocean and maintaining a seal against the high water pressure.

It was good seeing you at Ramey.

Sincerely yours,

Robert W. Van Dolah
Research Director
Explosives Research Center

Enclosures

Illustration 35. Copy of 1966 letter in which Robert W. Van Dolah, then Research Director of the Explosives Research Center of the U.S. Bureau of Mines, talks about the feasibility of boring a shaft to a 10,000 foot depth and then tunneling out under the ocean. He expresses the opinion that it can be done, although sealing off the tunnel from water inflow requires special attention. (*Source*: U.S. Bureau of Mines.)

150

or more, as with the British coal mines that extend out under the North Sea, and the Firth of Clyde. Among the places where submarine coal mines have been worked, in addition to Britain, are Canada, New Zealand, Australia, Chile, Japan and Taiwan.[110] By way of further example of undersea, hard rock mining, there is the Jussaro Island undersea iron mine off the coast of Finland, beneath the Gulf of Finland. In the Jussaro Island mine tunnels extend hundreds of feet beneath the sea to bodies of iron ore that lie just offshore. The tunnels are accessed from shafts that have been sunk from islands in the vicinity.[111] (See Illustration 36. The sketch makes quite clear that it really is no problem to drive a mine right out to sea, deep beneath the sea floor.)

As alluded to above, in Britain coal has long been mined from under the North Sea and the Firth of Clyde, at depths ranging as much as 1,800 feet below the sea floor.[112] In Cornwall, tin mines ran out under the Atlantic Ocean in the early years of the 20th Century.[113] In Canada, there have been many undersea mines. Sixty-five years ago, coal was being mined three miles out to sea, off the coast of

[110] Shan-tung Lu, "Undersea Coal Mining," Paper presented to the Department of Mining, College of Mineral Industries, The Pennsylvania State University, University Park, Pennsylvania, USA, March 1959.

[111] John L. Mero, *The Mineral Resources of the Sea* (New York: Elsevier Publishing Company, 1965).

[112] George E. Sleight, "A Hydrographic Survey and Undersea Borings in Ayr Bay," *Transactions- The Institution of Mining Engineers* Vol. 112 (1952-1953); R.S. McLaren, "Undersea Mining off the North-East Durham Coast," *The Iron and Coal Trades Review* (8 August 1952); J.H. Pierce, "Horden, One of England's Crack Collieries," *Coal Age* Vol. 34, No. 7 (July 1929); J.T. Robertson, "Drifting Under the Firth of Forth," *Canadian Mining Journal* (December 1964).

[113] "The Tin Mining Industry of Cornwall," *Scientific American Supplement* Vol. LXIII, No. 1635 (4 May 1907).

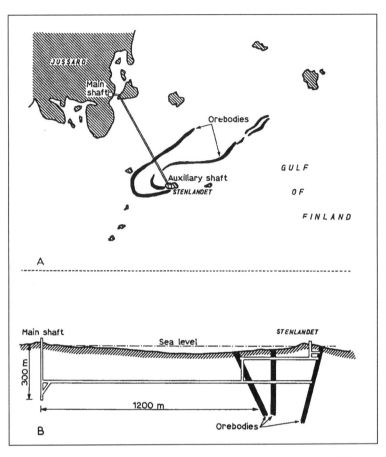

Illustration 36. Jussaro iron mine lies undersea off the coast of Finland. Notice there are two access shafts, one onshore, and the other offshore, on a small island. The actual mine workings are undersea. The Jussaro mine is a good example of a deep mining operation beneath the sea floor. [*Source*: John L. Mero, *The Mineral Resources of the Sea* (New York: Elsevier, 1965).]

Nova Scotia, as far as 1,600 feet beneath the sea floor.[114] The Wabana iron mine,[115] at Bell Island, Newfoundland,

[114] Syndney C. Mifflin, "Weak and Heavy Top Make Longwall and Mechanization Imperative in Nova Scotia," *Coal Age,* Vol. 38, No. 7 (July 1933); R. Dawson Hall, "Reallocation and Tunnels Make Nova Scotian Undersea Coal More Accessible from Shore, " *Coal Age*, Vol.

is undersea; there has also been submarine mining in other places in Canada, including off of Vancouver Island, British Columbia,[116] as well as coal mining off of Cape Breton Island, Nova Scotia,[117] and elsewhere offshore in Nova Scotia.[118] (See Illustration 37.)

There have been other submarine coal mines off the coast of New South Wales, in Australia,[119] and undersea in Japanese coastal waters, for example, off the coast of Kyushu and elsewhere.[120] Coal has been mined off South

44, No. 10 (October 1939); Alexander S. McNeil, "Notes on Mining Coal in Submarine Areas at Princess Colliery, Sydney Mines," *The Canadian Mining Journal* (10 June 1921); and Louis Frost, "Submarine Mining in the Sydney Coalfield, Cape Breton Island, Eastern Canada," *Transactions of the Institution of Mining Engineers*, Vol. LXXXI (1930-1931).

[115] J.B. Gilliat, "Folding and Faulting of the Wabana Ore Deposits," *Monthly Bulletin of the Canadian Institute of Mining and Metallurgy*, No. 141 (January 1924).

[116] James Dickson, "Submarine Coal Mining at Nanaimo, Vancouver Island, British Columbia", *The Transactions of the Canadian Institute of Mining and Metallurgy and of the Mining Society of Nova Scotia 1935*, Vol. XXXVIII; and "The Submarine Coal-Field of Nanaimo, Vancouver Island, B.C.," *The Canadian Mining Journal* (25 March 1921).

[117] Richard H. Brown, "Submarine Coal Mining," *Mining Reporter*, Vol LIV (July to December 1906).

[118] Francis W. Gray, "Mining Coal Under the Sea in Nova Scotia, With Notes on Comparable Undersea Coal-Mining Operations Elsewhere," *The Canadian Mining and Metallurgical Bulletin 1927*, Vol. XX, Nos. 177-188; A.S. McNeil, "Nova Scotia Steel & Coal Co. Is Completely Removing Coal Seam Under Ten Square Miles of Sea Area," *Coal Age*, Vol. 20, No. 6 (11 August 1921).

[119] A. Selwyn-Brown, "Submarine Coal Mining," *Engineering and Mining Journal* (18 November 1905).

[120] C.L. O'Brian, "Some Comments on the Japanese Coal Industry," *The Canadian Mining and Metallurgical Bulletin* (May 1965); and Carl Helmut Fritzsche and Günter Fettweis, "Eindrücke aus dem japanischen Steinkohlenbergbau," *Glückauf Bergmännische Zeitschrift*, 91. Jahrgang, Heft 1/2, (1. Januar 1955). It is interesting to note that the

America's Pacific Coast, in Chile.[121] More submarine coal workings that extend out under the Bay of Biscay have been located at Arnao, Spain.[122] There were even submarine mine workings in the United States eighty years ago. The rich Treadwell Gold mines on Alaska's Douglas Island burrowed more than 2,000 feet deep under the Gastineau Channel in the early Twentieth Century.[123]

The point is clear: tunneling out under oceans, seas, bays and estuaries has been done for a very, very long time, all over the world, stretching way back at least into the 19th Century, if not before. Undersea tunnels can stretch for miles, and reach depths of 2,000 feet or more beneath the ocean floor. Of course, today's technology is far more powerful and sophisticated than it was 50, 100 or 150 years ago. One can only speculate as to how long, how deep and how elaborate contemporary, clandestine, submarine tunnels might be.

Modern Undersea Tunneling Technology in the U.S.A., Canada and Japan

Do not doubt the reality of submarine tunneling, because there are plenty of examples in the civil

Japanese make use of both natural islands, as is the case at the Wabana mine at Bell Island in Canada, and artificially constructed islands as surface openings (sites for ventilation shafts) for their submarine mine workings. There are 14 undersea coal mines in Japan, ranging from 600 to 3,000 feet below the seabed.

[121] J. H. Wright, *Chile, Economic and Commercial Conditions in Chile* (London: Her Majesty's Stationery Office, 1958); and "The Chilean Coal Industry," *The Iron and Coal Trades Review* (27 January 1928).

[122] "Under-Sea Mining at Arnao, Spain," *The Colliery Guardian and Journal of the Coal and Iron Trades*, Vol. LXXIX, No. 2046 (16 March 1900).

[123] "The Subsidence in the Alaska-Treadwell Mines," *Mining and Scientific Press* (10 February 1917).

Illustration 37. Entrance to undersea mine in Canada's Maritime Provinces. The mine shaft continues straight ahead, out under the Atlantic Ocean, beyond the horizon. (*Source*: Carl Austin.)

155

engineering literature of submarine tunneling. Perhaps the most famous example is the *Chunnel*, the well known, high speed, rail link that burrows deep under the English Channel, between France and England. It is so famous that it scarcely needs mentioning. (See Illustration 38.)

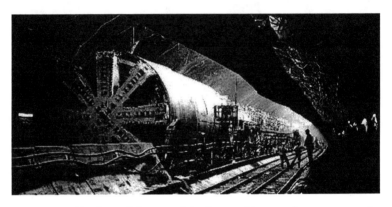

Illustration 38. One of the tunnel boring machines used to excavate the Chunnel, the tunnel that connects England and France deep beneath the English Channel. The machine is shown here in an underground work area. (*Source:* Eurotunnel, 1999.)

My purpose here is not to do an exhaustive review of the many undersea tunneling projects that can be found in the civil engineering and tunneling literature to prove the feasibility and reality of undersea tunneling.

Rather, in this section I will cite just four other examples, one from Japan, one from Canada, and two from the United States, chosen more or less at random from the slew of projects that could be discussed. All four are civil engineering projects with an open, public purpose. They suffice to illustrate the very simple point that I am making: underwater and undersea tunneling are well within the state of the art for the modern underground excavation industry and have been carried out for many years. It really is not a problem to bore large, lengthy undersea tunnels.

The Seikan Tunnel

In 1988 the Japan Railway Construction Corporation completed a 33.4 mile rail tunnel that connects the Japanese islands of Honshu and Hokkaido. Almost half of the tunnel's length, some 14.3 miles, lies deep underwater beneath the Tsugaro Strait. At 787 feet beneath the sea it is the deepest railway in the world.[124]

Rock and soil conditions were unfavorable for TBM operation, so the more laborious drill and blast method of tunnel excavation was employed. The total cost of the project was $7 billion. It is interesting that the tunnel runs right through a major earthquake zone,[125] clearly establishing the feasibility of tunneling undersea in areas prone to earthquakes. Hence, the Seikan tunnel's construction has obvious implications for possible sub-sea tunneling in other seismically active areas of the world, potentially including the opposite side of the Pacific Rim, along the California Coast. During the writing of the book, one expert with whom I spoke said that with today's tunneling capabilities, constructing a tunnel like the Seikan tunnel is comparative "child's play".[126]

It is important to underscore that like its European counterpart, the Chunnel, the Seikan tunnel is a rail tunnel.[127] Both of these tunnels demonstrate the practical feasibility of modern rail transport deep beneath the sea. Of course, it goes without saying that if high speed, undersea rail tunnels can be made openly, it is also within the realm of possibility that large corporations and powerful government agencies can make them clandestinely.

[124] "Seikan Tunnel," on the WWW at http://www.pbs.org/wgbh/build ingbig/wonder/structure/seikan.html, 2000.
[125] Ibid.
[126] Conversation with anonymous expert.
[127] "The Seikan Tunnel", on the WWW at http://www.pref.aomori.jp/ newline/sin-e08.html, 2000.

Ripple Rock Project

Many years ago there was a grave hazard to shipping in the Seymour Narrows of British Columbia, Canada. The so-called Ripple Rock, actually twin peaks that lurked just nine feet below the water's surface of Seymour Narrows, sank more than 100 vessels as they attempted to slip through the swift, turbulent waters between Maud and Vancouver islands. The first to succumb was the steamer U.S.S. Saranac on its way to Alaska. In subsequent years, dozens more sank. The barely submerged twin peaks of Ripple Rock were clearly an enormous hazard to maritime commerce, but their removal posed a serious engineering challenge, not least because they were underwater in a turbulent channel, where the current was swift and unpredictable.

In 1943, and again in 1945, attempts were made to position drilling barges over the submerged peaks. The idea was to drill holes into the rocks, pack the holes with explosives and blast the peaks to bits, thereby freeing the channel for safe passage. Both attempts failed. The swift current snapped the anchoring cables on the first attempt and nine men drowned on the second attempt.[128] Ripple Rock and the treacherous waters of Seymour Narrows would not yield easily.

It was not until the 1950s that work was completed on an ambitious, innovative demolition project that entailed tunneling deep underground, out under the channel and then up into the twin peaks, without breaking the water's surface. Using conventional mining methods, a seventy-five man crew working in 3 shifts sunk a 570 foot deep

[128] "April's Site", on the WWW at http://www.northislandlinks.com/campbell_river/archives/oldsites/98site04/site.htm, 1999; and Jeremy Leete, "The Taming of the Rock", *Vancouver Island Abound Outdoor Pages*, on the WWW at http://www.vancouverislandabound.com/tamingof.htm, 1999.

shaft from Maud Island. From the bottom of that shaft the crew then tunneled over 2,500 feet under the channel's bottom before raising two, parallel, 300 foot elevator shafts straight up into the bowels of the Ripple Rock peaks. Once inside the rock of the twin peaks, the miners created a series of tunnels and packed them full of 1,375 tons of explosives. After 27 months of work, the explosives were detonated on 5 April 1958. The ensuing blast exploded 370,000 tons of rock and removed the tops of the peaks from 9 feet below the surface to a much safer 47 feet below the surface at low tide. With the barely submerged tops of the menacing peaks sheared off by the blast, ships could navigate the previously dangerous Seymour Narrows without harm.[129]

This project has obvious implications for the construction of clandestine underwater facilities. It demonstrates the feasibility of tunneling out under a shipping channel, and then excavating a network of tunnels inside a submerged sea mount. This technique can be employed anywhere there are submerged sea mounts, by anyone who has the requisite tunneling equipment. The world's seas and channels are full of sea mounts -- it would be my educated guess that some of them have probably been clandestinely tunneled in this way.

[129] David S. Boyer, "British Columbia: Life Begins at 100", *The National Geographic Magazine*, Vol. 114, No. 2 (August 1958); "April's Site", on the WWW at http://www.northislandlinks.com/ campbell_river/ archives/oldsites/98site04/site.htm, 1999; and Jeremy Leete, "The Taming of the Rock", *Vancouver Island Abound Outdoor Pages*, on the WWW at http://www.vancouverislandabound.com/ tamingof.htm, 1999.

South Bay Ocean Outfall Tunnel (San Diego)

In more recent years, another tunnel has been excavated under the coastal waters off the Pacific coast of North America -- this time just off of San Diego, California. The so-called South Bay Ocean Outfall Tunnel is designed to carry treated effluent water from the heavily polluted Tijuana River through an undersea tunnel to a diffusion system several miles off shore, where it disperses into the waters of the Pacific Ocean. (See Illustration 39.) The method of construction bears some similarity to the Ripple Rock Project, in that the initial step in the project involved sinking a deep shaft onshore, 200 feet straight down, and then tunneling under the land and beneath the ocean bottom, straight out to sea for a total distance of about four miles.[130] However, the sub-sea tunneling off of San Diego (unlike at Ripple Rock, British Columbia) was performed by a tunnel boring machine (TBM). The machine, nicknamed "Molita", was made in Japan especially for the project and transported by ship to California. The 186 ton TBM is thirteen feet in diameter and stretches over 330 feet, including the trailing gear and equipment.[131] (See Illustration 40.) The TBM was lowered in sections 190 feet down a 36 foot diameter vertical shaft, and then reassembled at the bottom to tunnel out under the ocean bottom. (See Illustration 41.) Some 3.5 miles offshore, the tunnel intersects a riser shaft that was constructed on a marine platform in 80 feet of water on the ocean bottom. Here the tunnel connects with a diffuser system that flushes the treated wastewater into the ocean

[130] South Bay Ocean Outfall Tunnel: San Diego, on the WWW at http://www.traylor.com/tunnels/t6info.html, 1997.

[131] "FACTS: Tunnel Boring Machine", photocopy from the City of San Diego's Metropolitan Wastewater Department, 1997; and "International Wastewater Treatment Plant FACT SHEET," photocopy from the City of San Diego's Metropolitan Wastewater Department, 1997.

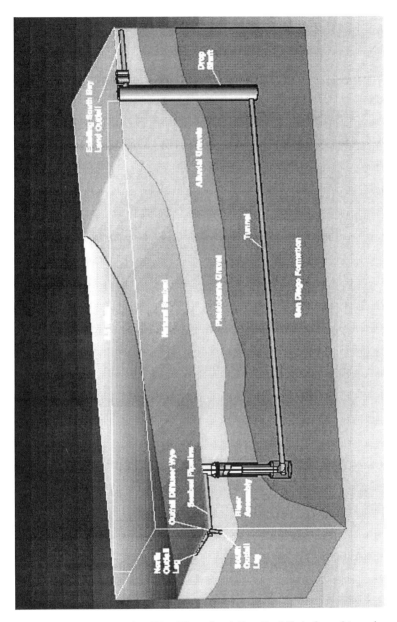

Illustration 39. Schematic of San Diego South Bay Outfall shafts and tunnels. The system extends 3.5 miles out to sea beneath the ocean floor. (*Source:* The City of San Diego, Metropolitan Wastewater • Public Works Department.)

161

FACTS

Tunnel Boring Machine

- **Was uniquely designed and made specifically for this project**

- **Was made in Japan, transported by ship to Long Beach**

- **Is 13 feet in diameter**

- **Weighs 186 tons**

- **Including the trailing gear is over 330 feet long**

- **Is designed to withstand 100 pounds per square inch of pressure**

- **Will tunnel 3.5 miles out under the Pacific Ocean**

- **Named "Molita"**

Illustration 40. Fact sheet for San Diego South Bay Outfall Project TBM. The name "Molita" is a Spanish, feminine, diminutive form of the English word, "mole". TBMs are often referred to as "moles", because they operate somewhat like those small, burrowing rodents. Notice the great weight and length of the complete TBM assembly. (*Source*: The City of San Diego, Metropolitan Wastewater • Public Works Department.)

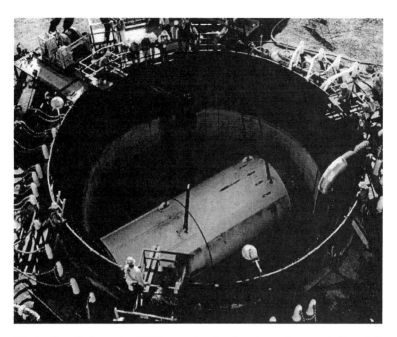

Illustration 41. Lowering TBM cutter head and engine underground. The shaft is 36 feet wide. Components of the TBM were lowered straight down 190 feet and then reassembled underground. After reassembly the TBM bored an 11 foot diameter tunnel under the seabed. (*Source*: The City of San Diego, Metropolitan Wastewater • Public Works Department.)

depths.[132] An oceangoing barge, with heavy lift cranes provided surface support for the construction of the diffuser assembly on the ocean floor. (See Illustration 42.) Deep sea divers went down to the sea bottom to complete the final phase of construction. (See Illustration 43.)

In this case, the tunnel system was constructed to handle waste water. However, the important point here is the use of a tunnel boring machine to excavate a tunnel

[132] "About the South Bay Ocean Outfall," METROFACTS from the City of San Diego's Metropolitan Wastewater Department, 1997; and "South Bay Ocean Outfall Tunnel: San Diego", on the WWW at http://www.traylor.com/tunnels/t6info.html, 2000.

beneath the bed of the Pacific Ocean. Clearly, tunnel boring machines are capable of carving out miles of tunnels beneath the bottom of the ocean. (See Illustration 44.)

Illustration 42. Oceangoing barge used to construct San Diego South Bay Outfall. This barge is well equipped for heavy construction at sea. Notice the large cranes. The use of seagoing construction platforms such as this, in tandem with the efforts of divers on the ocean floor, is one means to carry out major industrial operations on the sea bottom. The barge is 300 ft. long, as long as an American football field, and has an incredible heavy lift capacity of up to 600 tons. It is owned and operated by the Manson Construction Company of Seattle, Washington. Manson Construction is a leader in the marine construction industry worldwide, and works for many agencies, including the U.S. Navy. As an aside, this barge is named "WOTAN". You can see WOTAN stenciled on the edge of the helicopter pad to the left. Wotan was the principal God of the ancient Germans. *(Photo Source:* The City of San Diego, Metropolitan Wastewater • Public Works Department; other information on the WWW at http://www.mansonconstruction.com/, 2001.)

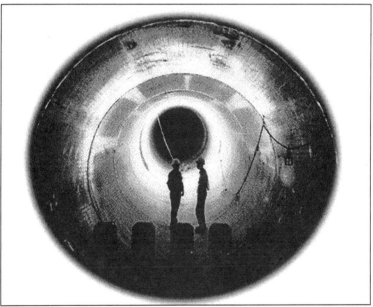

Illustrations 43 and 44. San Diego South Bay Outfall Project. **Top:** Deep sea diver preparing to descend to ocean bottom to perform construction. **Bottom:** Men silhouetted in completed tunnel beneath Pacific Ocean. (*Source*: The City of San Diego, Metropolitan Wastewater • Public Works Department.)

165

Effluent Outfall Tunnel (Boston Harbor)

Another tunneling project, this time under the coastal waters of the Atlantic Ocean, off of Boston, Massachusetts, also demonstrates the reality of undersea tunneling. Boston Harbor has had a water quality problem for hundreds of years.[133] The federal courts finally mandated in 1986 that the State of Massachusetts clean up the harbor's waters. Ever since, the state has been hard at work to comply with the federal mandate for cleaner coastal water.[134] Today there is a brand new undersea effluent outfall tunnel that is intended to alleviate the problem by carrying waste water out of the inner harbor and as much as 9.5 miles offshore from Deer Island, which is situated at the mouth to the harbor, to deeper waters. (See Illustration 45.) The 9.5 mile-long, undersea tunnel was bored by a 27 foot diameter, 770 ton TBM that was lowered in pieces down a 420 foot shaft, assembled underground and then used to bore out under the ocean, 200 to 300 feet beneath the sea floor. In addition there is already another, brand new 4.8 mile-long undersea tunnel that has been bored from Nut Island, also in the Boston Harbor area, all the way to Deer Island. The smaller tunnel "will carry screened wastewater...to Deer Island for Treatment."[135] These two tunnels are intended to prevent the discharge of wastewater into the shallow waters of Boston Harbor, thereby ameliorating water quality in the

[133] *Facts About History: Boston Harbor*, Massachusetts Water Resources Authority, circa 1990s (date illegible, poor quality photocopy obtained from the State of Massachusetts).
[134] *Facts About BHP Construction*, A Massachusetts Water Resource Authority Publication, Winter 1998; and *Facts About Boston Harbor Project*, A Massachusetts Water Resources Authority Publication, Winter 1998.
[135] On the internet at http://mwra.state.ma.us/sewer/html/sewmaj.htm, 1999 and http://mwra.state.ma.us/sewer/html/sewtun.htm, 1999.

coastal shallows. The $3.4 billion, eleven year project has been headed up by Metcalf & Eddy (M&E). [136]

One of the most interesting features of the project from the standpoint of this book occurred along the last 1.25 miles of the outfall tunnel. Let me quote from the Massachusetts Water Resources Authority literature about the project:

> For 10 months in 1991-1992, a barge that resembled an oil-drilling platform moved along the last 1.25 miles of the new effluent outfall's path. The elevated barge served as a construction deck for crews installing 55 riser pipes and caps that have been connected to the tunnel to ensure the thorough dilution of effluent with seawater.
> Each riser consists of a 30-inch diameter pipe that rises 250 feet from the tunnel to the sea floor. The pipes were inserted into predrilled holes, then topped with diffuser cap assemblies with mushroom-shaped, protective polyethylene domes.
>
>
> By fall 1997, tunneling crews using laser technology had connected all 55 riser pipes in the diffuser system to the tunnel and were preparing the facility to be filled with water... [137]

This last point may seem minor. But it has real relevance, as will become clear a little later on. The technique of using an ocean-going barge as a drilling platform to bore a shaft hundreds of feet down through the sea floor to connect with a tunnel, or tunnels, beneath the sea floor, is important. Here the technique is explicitly mentioned in connection with an

[136] On the WWW at http://www.m-e.com/site/projects/bosthrbrprj.htm, 1999.

[137] *Facts About BHP Construction*, A Massachusetts Water Resources Authority Publication, Winter 1998.

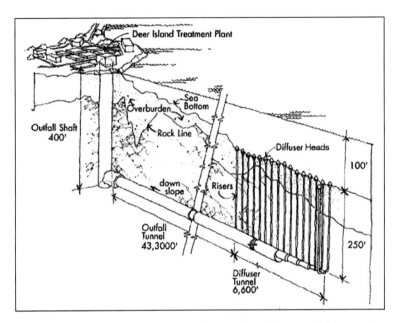

Illustration 45. Depiction of the nearly 9.5 mile effluent outfall tunnel for Boston's new waste water treatment system. The waste water goes down a 400 ft. vertical shaft and then flows 9.5 miles out to sea. In the diffuser tunnel the waste water enters the diffusers and is diffused into the Atlantic Ocean via the diffuser heads that are located on the sea floor. (*Source*: the WWW at http://mwra.state.ma.us/sewer/graphic/diffusers_linedrawing.gif, 2000.)

ordinary civil works project. But the same technique could just as easily be used in construction of a clandestine undersea facility or tunnel system. The method would entail sinking the shaft down through the sea and through the seabed, into the rock beneath the sea floor. Then equipment and men would be lowered into the shaft to bore out tunnels far beneath the sea floor. The technology and methods involved would be very similar to what was done in recent years just off the coast of Massachusetts (with the important exception that the shafts were a smaller diameter in the Massachusetts project, and men and equipment were not lowered into them). The main difference would be that clandestine projects are rarely, if ever, discussed in the

daily newspapers. And of course, the undersea tunnels in Massachusetts' coastal waters are full of wastewater and treated effluent; whereas, a clandestine manned undersea facility would be kept dry and free of seawater or wastewater. But although the final uses are greatly different in the two cases, the actual construction techniques for both would be substantially similar.

The Take-Home Message About Undersea Tunneling

The point I am endeavoring to make with the Seikan Tunnel, Ripple Rock, San Diego Ocean Outfall and Boston Harbor projects is very simple: tunneling under the sea is state of the art for the mining and tunneling industries. It has been done for a very long time now, and continues to the present day. The tunnel boring machines, oceangoing, underwater construction barges, trained deep sea divers, and a wide variety of other equipment and personnel necessary to carry out major construction and tunneling projects under the sea bottom exist. I reiterate that my objective here has not been to provide an exhaustive review of the relevant literature in the world's civil engineering and mining journals. Those who are interested can easily do that for themselves. Any good research library, such as at a large university, will provide reams of literature on the topic. My objective has been to simply cite four civil engineering projects, one from the 1950s, one from the 1970s and 1980s, and two from the 1990s, as proof that substantial tunnels and shafts, at considerable depth under large bodies of waters, can be, and have been, made. And in the case of the projects off the coasts of Massachusetts and California, tunnel boring machines were used to bore miles of tunnels through the rock and soil, hundreds of feet beneath the sea bottom.

Let me be clear that I am not attributing any clandestine purpose or motive whatever to any of the four

projects cited here, to any of the respective government agencies or to any of the private companies and corporations involved in the construction of the tunnels and shafts mentioned above.

Just because something is new, or not generally known, says nothing about its feasibility. This is the case with undersea excavation and undersea tunneling, even if most people are barely, or not at all, aware of what can, and does, take place beneath the sea.

U.S. Navy Underwater Construction Teams

Of course, if the U.S. Navy has secretly constructed manned facilities and rail tunnels deep beneath the sea floor it would need a cadre of trained personnel capable of heavy construction at great depth underwater. Is there evidence of a trained, underwater construction unit within the Navy? In fact, there is.

The Navy operates special Underwater Construction Teams (UCTs) out of Port Hueneme, California and Little Creek, Virginia. The UCTs are special Seabee units that carry out underwater construction projects around the globe. These UCTs deploy literally anywhere in the world "aboard ships and other seagoing platforms." Among the areas where UCTs have deployed are Africa, the Arctic ice cap, Diego Garcia, Iceland, Bermuda, Australia, the Persian Gulf area and other locations around the world. Each of the UCTs consists of three officers and 52 enlisted personnel. After a few years of experience in the UCTs qualified divers are eligible to complete the "Advanced Underwater Construction" course at Port Hueneme, California. One of the requirements to be a UCT member is to be "eligible for a secret security clearance."[138]

[138] U.S. Naval Facilities Engineering Command, "Wanted: Seabees for Underwater Construction Teams." No publication date; possibly 1993. No place of publication given; possibly Alexandria, Virginia.

In other words, there is a unit of specially trained personnel within the U.S. Navy that carries out underwater construction projects all over the world and whose members have "secret" security clearances. This is exactly the type of unit that would be necessary for constructing secret, manned undersea installations and/or tunnels many miles offshore—perhaps even in the middle of the ocean or beneath other bodies of water, large and small.

As an aside, during the Cold War between the United States and the Soviet Union, clandestine diving units operating from on board top secret American submarines, repeatedly conducted covert, communications cable tapping missions on the sea floor itself, in Russian coastal waters. The divers would never surface. The entire operations were carried out underwater, using submerged submarines as a base. The men would go out from the submarines and carry out their work on the sea floor, and then reenter the submarines.[139] If there are top secret bases beneath the sea floor the UCTs of the U.S. Naval Facilities Engineering Command may possibly have helped build them, perhaps even on clandestine submarine-based missions similar in secrecy and daring to the top secret undersea communications cable tapping operations in recent decades.

Naval Facilities Engineering Service Center

If there are secret, undersea manned installations then it is a safe bet that the U.S. Navy's *Naval Facilities Engineering Service Center* (NFESC) either constructs and maintains them, or knows who does. The NFESC's website

Bibliographic information from Victor, University of Maryland online library catalog at http://www.lib.umd.edu/UMCP/, 1998.
[139] Sherry Sontag and Christopher Drew, with Annette Lawrence Drew, *Blind Man's Bluff: The Untold Story of American Submarine Espionage* (New York: Public Affairs, 1998).

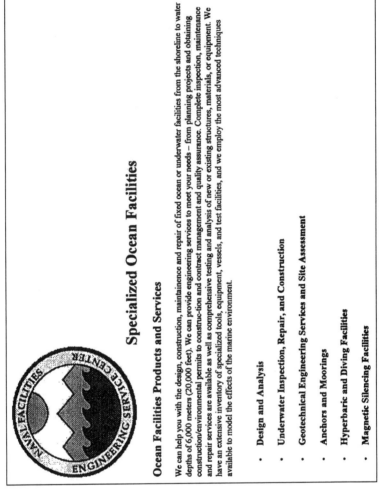

Specialized Ocean Facilities

Ocean Facilities Products and Services

We can help you with the design, construction, maintainence and repair of fixed ocean or underwater facilities from the shoreline to water depths of 6,000 meters (20,000 feet). We can provide engineering services to meet your needs – from planning projects and obtaining construction/environmental permits to construc-tion and contract management and quality assurance. Complete inspection, maintenance and repair services are available as well as comprehensive testing and analysis of new or existing structures, materials, or equipment. We have an extensive inventory of specialized tools, equipment, vessels, and test facilities, and we employ the most advanced techniques available to model the effects of the marine environment.

- **Design and Analysis**

- **Underwater Inspection, Repair, and Construction**

- **Geotechnical Engineering Services and Site Assessment**

- **Anchors and Moorings**

- **Hyperbaric and Diving Facilities**

- **Magnetic Silencing Facilities**

Illustration 46. The Naval Facilities Engineering Service Center (NFESC) "Specialized Ocean Facilities" page. The NFESC asserts that it can help with the construction, maintenance and repair of underwater facilities to water depths of 20,000 feet-- like something out of Jules Verne! (*Source*: Naval Facilities Engineering Service Center, on the WWW at http://www.nfesc. navy.mil/ocean/, 1997.)

OCEAN FACILITIES DEPARTMENT - ESC50E EAST COAST

- Department Head, ESC50
 CAPT (Sel) Karin Lynn
 (202) 433-5596

- Ocean Construction Division Director, ESC55
 CDR Steve Jennison
 (202) 433-5369

- Engineering and Production Branch, ESC551
 Mr. Tom O'Boyle
 (202) 433-5166

- Demand & Workload Management Branch, ESC552
 Mr. Dave Raecke
 (202) 433-5325

- Contracts Branch, ESC553
 LCDR Joe Hedges
 (202) 433-5333

- Naval Ocean Facilities Program Office, ESC56
 CAPT (Sel) Karin Lynn
 (202) 433-5596

OCEAN FACILITIES DEPARTMENT - ESC50W WEST COAST

- Department Head, ESC50W
 Mr. Norman Albertsen
 (805) 982-1159

- Seafloor Engineering Division Director, ESC51
 Mr. Mike Atturio
 (805) 982-1001

- Ocean Systems Division Director, ESC52
 Mr. Gary Lairmore
 (805) 982-1428

- Support Operations Division, ESC54
 LCDR Mike Blumenberg
 (805) 982-4435

http://archrock.nfesc.navy.mil/7434dept.htm

Illustration 47. Ocean Facilities Department, U.S. Naval Facilities Engineering Service Center. Notice that there are Ocean Construction and Seafloor Engineering Divisions. (*Source*: U.S. Navy, on the WWW at http://archrock. nfesc.navy.mil/7434dept.htm, 1997.)

173

says that it is "the Navy's center for specialized facilities engineering and technology."[140] The NFESC's website further advises that it constructs "Specialized Ocean Facilities." It states:

> We can help you with the design, construction, maintenance and repair of fixed ocean or underwater facilities from the shoreline to depths of 6,000 meters (20,000 feet)... We can provide engineering services to meet your needs... We have an extensive inventory of specialized tools, equipment, vessels, and test facilities...[141]

Notice that this agency is talking about the design, construction, maintenance and repair of underwater facilities as deep as 20,000 feet. (See Illustration 46.) Interestingly, the NFESC's Ocean Facilities Department includes both an Ocean Construction Division and a Seafloor Engineering Division.[142] (See Illustration 47.) This is exactly the sort of bureaucratic structure that one would expect to find if the U.S. Navy has built secret manned facilities beneath the seabed.

Is the U.S. Army Corps of Engineers Undersea?

If secret manned facilities under the seabed do exist I would certainly expect to find evidence here and there that points to the possibility of such facilities—evidence of just the sort that I am presenting here. During my research at the U.S. Army Corps of Engineers archives I discovered a *Program Activity and Funding* report, issued by the Corps of Engineers Construction Engineering Research Laboratory (CERL), as ENG FORM 0-4098 on 16 August

[140] WWW at http://www.nfesc.navy.mil/, 1997.
[141] WWW at http://www.nfesc.navy.mil/ocean/, 1997.
[142] WWW at http://www.archrock.nfesc.navy.mil/7434dept.htm, 1997.

1967. It contains several entries that are germane to the instant discussion. Line Item 1, Task Number -01 states:

Engineer Studies and Investigations

The objective of this task is to identify, analyze, and initiate research in areas of specialized military construction which are beyond the current state-of-the-art. This task will provide means for applying the current state-of-the-art and anticipated developments in the future. It will enable coordination of the construction research efforts of CERL and other DOD laboratories, government agencies, industry and educational institutions.[143]

The report has several other, interesting entries. Line Item 1, Task Number -02-005 says:

Sealing Deep Underground Structures

Explore economical epoxy coatings, concrete additives and other techniques for sealing walls from deep underground hydraulic pressure.[144]

[143] U.S. Army Corps of Engineers, Construction Engineering Research Laboratory, Program Activity and Funding, ENG FORM 0-4098, 16 August 1967. I found this report in one of several boxes of documents that the archivist's assistant brought to me. The material was uncatalogued. She told me the documents were about to be thrown in the trash for lack of staff, funding and space to file them. There were several additional boxes of documents that I expressed an interest in seeing. However, as soon as I found the document cited here the assistant refused to let me examine the documents in the additional boxes. She informed me that they were just full of worthless papers that were not worth my time. I assured her that, indeed, I would like to look at them. She adamantly refused to permit me to examine them.
[144] Ibid.

Of course, if the construction were taking place beneath the sea floor the Army would want to seal the base against the unwelcome intrusion of the deep sea.

The document contains more information that reveals the U.S. Army's secret role underground. Line Item 1, Task Number-05 says:

Power Plant Construction

The objective of this task is to develop new essential knowledge in the design, operation and maintenance of fixed and floating power plants which is peculiar to military requirements. Essential knowledge is required in hardened above and below surface plants, in precise, uninterrupted power and in system reliability and maintainability...[145]

The report then discusses Line Item 1, Task Number -05-001:

Hardened Underground Power Plants

Develop design criteria for hardened underground facilities to permit rapid concept selection and design of underground defense power systems.[146]

And Line Item 1, Task Number -05-004:

Advanced Heat-Sink Technology

Develop design criteria for heat dissipation and storage in various underground geological formations as applicable to hardened underground facilities.[147]

[145] Ibid.
[146] Ibid.
[147] Ibid.

176

Illustration 48. Proposed underground base near McConnelsville, Ohio. Two entrance tunnels are depicted. (*Source*: S.M. Genensky and R.L. Loofbourow, *Geological Covering Materials for Deep Underground Installations*, U.S. Air Force Project RAND Research Memorandum, RM-2617, 4 August 1960.)

177

Of course, this information dovetails very nicely with other U.S. Army information presented earlier in this book, concerning the dissipation of excess heat that underground installations generate. This is a problem whether the subterranean facility is under a New Mexico desert, burrowed way down in the hard rock below the Antarctic ice sheet, deep beneath a sea mount in the mid-Atlantic Ridge, or in the middle of the North American continent beneath the Midwestern corn fields. (See Illustration 48.) No matter where a deep underground base is located, it needs to get rid of excess heat.

Underwater Construction

Finally, the document gets around to talking about underwater construction. Line Item 1, Task Number - 07 says:

> **Underwater Construction**
> **(CERC Work- CERL Management)**
>
> The objective of this task is to explore and develop ocean engineering technology to meet Army Military Construction objectives. This task, involving original exploratory developments, studies and investigations and utilization of knowledge and capabilities developed by other agencies involved in oceanography, is to provide methodology essential to planning for and construction of unique military facilities in marine environments.[148]

This is an interesting choice of words: "construction of unique military facilities in marine environments." (See Illustration 49.) Remember the quotation earlier in this book from Lloyd A. Duscha, former Deputy Director of Engineering and Construction for the U.S. Army Corps of

[148] Ibid.

Engineers in Washington, D.C., who said in a public speech: *"There are other projects of similar* scope (to the NORAD base- author's parentheses)*, which I cannot identify, but which included multiple chambers up to 50 feet wide and 100 feet high using the same excavation procedures* (as) *for the NORAD facility."* As you may recall, Mr. Duscha then referred to the *"...critical and unusual nature of these projects..."*[149]

Might these large, secret, "critical and unusual" projects be the "unique military facilities in marine environments" that the U.S. Army Corps of Engineers 1967 report refers to? Might both be referring to huge, deeply buried, undersea bases? I think that is very possible.

The 1967 report continues with Line Item 1, Task Number -07-001:

Structural Systems for Underwater Construction

Develop concepts for constructing underwater storage and transportation facilities for ammunition and other hazardous materials.[150]

Remember, this is the U.S. Army talking about underwater construction, not the U.S. Navy. We may have to rethink preconceived notions about which agencies do what. In the black budget world of the *Secret Team* and the *Invisible Government* the tidy agency boundaries that we are accustomed to thinking about may not be very relevant at all.

[149] Lloyd A. Duscha, "Underground Facilities for Defense—Experience and Lessons," in *Tunneling and Underground Transport: Future Developments in Technology, Economics and Policy*, ed. F.P. Davidson (New York: Elsevier Science Publishing Company, Inc., 1987).

[150] U.S. Army Corps of Engineers, Construction Engineering Research Laboratory, Program Activity and Funding, ENG FORM 0-4098, 16 August 1967.

ENG FORM 0-409?
AUG 67

Line Item	Task Number	Project/Task/Work Unit Title	Activity Description
	-006	Accelerated Testing of Construction Materials	Develop accelerated testing techniques to enable rapid introduction of new materials and methods to design drawings and specifications.
	-07	Underwater Construction (CRC Work - CERL management)	The objective of this task is to explore and develop ocean engineering technology to meet Army Military Construction objectives. This task, involving original exploratory developments, studies and investigations and utilization of knowledge and capabilities developed by other agencies involved in oceanography, is to provide methodology essential to planning for and construction of unique military facilities in marine environments. Work units of this task are:
	-001	Structural Systems for Underwater Construction	Develop concepts for constructing underwater storage and transportation facilities for ammunition and other hazardous materials.
	-002	Coastal Exploration	Develop techniques for rapid evaluation of coastal and inland bottom conditions for construction purposes.

U. S. ARMY CORPS OF ENGINEERS
CONSTRUCTION ENGINEERING RESEARCH LABORATORY
Program Activity and Funding (M Dollars)

Illustration 49. Second-generation photocopy of 1967 U.S. Army Corps of Engineers' document that proposes "construction of unique military facilities in marine environments." Could this be a reference to the construction of manned bases beneath the ocean floor? (*Source*: U.S. Army Corps of Engineers, Construction Engineering Research Laboratory, Program Activity and Funding, ENG FORM 0-4098, 16 August 1967.)

180

Finally, there is Line Item 1, Task Number -07-002:

Coastal Exploration

> Develop techniques for rapid evaluation of coastal and inland bottom conditions for construction purposes.[151]

Here the Army alludes to evaluation of the continental shelf (the ocean bottom just off the coastline) and inland bottom areas for underwater construction. Presumably those inland bottom areas would include (but not be limited to) areas such as Puget Sound, in Washington state, the Chesapeake Bay, in the mid-Atlantic region, and the Great Lakes, in the upper Midwest. It is my educated guess that any or all of these areas could be locations for clandestine, underwater facilities, deep beneath their bottoms.

Is there any other evidence indicating the possible existence of secret, undersea bases, deep below the sea floor? In point of fact, there is.

[151] Ibid.

Chapter 6. Undersea Bases: The Rock-Site Concept

An U.S. Navy document from 1966 forthrightly discusses the construction of major military installations below the sea floor, in the middle of the ocean. Quoting from the title page:

ABSTRACT. Large undersea installations with a shirt-sleeve environment have existed under the continental shelves for many decades. The technology now exists, using off-the-shelf petroleum, mining, submarine, and nuclear equipment, to establish permanent manned installations within the sea floor that do not have any air umbilical or other connection with the land or water surface, yet maintain a normal one-atmosphere environment within...[152]

The text of the report elaborates what is meant by the Rock-Site concept:

...a Rock-Site installation consists of a room or series of rooms, excavated within the bedrock beneath the sea

[152]C. F. Austin, "Manned Undersea Structures- The Rock-Site Concept," NOTS TP 4162, U.S. Naval Ordnance Test Station, China Lake, California, October 1966.

floor, using the in situ bedrock as the construction material.[153]

Note what is being said here. The installation is carved out of the native bedrock beneath the floor of the ocean itself. And the installation is composed of one or more "rooms". Now, keep in mind that a "room" to a hard rock miner or underground construction engineer is not necessarily the same thing as a "room" in an ordinary house. Think back to the beginning of the book where I mentioned the dimensions of an underground power plant in the Himalayan Mountains of Bhutan that was hundreds of feet long and more than one hundred feet high; or reflect on Lloyd Duscha's remarks, where he refers to multiple underground chambers that are more than 50 feet wide and 100 feet high. In fact, my research suggests that it would be within the state of the art in the underground construction industry to make mammoth underground chambers, in the middle of the ocean, hundreds of feet below the sea floor that would have no visible connection to either the land, or to the surface of the ocean.

Because I realize this assertion may well be controversial for the uninitiated, I am going to quote at length from the U.S. Navy's Rock-Site report. (See Illustration 50.) As you read what follows, keep in mind that already in the 1960s the technology existed to construct facilities beneath the ocean floor that could accommodate full sized submarines, with locks that would permit their crews to enter and exit, well below the surface of the sea. Over the last 35 years the technology to carry out subterranean and submarine construction has only become more sophisticated and powerful. Truth may, indeed, be stranger than fiction. I am increasingly inclined

[153] Ibid.

NOTS TP 4162

MANNED UNDERSEA STRUCTURES – THE ROCK-SITE CONCEPT

by

C. F. Austin

3 1788 00040 4999

Research Department

ABSTRACT. Large undersea installations with a shirt-sleeve environment have existed under the continental shelves for many decades. The technology now exists, using off-the-shelf petroleum, mining, submarine, and nuclear equipment, to establish permanent manned installations within the sea floor that do not have any air umbilical or other connection with the land or water surface, yet maintain a normal one-atmosphere environment within. This presentation briefly reviews the past and present in-the-sea-floor mineral industry. The methods presently practical for direct access to and from permanent in-the-sea-floor installations are outlined, and the specific operations and types of tools indicated. Initial power requirements and cost estimates are included.

U. S. NAVAL ORDNANCE TEST STATION
China Lake, California October 1966
TECHNICAL

DEC 6 1966

Illustration 50. The *Rock-Site* plans. The Navy's startling proposal to bury huge, manned installations deep beneath the sea floor, hundreds of miles out to sea, in the middle of the ocean. (*Source*: C.F. Austin, "Manned Undersea Structures- The Rock-Site Concept," NOTS TP 4162, U.S. Naval Ordnance Test Station, China Lake, California, October 1966.)

to think that such facilities just may have been built, and just may be in secret use. What follows is a little lengthy, and a little technical, but is well worth the reading.

Land-based undersea installations are not only practical today but are not overly expensive. The depth of shaft needed for a land-based installation will depend on the depth needed to reach either a competent rock horizon beneath the sea floor or else a desired depth from a construction point of view. Assume an installation depth of 1,000 feet below the surface is desired. A probable depth of shaft is then 1,200 feet. Shafts can be excavated by drilling and blasting, but a more usable shaft with far less maintenance and damage to the rock around the shaft will result from boring, a technique just now coming into general industrial use [mechanical shaft boring is now a common practice in the mining and underground construction industries- *author's note*]. With a bored shaft in the range of 5 to 8 feet in diameter, the cost will be roughly 4 million dollars completed [in 1966 dollars- *author's note*], including the life support and service systems although some industrial firms will now estimate a cost of about 2 million dollars for this size of installation. Large diameter shaft drilling has been well discussed in the literature and extensive charts and graphs for detailed cost estimating are available. For long distance undersea tunneling, boring is especially attractive. Boring methods require only electric power, and yield no serious fumes or gases as would be the case for tunnels driven by conventional explosive methods. Boring machines are now essentially off-the-shelf equipment for rocks ranging from rather weak shales to strong hard sandstones and have been used with encouraging results in even stronger metamorphic rocks. With hydraulic or other automated handling of the ground-up waste rock, including ejection of the waste to the sea floor, tunnel boring in a rock strong enough to be fully self-supporting with a 15- 20-foot diameter bore

can proceed at rates up to 5 miles per year for a cost of 1 to 1.5 million dollars per mile [in 1966 dollars-*author's note*].... <u>With modern day shaft and tunnel boring techniques, access to the sea floor from land can be carried out at depths beneath the sea of several thousand feet (to at least 10,000 to 12,000 feet) and to distances offshore of tens to hundreds of miles.</u>[154]

Astonishing, isn't it? We need to adjust our ideas as to what is possible and what is not. Here is a U.S. Navy document from the 1960s that plainly describes the capabilities of the underground construction industry *at that time* as fully able to tunnel out hundreds of miles beneath the ocean, at depths as great as 2 miles below the sea floor! I have spent a great deal of time in recent years reading tunneling and underground excavation literature and I assure you that the technology, and the machinery, for underground excavation has only gotten more powerful, and more sophisticated, in the intervening years.

The Rock-Site report continues:

FROM THE SEA

Direct access into the sea-floor bedrock by means of a lock system for passing through the sea-floor-water interface is a practice now within the technological capability of this nation's industry.

.....................

The Rock-Site method of direct sea-floor access ... consists of four steps ...:

[154] Ibid.

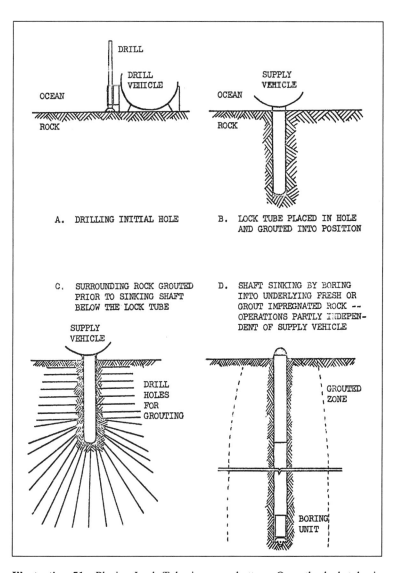

Illustration 51. Placing Lock Tube in ocean bottom. Once the lock tube is embedded in the sea floor, further excavation can proceed down and out from the lock tube, to construct a Rock-Site undersea base. (*Source*: Carl F. Austin, "In-the-Rock: An Approach to Undersea Mining," photocopied manuscript, 18 August 1965.)

1. Drill a 5- to 8-foot-diameter drill hole a distance of 50 feet into competent sea-floor bedrock.
2. Cement a lock tube into the borehole and then deballast the tube.
3. From inside of the tube, drill and grout as needed to consolidate the adjacent host rock with emphasis on consolidating the underlying rock.
4. Open the tube bottom and drill vertically downward into the bedrock until a suitable rock cover exists for the establishment of horizontal working and living space.

Although this method of entering the sea floor is new, there has been no new technology proposed in any of the four steps. The drilling of large diameter holes for mine shafts and ventilation winzes has been practiced for years in rocks ranging from incompetent to very strong and hard. By using only a short length of hole, no bit or cutter changes will be needed during the drilling program and no rods need be added in the event the drilling is to be done submerged. The latter is certainly feasible with lowered packages and appears feasible from existing submersible hulls as well. Present-day drilling platforms and barges can work at depths comparable to the depths attainable by older fleet boats (World War II-type submarines).

Since the desired hole into the sea floor is short, the drilling rate need not be high in order to result in a short drilling time, thus permitting considerable trade off between total drilling times, bit weights, and horsepower applied. Drilling from barges and platforms i(s) an established petroleum-drilling and coal-boring technique that is available for immediate operations in water up to a few hundred feet in depth. Drilling from large complex barges has been successfully demonstrated in 11,700 feet of water and is approaching operational

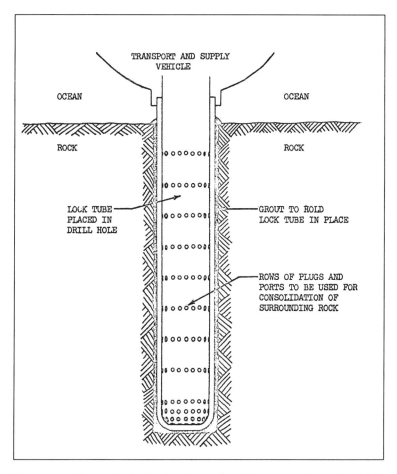

Illustration 52. Lock tube in place in sea floor. Transport and supply vehicle positioned on lock tube after tube has been grouted into an ocean bottom drill hole. Section view prior to consolidation grouting or deepening of the bore hole. (*Source*: Carl F. Austin, "In-the-Rock: An Approach to Undersea Mining," photocopied manuscript, 18 August 1965.)

reality in very deep waters such as the 14,000-foot depths contemplated by the MOHO project...

Rock-Site entry into the sea floor will require that the lock tube be set in some sort of rock that is at least competent enough to permit consolidation by

grouting or other cementing operations. The length of lock tube and the depth of bottom mud over the sea-floor bedrock that can be economically dealt with will depend obviously upon the wind-wave-time hazards of the site and on the importance of the anticipated undersea installation (that is, is the cost of a long penetration in mud prior to bedrock justifiable).

Any location on the sea floor that consists of consolidated sediments strong enough to stand as an open bore can be entered to yield one-atmosphere working sites. A surprising amount of the deep ocean appears to be accessible competent bedrock. Some oceanographers now estimate that as much as 20% of the deep ocean may be bare rock while within a few tens of feet of the sea-floor area some 40% of the sea-floor is expected to be competent rock. Even on the flatter continental shelves, there is considerable exposed bare rock that will permit Rock-Site-type lock-tube installations. For example, the continental shelf off the coast of Southern California appears to have some 10 to 15% of its area comprised of bare hard bedrock, with considerably more area being underlain by hard drillable sediments very close to the sea-floor surface.

The second step of the sea-floor entry method proposed is to cement a prefabricated lock tube into the borehole. This procedure is no different than the setting of casing in any well. Once the lock tube is in place, cement is pumped into the annulus between the tube and the host rock, and allowed to set. Following this, the lock tube is dewatered or deballasted and can then be entered for its full length. Getting the lock tube into the drill hole can be done in many ways, ranging from lowering the tube from a barge or platform, to swinging the tube into the hole after the bit is swung out (when boring from a submersible), or by having the tube follow the bit into the hole....

With the lock tube in the drill hole and cemented in place, continued access to the lock tube is the next

consideration.... Access to fully isolated continental shelf installations can be by means of submersible vehicles, by tubes to the surface, or by a combination of tubes and vehicles. ...

Two methods of access are especially attractive where fully submerged operations are not required. One is to use a telescoping system that is either an integral part of the lock tube or that can be mated to the top of the lock tube, and the second is to use a tube that can be pivoted about the lock seal, that is, raised for access or swung downward and sunk to one side for protection from rough weather.... Older obsolete fleet boats or nuclear submarines could also be fitted with a lock system that could mate with Rock-Site lock tubes, thus enabling under ice and moderately deep undersea operations that would be free of immediate surface-support requirements.[155]

Note what the report says here: it says that older submarines and nuclear submarines could be fitted with locks that would permit them to "mate" with the lock tubes of Rock-Site installations, thus permitting them to go to and from deep undersea bases and bases under ice—as, say in the Arctic and/or Antarctic regions. In other words, the technology for secret, deep undersea, manned bases in the middle of the ocean, or even under the massive ice shelves of the polar regions was available more than 30 years ago. (See Illustrations 51 and 52.) The report continues:

The third step in the lock-tube emplacement program is to grout the host rock surrounding the tube, thereby consolidating the host rock and providing both strength and a barrier to large water inflows. Grouting

[155] Ibid.

from inside of drill holes, shafts and tunnels has been practiced for years.

The final access step to the sea floor is to bore downward to some convenient depth within the sea floor below. This operation requires the insertion or assembly of a drill within the lock tube, unless the lock tube had followed the drill into the bore hole with the drill allowed to remain in the hole; an initial source of power to operate the drill; and sufficient life-support capability to maintain the drilling crew. Power can come from a submersible support boat or vehicle, from a support barge, or from a temporary bottom-sitting power plant. Life support can also come from a submersible support boat or from a tube raised to the surface. In the case of sea-floor entry based upon present-day platform and barge techniques, there are some obvious advantages to drilling much more than merely 50 feet into the sea floor prior to the setting of the lock tube, which can in itself be longer and provide more working room prior to manned entry into the hole already drilled below the lock tube. Cuttings disposal for this phase of the drilling operations can be by pumping overboard as a slurry or by dewatering and storage on board a submersible for dumping elsewhere.

.....The cost of access directly into the sea floor, including the lock tube and a raisable access tube is not believed to be greater than twice the cost of the comparable shaft on land, that is, a direct sea-floor access system will be in the 4 to 8 million dollar price range... [in 1966 dollars- *author's note*].[156]

Notice that the price of installing an entry shaft for a manned, undersea base, via a lock tube set in the ocean floor, is comparatively inexpensive. It costs millions of dollars, but that is relative peanuts in light of the size of the black budget. The black budget conservatively runs to tens

[156] Ibid.

of billions of dollars each year, meaning that there would easily be enough money to secretly construct multiple undersea bases. Finding the secret funding for such a project would be no problem at all. The report continues:

> Shaft sizes can range from a minimum for manned access of 24 inches in diameter to about 16 feet in diameter. A shaft size initially of 5 to 8 feet in diameter has been selected as permitting the installations of quite large equipment including a disassembled 5-Mwe reactor, an assembled 500-kilowatt-electrical- (kwe) reactor (which may be in several discrete packages), and a disassembled tunnel boring machine. [157]

In other words, huge pieces of machinery can be disassembled into their component parts, lowered piece by piece underwater, taken through the relatively small diameter lock tube, and then reassembled once inside the deep undersea Rock Site installation. In this way, huge tunnel boring machines, even nuclear reactors and electrical generating equipment, can be taken undersea, piece by piece, lowered through a narrow shaft drilled through the ocean floor, then bolted back together and put to work. (See Illustration 53.)

The report contains more fascinating information. It states:

> Merely putting a man into the sea floor inside of a lock tube has relatively little to recommend it except perhaps as a means of repairing and installing equipment that otherwise operates unattended. Manned sea-floor installation requires room for the performance of useful tasks, for supply storage, for crew and family accommodations, for recreation facilities, for power, for life-support equipment, and for pumping installations.

[157] Ibid.

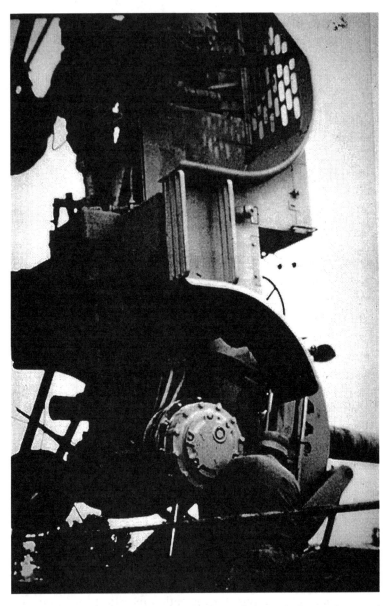

Illustration 53. Heavy equipment being lowered down shaft to underground workings. The wheels have been removed from the chassis to facilitate passage down a narrow shaft. The machinery will be lowered down in pieces and reassembled underground. (*Source*: Carl Austin.)

Power in existing undersea mines today is usually compressed air, electricity, or diesel engines. Electricity and compressed air are certainly the best for fully submerged undersea operations as they do not in themselves contribute to the life support or ventilation burden when used in confined spaces.

During the establishment of an initial horizontal working space, as during the initial access boring operations, power and life support gases must be provided from the outside. Power can be from shipboard, from a temporary platform, from an anchored barge, or from a bottom-sitting power package adjacent to the lock tube. Life-support gases will continue to be obtained from the supply and power boat if a submersible is used, or from a snorkel-type tube to the surface if the surface is free of obstructions and not too distant, or can be produced by means of electrolysis. As a matter of fact, the use of snorkel tubes to the surface allows the use of cheap, off-the-shelf internal combustion generating equipment in bottom-sitting power packages, or within the sea-floor installation itself. As a general rough estimate, power needs during access shaft boring and the initial working space establishment will be 500kwe. A large pumping load will require an upward adjustment of this figure, suggesting for such installations the use of two or more reactors as a source of power.

Given power, air, and crew access, the bottom of the lock tube is opened and boring continued on downward into the sea floor. Waste rock or cuttings are slurried and pumped overboard. Boring, being noncyclic and free of atmospheric pollution can continue on a round-the-clock basis even though the lock tube may be a little cramped and crowded initially...

Once an adequate depth of rock cover exists overhead, between the elevation of the desired horizontal openings and the sea floor, conventional drilling and light blasting or else chipping and boring combined can open out a lateral room with sufficient horizontal space

to permit the installation of pumps, life-support gas generation equipment (if desired), and the initial in situ power plant of one or more 500-kwe-size nuclear reactor plants. This equipment will now free the installation from surface or shipboard support save for spare parts, supplies and crew changes. The actual size of the initial power package needed within the sea floor will depend on the type of life-support system used, the intended rate of advance both vertically and laterally at the main working level, and on the anticipated leakage rate of pumping load. Nuclear power packages in increments of 500 kwe are of a size that will fit within the 5- to 8-foot lock-tube diameters anticipated. Furthermore, air-breathing installations can be used for life support in shallower installations through the use of snorkeling systems that consist of tubes to the surface, presuming the air-water interface to be accessible.

When the vertical access shaft reaches some desired depth, say 500 to 1,000 feet below the sea floor, the next step in establishing a useful Rock-Site installation is to construct a permanent working and living complex. This complex will have crew and family quarters, recreation facilities, community facilities, the main power plant, and life systems plus access tunnels to laboratory spaces, supply dumps, and to weapon and sonar sites, major-sized vehicle locks or to other installations, depending on the intended use of the Rock-Site installations.

The main operating level should be constructed by boring since this procedure yields a strong, smooth tunnel and places no burden on the ventilation system. Using boring methods, the main operating complex can be a series of parallel rooms, a long strung out linear array, or perhaps best, a spiral that is then cut by a series of "radial" access tunnels. Accurate spiral boring is within the guidance capability of present-day boring machines.

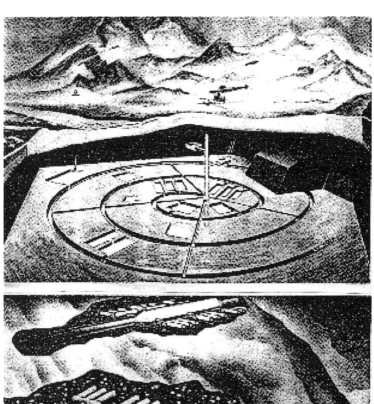

Illustrations 54 and 55. Two conceptual designs for undersea bases. **Top:** a radial design, with a tunnel complex that spirals outward from a central shaft. Look for the submarines near the lock tube entrance on the sea floor. **Bottom:** submarines enter a Rock-Site inside a sea mount through large air locks and dock inside. (*Source: Science Digest,* August 1967.)

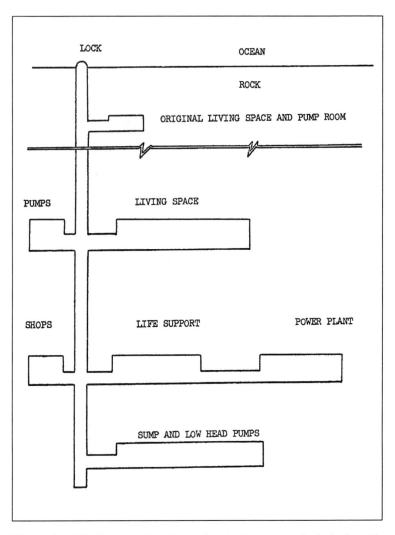

Illustration 56. Cross-section view of a basic, sub-sea bed, in-the-rock installation. Living and working areas would open off of the connecting, vertical shaft which could contain elevators, utility conduits, communications cables, stairs and the like. (*Source*: Carl F. Austin, *In-The-Rock: An Approach to Undersea Mining*, 18 August 1965.)

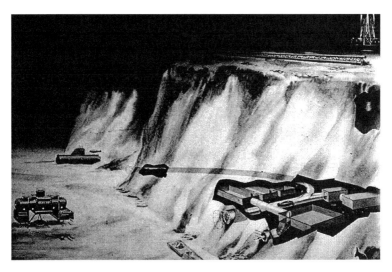

Illustration 57. Artist's depiction of Rock-Site. Here you can see an undersea installation inside a sea mount, with locks for small submarines to come and go. A drilling derrick is on top of the mount, at upper right. The long, tubular array on top of the mount could serve as a long-wave radio transmitter (ELF) or as a water desalinization and/or oxygen-generating mechanism. (*Source*: U.S. Navy.)

Excavation costs for the main portion of the installation will be no different than for ordinary mining operations in a comparable rock type. Life support and power costs will vary greatly, depending on the type of source employed. Air-breathing installations drawing air from the water surface will be cheap compared to the use of reactors and self-contained, life-support systems, of the type used today on submarines, but the latter can be used in deep water or in areas where the water-air interface is inaccessible.

Reactor costs, for the main operating power in large installations, vary strongly depending on whether you buy the first model or a later edition, and on whether or not the seller thinks a continuing market will exist. Thus a 5-Mwe installation, small enough to transport through an 8-foot lock tube (or a little less) will for the

first model cost between 15 and 20 million dollars installed. These reactors will be cooled by circulating sea water using convective or force circulation systems or by the use of sump water resulting from installation leakage, prior to its ejection to the sea floor.

.....Once beneath-the-sea-floor access is achieved, through either a shaft and tunnel from land or through a lock tube in the sea floor, all operations within the sea-floor bedrock itself are identical to present-day routine industrial activities save for the life-support gas generation and the hydraulic ejection of waste rock to the sea floor, though these two are demonstrable proven processes.An estimate of the cost of (a) fully isolated installation.... is 25 to 50 million dollars. This installation includes a 5-Mwe power supply, and a submersible vehicle lock for transport and deep-sea explorational purposes, and a glass observation dome.[158]

And finally, the Rock-Site report points out that:

The Rock-Site installations can be placed at great depth beneath the sea floor; their openings can be numerous and scattered; and access to the installation is absolutely controlled by the base occupants.[159]

Moreover:

Structures within the sea floor can easily be made large and comfortable enough to permit the quartering of crews and their families for extended periods of time, and can be made large enough to serve as supply and repair depots for large submersibles.[160]

[158] Ibid.
[159] Ibid.
[160] Ibid.

(See Illustrations 54 to 57 for examples of various possible Rock-Site configurations.) Where sea floor geology is concerned, the report has this to say:

Rock masses free of fractures and faults need not be present. Many undersea fault zones have been found to be free of leakage due to the sealing action of the crushed rock (gouge) filling the fracture zone. Indeed, some undersea coal mines for years have practiced long wall mining during which the sea floor is allowed to collapse, relying on intervening shale horizons to provide a continuing seal against the waters above. Rock masses with overlying or interlayered shales and muds are least apt to leak. Rocks of all types can be protected from leakage by coverings of bottom mud or ooze. Complex fault systems with their attendant gouge zones can protect large blocks of otherwise highly permeable rock from leakage although water statically stored in such a rock mass can be a temporary problem. Volcanics, especially blocky and high vesicular lavas can be protected from leakage by interflow beds of tuffaceous material or by alteration along joints and flow planes. Any type of rock strong enough to stand unsupported can be used for a Rock-Site installation as can many rocks requiring grouting consolidation and even extensive timbering or other artificial support.

Topographic considerations dictate the type of entry locks and the depth to which installations must be placed beneath the point of initial sea-floor entry. A horizontal submersible entry lock will require a steep, preferably vertical, canyon wall or slope. An observation tower may require a broad flat plain or a prominent hill such as a sea mount. The terrain should match the needs of the installation as much as possible.[161]

[161] Ibid.

Well. Let's recapitulate some of the salient points of the Navy's Rock-Site document. It discusses: 1) large, permanently manned installations carved into the solid rock far beneath the sea floor many miles out to sea, perhaps in the very middle of the ocean, or beneath a polar ice shelf; 2) observation domes on the sea floor; 3) locks permitting submarines to come and go; 4) working areas for weapons storage, and research; 5) pumping stations; 6) widely dispersed tunnels dug out by tunnel boring machines roaming for miles, hundreds of feet beneath the ocean bottom; 7) nuclear reactors to provide power; 8) crews and their families living far below the ocean floor for extended periods.

It all seems so bizarre, and yet the report explains at great length how all of the crucial technology to make Rock-Site installations exists (and has existed for at least 35 years now). The question is: have such facilities been made? Is there a secret Navy, within the Navy we all think that we know, that operates clandestine bases and tunnels deep below the world's oceans? Is there a resident underground, or undersea population, that exists apart from the society with which we topside landlubbers are familiar? I have to say that the more I research this topic the more I wonder about that. Mind you, I have no concrete proof of such a secretive subterranean, or submarine culture—but the question has started nagging at me.

Cities Under the Ocean Floor?

The Rock-Site concept was further elucidated in the popular press the year following the appearance of the Rock-Site document from the Navy. Three types of Rock-Sites were envisioned: a) Rock Site I, which would have tunnel connections to the shore; b) Rock Site II, which would be entirely offshore, with no connection to land; and

c) Rock Site III, deep underwater in mid-ocean, with locks that could accommodate submarines.[162]

Interestingly, in the 1960s the U.S. Navy was considering building a Rock Site I installation off of San Clemente Island, in coastal California waters. [163] This means that the Navy possibly might have tunneled out under the ocean floor from the island. I don't know if the Navy ever made a Rock-Site installation under, or near, San Clemente Island. Coincidentally, Richard Nixon's western base of operations during his presidency was at nearby San Clemente, California.

For a deep ocean base, a barge or drilling platform would bore a five to eight foot diameter hole fifty feet down into the bedrock on the ocean floor. Then the hole would be lined with a steel casing and sealed off from the ocean with an air lock. Mining crews would subsequently enter the sealed, lined hole and bore a couple of hundred feet farther down into the rock beneath the sea, where a large work area would be excavated. After the installation of pumps, a 5,000 kilowatt atomic power generator and air supply equipment, the miners would continue boring on down to 500 or 1,000 feet beneath the ocean bottom. There, living and working quarters would be excavated.

Many areas lend themselves to possible Rock-Site installations: coastal Alaska, the mid-Atlantic Ridge, and sea mounts between California and Hawaii, off of New England, and in the eastern Atlantic to the west of Gibraltar.[164] (See Illustration 58.) Of course, other locations all over the world are also suitable. Islands in the Mediterranean Sea would be likely candidates, in my view. Corsica, Sardinia, Sicily, Malta, Cyprus, the Balearic

[162] Bruce H. Frisch, "Cities Under the Ocean Floor," *Science Digest*, August 1967.
[163] Ibid.
[164] Ibid.

Islands, Crete and many of the Greek islands in the Aegean Sea would be ideal for Rock-Site installations. The Shetland, Orkney and Outer Hebrides Islands in the United Kingdom would be possibilities, as would other British controlled islands such as the Falkland and South Sandwich Islands and South Orkney, Coronation, Bouvet and South Georgia Islands in the far South Atlantic. I consider it very possible that one, or more, of these islands has a Rock-Site-like installation on it or very nearby. I have also heard some scuttlebutt about the islands of New Zealand.

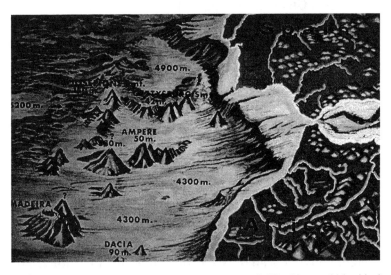

Illustration 58. Atlantic Ocean sea mounts west of Gibraltar would be ideal for Rock-Site installations. (*Source*: U.S. Navy.)

Undersea Navy Base off Newfoundland?

A 1969 report recommending the conversion of existing undersea mine space off the Atlantic coast of Canada to military use[165] leads to speculation that perhaps

[165] Carl F. Austin and William A. Wundrack, "The Potential for Converting an Existing Undersea Mine to a Rocksite-I Installation," unpublished paper, 1969.

the U.S. Navy just might have created undersea bases off the Atlantic Coast of Canada. The report specifically states that the abandoned Wabana mine at Bell Island, Newfoundland would be suitable for conversion to an undersea military facility. The cost of conversion to military use was estimated at $20 to $40 million (in 1969 dollars). This would include sinking a shaft down to the sub-sea space, and installing air locks and a sea floor observation dome. The report concludes that it is "feasible and attractive" to convert an abandoned undersea mine such as the Wabana mine to military use.[166]

As I have shown, there are presently and there have been submarine mines many other places around the world for years. Has the United States Navy made secret undersea bases in converted, submarine mines off the coast of Canada or elsewhere? Perhaps even in the Wabana mine? I honestly do not know; but if you have read this far, you will certainly understand that it is well within the realm of possibility.

Curiouser and Curiouser

And then there was this curious little note in the corporate mining literature about a submarine mining base:

> By 1972, the Bureau of Mines expects to have a manned submersible that can sit on the ocean floor at 1,000 foot depth and with boring equipment drill through another 1,000 feet of rock. An ocean-floor mine shaft, livable shelters at an underwater mine entrance, and underwater laboratories are also planned. The Bureau and two private firms are now cooperating in exploration off the California coast to develop practical recovery methods as well as materials, equipment, instruments, and

[166] Ibid.

underwater operating systems, but as yet, Bureau funds for this work are limited.[167]

These plans sound very much like the Navy's Rock-Site plans above, to bore deep down through the sea floor and create a living and working space beneath the sea bottom. Moreover, the planned location for the "ocean floor mine shaft" off the California coast brings to mind the Navy's exploration of San Clemente Island for a Rock-Site installation, also off the California Coast. Might such a project have been secretly carried out, perhaps with initial Bureau of Mines input, and then taken *black* by the Navy, to be developed by clandestine funding sources? I don't know, but I have heard many rumors about secret undersea bases and tunnels along the California coast. The technology to make sophisticated facilities beneath the ocean bottom certainly exists. The available literature suggests interest and awareness on the part of the Navy and industry. And there is plenty of black budget money in the military-industrial complex's multi-billion dollar slush funds. So it is within the realm of possibility that something like that has been done.

The Glomar Explorer
There is further the mysterious matter of the *Glomar Explorer*. Reference is repeatedly made in the sub-sea floor base literature to carrying out major construction operations on the sea floor itself. These operations would necessitate having work crews on the sea floor, boring large shafts, lining the shafts, excavating further from the interior of the shafts, installing air locks, and lowering component parts and sub-assemblies of huge equipment such as tunnel boring machines and nuclear power plants down from the

[167] "Depth Mines," *Industrial Bulletin of Arthur D. Little, Inc.*, No. 433 (September 1965).

surface of the sea and into the excavated spaces beneath the sea floor. In this regard, mention is also repeatedly made to appropriate surface support vessels, such as a drilling platform or barge.

The documents I have cited above all appeared in the period from 1965 to 1969. The last reference I cite, from 1965, explicitly says that by 1972, the Bureau of Mines expected to have the capability, via a submersible that would sit on the ocean floor in waters 1,000 feet deep, to bore a shaft 1,000 feet into the ocean bottom. Of course, this is precisely the capability needed to construct a sub-sea floor base.

So is there any evidence from that time period, approximately 30 years ago, to indicate that any agency of the United States government developed such a technology, i.e., a submersible that could sit on the ocean floor at great depth and carry out major industrial operations? If such evidence does exist, then it would be yet another circumstantial indication of possible covert, deep undersea manned bases.

In fact, a ship that almost precisely fits the bill was constructed in 1971 and went into operation in late 1972. The date corresponds exactly to the date of 1972 mentioned in the *Industrial Bulletin of Arthur D. Little, Inc.*, cited just above. As it happens, the Hughes *Glomar Explorer* was launched in an air of great mystery in November 1972.[168] The ship was built by one of Howard Hughes' companies for clandestine use by the Central Intelligence Agency (CIA).[169] Speculation about its mission abounded. I was in senior high school that year and I remember clearly the

[168] Fritzi Cohen, "The Unanswered Questions of the Glomar Explorer," *Covert Action Information Bulletin*, No. 9 (June 1980).

[169] Sherry Sontag and Christopher Drew, with Annette Lawrence Drew, *Blind Man's Bluff: The Untold Story of American Submarine Espionage* (New York: Public Affairs, 1998).

discussion about this mysterious ship in the newspapers and news magazines. As I recall, the rumor was that it was a deep sea mining ship, intended to retrieve manganese nodules from the sea floor. In the event, in July of 1974 it recovered part of a sunken Soviet submarine, off the coast of Hawaii.[170] Because so much of what the *Glomar Explorer* did was shrouded in extreme secrecy, only its crew is likely to know if it did anything else beyond dredge up parts of a Russian submarine from the ocean depths.

But that the *Glomar Explorer* was designed for industrial operations on the sea floor in mid-ocean is true beyond any doubt. Could it have also made clandestine openings to the sea floor for covert Rock-Site bases? I simply don't know. However, it is interesting that an essential part of the *Glomar Explorer's* equipment was a gigantic submersible barge (the so called HMB-1), larger than a football field, that operated beneath the *Glomar Explorer*. In a deposition given in a legal proceeding in Los Angeles, Curtis Crooke, then Vice-President of Global Marine and President of Global Marine Development Corporation, testified:

> The barge in this program has served two functions. It has been a construction and assembly facility for certain pieces of underwater equipment, which equipment eventually has to be wound up; which is both too heavy and too large to be put in over the deck or with a crane. Therefore, it is placed into the ship by submerging the HMB to the ocean floor, driving the HMB over the top of it, opening the well gates, lowering the docking lines

[170]Ibid, and also see sci.military.naval FAQ, Part G Submarines, Section G.12: Project Jennifer, *Glomar Explorer, HMB-1*, and the "Golf"-class SSB, on the WWW at http://www.hazegray.org/faq/smn7.htm#G12, 2001.

down into the HMB and retrieving that all back up into the center well of the HGE.[171]

Compare this testimony of Curtis Crooke in 1976, with the brief article (cited above) in *the Industrial Bulletin of Arthur D. Little, Inc.*, in 1965:

> By 1972, the Bureau of Mines expects to have a manned submersible that can sit on the ocean floor at 1,000 foot depth and with boring equipment drill through another 1,000 feet of rock. An ocean-floor mine shaft, livable shelters at an underwater mine entrance, and underwater laboratories are also planned.[172]

The exact fit in time, and a certain similarity in the language, certainly give pause to wonder if the *Hughes Glomar Explorer* might not have been an inter-agency, clandestine project of the United States government, that also interacted with the corporate sector, to carry out sensitive operations on (and perhaps under) the sea floor, that went beyond the retrieval of parts of a Soviet submarine. The testimony of Curtis Crooke clearly alludes to the assembly of extremely heavy, underwater equipment in the HMB that eventually has to be wound back up into the ship again. This equipment is retrieved by sending the barge down to the ocean floor and then winding the barge and the equipment together back up to the ship. This procedure would be consistent with retrieving parts of a sunken submarine. But it could just as easily describe the retrieval of one or more tunnel boring machines (TBMs), or any other large equipment, from the sea floor. TBMs can weigh as much as a few hundred tons, and stretch anywhere

[171] Fritzi Cohen.
[172] "Depth Mines," *Industrial Bulletin of Arthur D. Little, Inc.*, No. 433 (September 1965).

from 100 to 300 feet, or more, in length. Remember that the submersible barge was the size of a football field (football fields are 300 feet long) and intended for the "construction and assembly" of certain very heavy, underwater pieces of equipment.

There is speculation that the *Glomar Explorer's* Soviet submarine retrieval mission, secretive though it was, may have been itself a cover for another, undisclosed mission.[173] I am inclined to agree. From the beginning, the cover story was that the Glomar Explorer was a deep-sea mining vessel. Curtis Crooke explicitly discussed this when he was asked in court about the sea floor manganese nodule mining cover story put out by his company:

> Quite obviously when one is looking for a cover, if the government interest is behind you, immediately you pick up the idea of offshore mining because there is no expert on what an offshore mining rig looks like. I dare say I can take anybody and I can convince them either way, because there's no background; nothing established.[174]

A further element of the story is that the *Glomar Explorer's* gigantic, underwater claw lift was named "Clementine."[175] The well-known folk song of that title immediately comes to mind:

Clementine

In a cavern by a canyon excavating for a mine
Dwelt a miner, forty-niner, and his daughter Clementine

Oh my darling, oh my darling, oh my darling Clementine
You are lost and gone forever, dreadful sorry Clementine

[173] Fritzi Cohen.
[174] Ibid.
[175] Ibid.

She was light just like a fairy and her shoes were number nine
Herring boxes without topses sandals were for Clementine

Oh my darling...

Drove her ducklings to the water, every morning just at nine
Hit her foot against a splinter, fell into the foaming brine

Oh my darling...

Ruby lips above the water blowing bubbles soft and fine
But alas I was no swimmer so I lost my Clementine

Oh my darling, oh my darling, oh my darling Clementine
You are lost and gone forever, how I'll miss you Clementine[176]

The song prominently mentions a miner "excavating for a mine" in the first stanza, and then goes on to describe the tragic death by drowning of the miner's daughter. If there was an intentional allusion to this song on the part of those who operated the *Glomar Explorer*, referring in code to the purpose of the ship, it may well have had a dual mission: 1) on the one hand, of recovering a Soviet submarine, along with the drowned crew (analogous to the miner's drowned daughter, Clementine); and 2) on the other hand of excavating tunnels beneath the ocean floor (analogous to the mine mentioned in the first line of the song) for one or more mid-ocean Rock-Site installations, as described above. I cannot say that this is the case; however, if mid-ocean, sub-sea floor, manned installations have been covertly constructed, a ship such as the *Glomar Explorer* would be a perfect candidate for the job.

[176] "Judy and David's Online Songbook", at http://judyanddavid.com/Songbook/C.html, 2000.

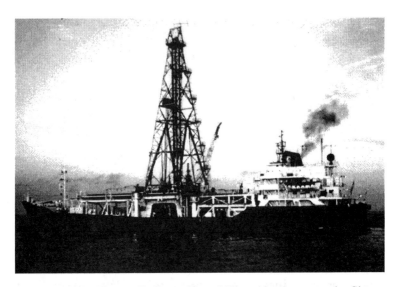

Illustration 59. *Glomar Challenger* deep drilling ship. For years, the Glomar Challenger roamed the world's seas drilling deep holes down into the bedrock beneath the bottom. A large drilling rig occupies the ship's midsection. At the base of the drilling rig, the boom of a crane juts up to the right. (*Source*: U.S. Geological Survey.)

Deep Sea Drilling Project

It may not be complete coincidence that the same company that was heavily involved with the *Glomar Explorer*'s activities, Global Marine, also operated a very interesting ocean bottom core-drilling program. From 1968 to 1983 Global Marine operated a worldwide *Deep Sea Drilling Project* from a ship named the *Glomar Challenger*. (See Illustration 59.) For 15 years the *Glomar Challenger* navigated the world's oceans and seas drilling deep into the sea floor, probing the sub-sea geology. Among the interesting projects that the Glomar Challenger completed was a series of 17 holes at 10 different sites along the mid-oceanic ridge between Africa and South America.[177] It is

[177] "Glomar Challenger, Drillship of the Deep Sea Drilling Project", on the WWW at http://www-odp.tamu.edu/glomar.html, 2000.

true that drilling into the rock beneath the world's seas and oceans has provided a wealth of basic scientific data for geologists to analyze. It is also true, however, that such pilot holes would provide basic geological information that would be indispensable to the possible excavation of clandestine facilities beneath the sea floor. Moreover, a ship with the *Glomar Challenger*'s deep sea drilling capabilities could potentially serve as a support vessel for building a mid-ocean, Rock-Site base. The temporal overlap of the two ships' activities gives pause to reflect.

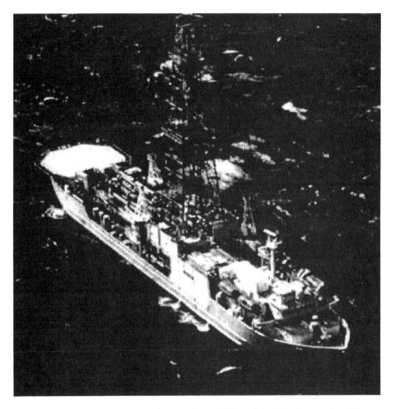

Illustration 60. *JOIDES Resolution* deep drilling ship. Similar to the *Glomar Challenger*, but more precise and able to drill deeper. Notice the helipad at the stern. (*Source*: U.S. Geological Survey.)

In the 1990s, the *Glomar Challenger*'s operations were superseded by a new ship, the *JOIDES Resolution* (JOIDES= Joint Oceanographic Institutions for Deep Earth Sampling). The *Joides Resolution* can position itself more precisely, and drill deeper than the *Glomar Challenger*.[178] (See Illustration 60.)

While very little can be said about the *Glomar Explorer* with certainty, this much *can* be said: the purpose and activities of the ship in the early 1970s were shrouded with enormous secrecy. It is interesting to note, as well, that the *Glomar Explorer* has recently been extensively refitted and is now working as a deepwater oil drilling ship in the Gulf of Mexico.[179] It kind of makes you wonder if there might not possibly be something more under the Gulf of Mexico than just natural gas and petroleum.

Further Official U.S. Navy Documentation
Well and good, you say, but is there any more documentation from the U.S. Navy, with regard to undersea bases? As it happens, there is. In 1972, the U.S. Navy published another report that discussed "undersea ports". The Report is entitled, "Subsurface Deployment of Naval Facilities."[180] The document cites five sorts of facilities which the future Navy might situate underground. The reasons for going underground range from the tactical to the practical -- many Navy bases face a real estate squeeze from the surrounding civilian communities and sea. They

[178] U.S. Geological Survey, on the WWW at http://pubs.usgs.gov/ publications/text/glomar.html, 2000.
[179] "State-of-the-Art Drill Ship Conversion", on the WWW at http://www.casgen.com/services/glomar_explorer.html, 2000.
[180] R. Hibbard, L. Pietrzak and S. Rubens, "Subsurface Deployment of Naval Facilities," NTIS federal document number AD-762 838, document also carries the number CR-2-318, Sponsored by U.S. Naval Facilities Engineering Command, December 1972.

are hemmed in on all sides. The logical solution is to build underground, since the surface possibilities for expansion are constrained. So the Navy planners envisioned placing the following sorts of facilities below the surface:

(1) Administration buildings
(2) Medical facilities
(3) Aircraft maintenance facilities
(4) Ammunition storage facilities
(5) Miscellaneous storage facilities[181]

Most interesting for the premise of this section of the book, however, is the following statement:

Underground facilities may someday play a greater role in Naval operations because of future developments such as:

• Improving effectiveness of satellite surveillance systems which could clearly require the subsurface deployment of any system this nation desired to keep a secret.

• The emergence, because of its continuing invulnerability, of the sea-based strategic missile system as our first line of deterrence against nuclear attack; and the importance of protecting its supportive basing and communication system, which may dictate the need for underground or undersea emplacement of key supporting elements of this force.

• The increasing vulnerability of surface fleets which could lead to the need for an all-

[181] Ibid.

submarine Navy, including cargo and troop transport vessels, supported by undersea ports.[182]

There you have it, the authors envision a submarine Navy, replete with "undersea ports" and "undersea emplacement of key supporting elements". This report appeared in 1972, the very year the secretive *Glomar Explorer* set sail.

If the Pentagon has built "undersea ports" or manned facilities beneath the sea floor along the North American continental shelf or well out to sea, perhaps even in other regions of the world, it has done so clandestinely. I would caution that the absence of public evidence for such projects says absolutely nothing at all about whether they exist or not. In a dual system such as exists in today's United States, with a purportedly open, *allegedly* constitutional government, side-by-side with a parallel, clandestine, "invisible" or "shadow" government that is hugely funded by the black budget, quite a lot is possible. Remember that tens of billions of dollars are available in the Pentagon's and intelligence agencies' so-called black budget each year. Considering the entire body of evidence, I think it is possible that highly secret, clandestine facilities beneath the ocean floor have been constructed by the American military-industrial complex.

[182] Ibid.

Chapter 7. Submarine UFOs and Closing Thoughts

Finally, I want to say something about the many submarine UFOs that have been seen over the years. Going back for decades, UFO witnesses have seen unexplained objects leaving and entering the world's oceans, seas, bays, rivers and lakes. In recent years, submarine UFO activity has been observed in the coastal waters off Puerto Rico and Iceland. And in late 1999 I spoke with the host of a radio show in the Midwestern region of the United States who told me of recent sightings of UFOs seen entering and leaving the waters of Lake Erie.

In light of observations such as these, I hypothesize that at least some of the observed submarine UFO activity could be related to clandestine sub-sea (or sub-lacustrine) bases made by terrestrial humans. This is a possibility that I believe researchers should consider when carrying out their investigations. Just because a phenomenon, or suite of related phenomena, are highly strange or bizarre, does not mean of itself that they must necessarily be alien, or extraterrestrial. Indeed, from published accounts in the popular aerospace press of recent years, it is clear that the American military-industrial complex has covertly developed a new generation of technology that has been carefully kept out of the public eye. In my view, it is

possible that some of the objects witnesses have seen coming and going from the ocean depths may be a new generation of technology secretly developed and funded, and deployed from secret facilities and installations, some of which may be highly clandestine facilities buried beneath the ocean floor, or beneath other bodies of water. I cannot prove this hypothesis, but the evidence I have uncovered logically leads me to raise the issue for further discussion and investigation.

For Us, or Against Us?

Of course, much of this secret planning and subterranean, and perhaps submarine, construction activity is carried out under the rubric of national defense. That sounds very patriotic and laudable. But when you examine the situation closely, maybe it is laudable and patriotic, and maybe it isn't. What do I mean by an equivocal statement like that?

Well, remember the *Secret Team*? The *Invisible Government*? The unconstitutional black budget? Given the extraordinary degree of secrecy surrounding the clandestine subterranean (and possible submarine) activities of the U.S. government (and other governments) and major corporations it is presently impossible to know whether what is taking place underground (and perhaps undersea, as well) is being done for us, or *to us*!

Why all the secrecy? Could it be that a massive agenda is being implemented *against* us, the great mass of the human race? If so, what might that agenda be? Electronic mind control?[183] Warehousing of the CIA's

[183] I discuss electronic mind control in my book, *Kundalini Tales*. The so-called intelligence agencies have been conducting mind control research and experimentation for decades. The CIA's MK-Ultra program of decades past is perhaps the best known, though assuredly not the only one, of these nefarious projects. See Richard Sauder,

industrial quantities of international narcotics shipments?[184] (Please read the footnote.) Demoniac military plans to incinerate the planet in a thermonuclear maelstrom that would cause even *Dr. Strangelove* to shudder? Biological and/or genetic engineering programs that are socially or politically unpalatable?[185] A vast, subterranean/submarine

Kundalini Tales (Kempton, Illinois: Adventures Unlimited Press, 1998.)

[184] Incredibly, many Americans remain blissfully, stupefyingly ignorant and unaware of the CIA's massive involvement in narcotics trafficking. The CIA has been heavily implicated in the ruthless, international narcotics trade for a half century or more, on a global scale. There are a whole slew of excellent books and articles available on this topic. For starters, try the following: Alexander Cockburn and Jeffrey St. Clair, *Whiteout: The CIA, Drugs and the Press* (New York: Verso Books, 1998); Peter Dale Scott, *Cocaine Politics: Drugs, Armies and the CIA in Central America* (Berkeley, California: University of California Press, 1998); Alfred W. McCoy, *The Politics of Heroin: CIA Complicity in the Global Drug Trade* (Brooklyn, NY: Lawrence Hill Books, 1991); and Jonathan Kwitny, *The Crimes of Patriots: A True Tale of Dope, Dirty Money and the CIA* (New York: W.W. Norton, 1987).

[185] I am reminded once again of the many rumors of alleged biological engineering experiments at the purported underground base near the small town of Dulce, New Mexico. According to the stories, extraterrestrial beings and covert United States military units are jointly engaged in clandestine, subterranean biological engineering projects involving cloning of humans and the creation of part human-part animal entities. While there is, so far, no unimpeachable proof of aliens underground, or of an underground base at Dulce, New Mexico, readers of this book and my previous work will understand that there certainly are secret underground facilities, including in New Mexico. It is also clear that biological engineering is a rapidly developing field. It now appears that human-animal hybrids are within the realm of possibility. Two years ago a firm in Massachusetts announced that it had created an embryo out of cow and human cells. (*Source*: On the WWW at http://www.washingtonpost.com/wpsrv/national/science/cloning /cloning.htm, 1998.) More recently, a company in Australia has been granted a patent to develop animals with human body parts. Embryos would contain cells from humans, mice, sheep, pigs, cattle, goats or

network of computers and a resident, paramilitary, self-selected technocratic "elite" that is hell bent on consolidating fascist global rule from their underground/undersea empire? None of the above? One of the above? Some of the above? All of the above and more? Or are we simply faced with mind-numbing, bureaucratic stupidity run amok, mechanically burrowing deep underground (or undersea) merely because it can be done, and sparing no expense, if only because the CIA's narcotics trafficking has generated so many black budget narco-dollars that ordinary commercial activity cannot possibly absorb them all?

I have delved much deeper into these issues than the average person and I honestly do not know all the answers. I admit to being perplexed. But the massive level of secrecy about what is happening underground (and perhaps undersea, as well) has absolutely raised the most serious warning flags in my mind.

Conclusion

In a better world, a book like this would not even be necessary. We would all be devoting ourselves to joyful pursuits. Instead, we live on a planet that is rife with war and massive lies. Treachery and great violence abound. That is one side of the world we live in.

But there is another side. A search for understanding also exists, side by side, with the systemic lies and destruction. This book, as with my other books,

fish. (*Source:* On the WWW at http://www.observer.co.uk/international/story/0,6903,403160,00.html, 2000.) So, perhaps there is an element of truth to some of the wilder stories circulating on the internet about clandestine, bizarre, genetic engineering projects being carried out in great secrecy in hidden, underground bases. I would not automatically dismiss the possibility out of hand.

represents one man's necessarily imperfect and limited attempt to get to the truth of at least one part of what is happening on this planet. My research demonstrates that clandestine underground facilities absolutely do exist, and that clandestine bases and tunnels under the sea floor quite possibly exist, as well.

However, these installations, and the activities that are carried out in them, are surrounded by an extremely high level of secrecy. Why? Are the things done in these secret facilities being done *for us,* or *to us*? If the former, then why haven't we been told? Of course, if it's the latter, then the reason for the extreme secrecy is transparent. Indeed, the fact that we have not been told argues for the latter and against the former.

The voice that spoke to me in 1992 explicitly described projects being carried out underground that would surprise most people if they knew about them. But most people don't know what happens underground (or perhaps under the sea floor), and what is out of sight, is out of mind. No doubt, that is the intention of the technocrats who run the clandestine political, espionage, scientific, engineering, military, and who-knows-what-other projects, that operate in such facilities.

I must say that the more I look into the question of clandestine underground (or secret undersea) bases, the more I am persuaded that those who build and operate them are up to no good. They are stealthy and deceptive. In many cases, we simply do not know what they are doing, or where, or why they are carrying out their clandestine programs. But we do absolutely know that highly secret underground facilities exist. The open literature paper trail also very strongly indicates the possibility of clandestine undersea bases and tunnels.

If you have information for me, you may contact me care of my publisher. If you desire anonymity, make that

abundantly clear when you write to me. Any information or documentation you may send to me becomes my property, to use or not, as I see fit. Address correspondence and documents to:

Richard Sauder, PhD
c/o Adventures Unlimited Press
P.O. Box 74
Kempton, Illinois 60946
USA

Appendix A

Note on the Source Data

In a work such as this I feel that it is important to say something about the data I have used. The data are of two general sorts: 1) anecdotal and 2) documentary. On occasion I cite information that has been relayed to me in conversation or by personal e-mail or snail mail. All of this information I regard as anecdotal. I sift such information carefully through my own investigative filters. My decision to include such information in this book depends both on whether I judge the source to be reliable and credible, and whether I judge the information itself to be credible, and within the realm of the possible. If I have misgivings or questions about either the source or the information, or both, I make that clear.

I also make extensive use of documented, factual information gleaned from a variety of sources: a) the Freedom of Information Act; b) official government documents; c) books and other reliable, popular literature from readily available, public sources; d) corporate, engineering and scientific newsletters, journals and conference proceedings; and e) corporate and official governmental web sites on the internet.

I have relied on a good deal of internet source material for data about corporate and government activities. To that end, I have made extensive references to a variety

of corporate and government web sites, and the information contained on them. Just like hard copy books, magazines and reports printed on paper, web sites also appear, flourish and may subsequently disappear after a time. When I have referred to a web site I reference its URL in the footnotes. In some cases, the URL may change over time, or the owner of the web site may remove the page entirely from the web. This is analogous to a book or a journal going out of print and dropping out of circulation. That is why I always include the date I viewed the page in the web site citation. In recent years, certain U.S. government agencies have removed some of the pages on their web sites from the internet, owing to fears of cyber attacks. It is always possible that this could happen to one or more of the pages I cite in this book. Unfortunately, I have no control over this. Therefore, when readers go to look for a web page in a future year, it may or may not be there; but the situation in that case is really not much different than in the case of an obscure hard copy government document for which only a handful of copies exist, and which can be obtained (if at all) only after considerable effort and the passage of an appreciable length of time. In both cases, the reader must rely on the author's word that the information does, or did, exist, even if it is not possible for the reader to actually put his/her hands on it. But then, that is *exactly* why you read a book like this! You simply cannot go down to your local lending library and obtain a great deal of the information that you will find here. Web pages come and go, government agencies may issue only five or ten copies of some obscure documents, certain journals may cease publication, and yet other information may be decades old and not readily accessible. In all of these cases, the average person would find it exceedingly difficult to derive information from these sources. But I am an experienced researcher with multiple academic degrees, and I ferret out

the data for you. You have but to read the book and ponder its contents. I have done the hard, tedious work and have assembled the most reliable data that I can, from the best and surest sources that I could find.

I want to say, too, that I have done my best to minimize speculation-- though I confess that a time or two I could not help but raise an idea that occurred to me as I worked with the material. To the extent that it is possible I have relied heavily on hard documentation to make my case. You will find lots of footnotes, citations and another lengthy appendix following this one. Please do read everything carefully, including the photograph captions-- it will greatly increase your understanding of the book.

Appendix B

Tunnels Built by United States Bureau of Reclamation in the Western States

The U.S. Bureau of Reclamation has built many tunnels in the western United States. The following pages provide a state-by-state listing of those tunnels, as found on the Bureau of Reclamation's own website on the WWW.

Tunnels in:
•Alaska
•Arizona
•California
•Colorado
•Colorado & New Mexico
•Idaho
•Montana
•Nebraska
•Nevada
•New Mexico
•North Dakota
•Oregon
•Utah
•Washington
•Wyoming

(*Source*: all information in this appendix from U.S. Bureau of Reclamation, on the WWW at http://www.usbr.gov/wcg/tunnels/tdata.html, 1997.)

Alaska

Eklutna
•Project: Eklutna 8/31/51
•27 miles NE of Anchorage, Alaska
•9.00 feet in diameter and 22,772 feet long
•Circular shape with ? feet of cover

Arizona

Agua Fría
•Project: Central Arizona
•12 miles N of Sun City, Arizona
•19.50 feet in diameter and 3,686 feet long
•Horseshoe shape with 450 feet of cover

Buckskin Mountains
•Project: Central Arizona
•20 miles NE of Parker, Arizona
•22.00 feet in diameter and 35,915 feet long
•Circular shape with 760 feet of cover

Burnt Mountain
•Project: Central Arizona
•10 miles NW of Tonopah, Arizona
•19.50 feet in diameter and 2,730 feet long
•Horseshoe shape with 600 feet of cover

Gila No. 1
•Project: Gila 2/27/36
•10 miles NE of Yuma, Arizona
•20.00 feet in diameter and 1,740 feet long
•Horseshoe shape with 138 feet of cover

Gila No. 2
•Project: Gila 2/27/36
•10 miles NE of Yuma, Arizona
•20.00 feet in diameter and 4,125 feet long
•Horseshoe shape with 255 feet of cover

Southern Pacific Railroad Underpass
•Project: Gila 12/6/49
•20 miles E of Yuma, Arizona
•15.33 feet in diameter and 224 feet long
•Non-standard shape with 45 feet of cover

Tucson Reach #3 Road Crossing
•Project: Central Arizona
•1 mile NW of Rillito, Arizona
•11.00 feet in diameter and 701 feet long
•Circular shape with 37 feet of cover

California

Camino
•Project: Central Valley 10/20/53
•11 miles E of Placerville, California
•7.00 feet in diameter and 2,289 feet long
•Horseshoe shape with 215 feet of cover

Camp Creek
•Project: Central Valley 10/16/52
•14 miles E of Placerville, California
•7.00 feet in diameter and 2,845 feet long
•Horseshoe shape with ? feet of cover

Clear Creek
•Project: Central Valley 12/20/56
•2 miles SW of Shasta, California
•17.50 feet in diameter and 56,668 feet long
•Circular shape with 2700 feet of cover

Clear Creek Sta. 457+10, Judge Francis Carr Powerplant By-Pass
•Project: Central Valley
•14 miles W of Redding, California
•6.00 feet in diameter and 263 feet long
•Excavated Horseshoe, 176 feet of cover

Contra Costa Canal No. 1
•Project: Central Valley 5/20/38
•4 miles SE of Antioch, California
•9.25 feet in diameter and 1,360 feet long
•Horseshoe shape with 108 feet of cover

Fire Hill
•Project: San Diego 12/1/45
•14 miles SSE of Escondida, California
•6.00 feet in diameter and 5,350 feet long
•Horseshoe shape with ? feet of cover

Lilac
•Project: San Diego 1/1/46
•14 miles N of Escondida, California
•6.00 feet in diameter and 500 feet long
•Horseshoe shape with ? feet of cover

Oat Hill
•Project: San Diego 1/1/46
•8 miles N of Escondida, California
•6.00 feet in diameter and 3,592 feet long
•Horseshoe shape with ? feet of cover

Pacheco No. 1
•Project: Central Valley
•17 miles E of Gilroy, California
•13.00 feet in diameter and 9,590 feet long
•Circular shape with 50 feet of cover

Pacheco Reach 2
•Project: Central Valley
•20 miles E of Gilroy, California
•9.50 feet in diameter and 27,984 feet long
•Circular shape with 1300 feet of cover

Poway
•Project: San Diego 12/1/45
•15 miles SSE of Escondida, California
•6.00 feet in diameter and 3,180 feet long
•Horseshoe shape with ? feet of cover

Rainbow
•Project: San Diego 1/1/46
•21 miles N of Escondida, California
•6.00 feet in diameter and 4,694 feet long
•Horseshoe shape with ? feet of cover

Red Mountain
•Project: San Diego 1/1/46
•10 miles N of Escondida, California
•6.00 feet in diameter and 3,053 feet long
•Horseshoe shape with ? feet of cover

San Vicente
•Project: San Diego 12/1/45
•16 miles SSE of Escondida, California
•6.00 feet in diameter and 4,694 feet long
•Horseshoe shape with ? feet of cover

Santa Clara
•Project: Central Valley
•15 miles SE of Gilroy, California
•9.67 feet in diameter and 5,095 feet long
•Circular shape with 490 feet of cover

Sheffield
•Project: Cachuma 8/30/51
•3 miles N of Santa Barbara, California
•6.00 feet in diameter and 6,027 feet long
•Horseshoe shape with 250 feet of cover

Spring Creek Power Conduit No. 1
•Project: Central Valley
•1 mile W of Shasta, California
•18.50 feet in diameter and 8,257 feet long
•Circular shape with ? feet of cover

Spring Creek Power Conduit No. 2
•Project: Central Valley
•1 mile W of Shasta, California
•18.50 feet in diameter and 4,450 feet long
•Circular shape with ? feet of cover

Spring Creek Power Plant, Tailrace
•Project: Central Valley
•1 mile W of Shasta, California
•21.00 feet in diameter and 567 feet long
•Horseshoe shape with ? feet of cover

Tecolote
•Project: Cachuma 12/29/49
•4 miles NW of Goleta, California
•7.00 feet in diameter and 33,557 feet long
•1,400 feet Horseshoe, 2000 feet of cover

Tule Lake
•Project: Klamath 9/27/40
•6 miles SW of Tule Lake, California
•5.75 feet in diameter and 6,600 feet long
•Horseshoe shape with ? feet of cover

Colorado

Alva B. Adams
•Project: Colorado-Big Thompson 6/20/40
•4 miles SW of Estes Park, Colorado
•9.75 feet in diameter and 68,810 feet long
•Circular shape with 3720 feet of cover

Bald Mountain
•Project: Colorado-Big Thompson 11/16/50
•11 miles SW of Loveland, Colorado
•10.50 feet in diameter and 6,750 feet long
•Circular shape with 100 feet of cover

Blanco
•Project: San Juan-Chama
•18 miles SE of Pagosa Springs, Colorado
•8.58 feet in diameter and 45,636 feet long
•Circular shape with 2000 feet of cover

Carter
•Project: Fryingpan-Arkansas
•19 miles N of Aspen, Colorado
•9.83 feet in diameter and 2,887 feet long
•Modified Horseshoe shape with 190 feet of cover

Carter Lake Pressure
•Project: Colorado-Big Thompson 6/27/50
•9 miles W of Loveland, Colorado
•8.00 feet in diameter and 5,792 feet long
•Circular shape with 550 feet of cover

Chapman
•Project: Fryingpan-Arkansas
•16 miles W of Leadville, Colorado
•7.00 feet in diameter and 14,597 feet long
•Horseshoe shape with 2100 feet of cover

Charles H. Boustead (Divide)
•Project: Fryingpan-Arkansas
•10 miles W of Leadville, Colorado
•10.50 feet in diameter and 28,511 feet long
•Horseshoe shape with 2100 feet of cover

Cunningham
•Project: Fryingpan-Arkansas
•30 miles E of Basalt,
•10.50 feet in diameter and 15,082 feet long
•Modified Horseshoe with 1960 feet of cover

Dolores
•Project: Dolores
•8 miles SW of Cortez, Colorado
•9.25 feet in diameter and 6,732 feet long
•Circular shape with 210 feet of cover

Dry Ridge
•Project: Colorado-Big Thompson 6/21/51
•8 miles WSW of Loveland, Colorado
•10.75 feet in diameter and 608 feet long
•Horseshoe shape with 118 feet of cover

Grand Valley No. 1
•Project: Grand Valley 11/1/12
•4 miles NNW of Palisade, Colorado
•17.50 feet in diameter and 3,723 feet long
•Horseshoe shape with ? feet of cover

Grand Valley No. 2
•Project: Grand Valley 3/1/13
•3 miles NNW of Palisade, Colorado
•16.00 feet in diameter and 1,655 feet long
•1,195 feet Horseshoe, ? feet of cover

Grand Valley No. 3
•Project: Grand Valley 12/1/13
•2 miles NNW of Palisade, Colorado
•11.83 feet in diameter and 7,293 feet long
•Horseshoe shape with ? feet of cover

Gunnison
•Project: Uncompahgre Valley 9/2/05
•10 miles NE of Ceder Creek, Colorado
•12.70 feet in diameter and 30,582 feet long
•Rectangular shape with 2135 feet of cover

Horsetooth Feeder No. 1
•Project: Colorado-Big Thompson 8/19/49
•8 miles W of Loveland, Colorado
•8.25 feet in diameter and 5,123 feet long
•Horseshoe shape with ? feet of cover

Horsetooth Feeder No. 2
•Project: Colorado-Big Thompson 6/11/47
•8 miles NW of Loveland, Colorado
•10.50 feet in diameter and 2,878 feet long
•Horseshoe shape with ? feet of cover

Horsetooth Feeder No. 3
•Project: Colorado-Big Thompson 6/11/47
•8 miles NW of Loveland, Colorado
•10.50 feet in diameter and 1,815 feet long
•Horseshoe shape with ? feet of cover

Horsetooth Feeder No. 4
•Project: Colorado-Big Thompson 6/11/47
•9 miles NW of Loveland, Colorado
•10.50 feet in diameter and 1,355 feet long
•Horseshoe shape with ? feet of cover

Horsetooth Feeder No. 5
•Project: Colorado-Big Thompson 6/11/47
•9 miles NW of Loveland, Colorado
•10.50 feet in diameter and 9,363 feet long
•Horseshoe shape with ? feet of cover

Hunter
•Project: Fryingpan-Arkansas
•10 miles S of Thomasville, Colorado
•8.50 feet in diameter and 24,049 feet long
•Horseshoe shape with 2000 feet of cover

Hunter Completion
•Project: Fryingpan-Arkansas
•6 miles E of Aspen, Colorado
•7.33 feet in diameter and 15,951 feet long
•Horseshoe shape with 560 feet of cover

Lyons
•Project: Colorado-Big Thompson 3/11/52
•1 mile E of Lyons, Colorado
•8.50 feet in diameter and 1,200 feet long
•Horseshoe shape with 140 feet of cover

Mormon
•Project: Fryingpan-Arkansas
•19 miles N of Aspen, Colorado
•9.83 feet in diameter and 7,450 feet long
•Modified Horseshoe shape with 1470 feet of cover

Nast
•Project: Fryingpan-Arkansas
•34 miles E of Basalt, Colorado
•9.75 feet in diameter and 15,653 feet long
•Circular shape with 1200 feet of cover

North Poudre Supply No. 1
•Project: Colorado-Big Thompson 3/28/51
•12 miles NW of Fort Collins, Colorado
•8.00 feet in diameter and 4,570 feet long
•Horseshoe shape with ? feet of cover

North Poudre Supply No. 2
•Project: Colorado-Big Thompson 3/28/51
•11 miles NW of Fort Collins, Colorado
•8.00 feet in diameter and 4,670 feet long
•Horseshoe shape with ? feet of cover

North Poudre Supply No. 3
•Project: Colorado-Big Thompson 3/28/51
•9 miles NW of Fort Collins, Colorado
•8.00 feet in diameter and 1,257 feet long
•Horseshoe shape with ? feet of cover

North Poudre Supply No. 4
•Project: Colorado-Big Thompson 3/28/51
•10 miles NW of Fort Collins, Colorado
•8.00 feet in diameter and 3,500 feet long
•Horseshoe shape with ? feet of cover

Olympus
•Project: Colorado-Big Thompson 8/2/49
•3 miles E of Estes Park, Colorado
•9.75 feet in diameter and 9,537 feet long
•Horseshoe shape with ? feet of cover

Oso
•Project: San Juan-Chama
•4 miles NE of Chromo, Colorado
•8.58 feet in diameter and 26,660 feet long
•Circular shape with 760 feet of cover

Pole Hill
•Project: Colorado-Big Thompson 8/2/49
•10 miles E of Estes Park, Colorado
•9.75 feet in diameter and 28,567 feet long
•Horseshoe shape with ? feet of cover

Prospect Mountain
•Project: Colorado-Big Thompson 2/26/46
•1 mile S of Estes Park, Colorado
•12.50 feet in diameter and 5,665 feet long
•Circular shape with 850 feet of cover

Rabbit Mountain
•Project: Colorado-Big Thompson 3/11/52
•4 miles NE of Lyons, Colorado
•8.50 feet in diameter and 3,145 feet long
•Horseshoe shape with 250 feet of cover

Rams Horn
•Project: Colorado-Big Thompson
•4 miles SW of Estes Park, Colorado
•10.00 feet in diameter and 6,924 feet long
•Horseshoe shape with ? feet of cover

Rattlesnake
•Project: Colorado-Big Thompson 8/24/50
•14 miles E of Estes Park, Colorado
•9.75 feet in diameter and 8,757 feet long
•Horseshoe shape with 540 feet of cover

Selig No. 1
•Project: Uncompahgre Valley 4/17/13
•4 miles E of Olathe, Colorado
•6.83 feet in diameter and 168 feet long
•Rectangular shape with 48 feet of cover

Selig No. 2
•Project: Uncompahgre Valley 4/17/13
•4 miles E of Olathe, Colorado
•6.83 feet in diameter and 360 feet long
•Rectangular shape with 70 feet of cover

Selig No. 3
•Project: Uncompahgre Valley 4/17/13
•5 miles NE of Olathe, Colorado
•6.83 feet in diameter and 113 feet long
•Rectangular shape with 30 feet of cover

Selig No. 4
•Project: Uncompahgre Valley 4/17/13
•5 miles NE of Olathe, Colorado
•6.83 feet in diameter and 309 feet long
•Rectangular shape with 42 feet of cover

South Canal No. 1 (UVP)
•Project: Uncompahgre Valley 8/28/05
•5 miles SE of Montrose, Colorado
•10.50 feet in diameter and 482 feet long
•Rectangular shape with 115 feet of cover

South Canal No. 2 (UVP)
•Project: Uncompahgre Valley 8/28/05
•5 miles SE of Montrose, Colorado
•10.46 feet in diameter and 395 feet long
•Rectangular shape with 132 feet of cover

South Canal No. 3 (UVP)
•Project: Uncompahgre Valley 8/28/05
•5 miles SE of Montrose, Colorado
•10.46 feet in diameter and 1,000 feet long
•Rectangular shape with 188 feet of cover

South Canal No. 4 (UVP)
•Project: Uncompahgre Valley 8/28/05
•7 miles SE of Montrose, Colorado
•10.50 feet in diameter and feet long
•Rectangular shape with ? feet of cover

South Canal No. 5 (UVP)
•Project: Uncompahgre Valley 8/28/05
•7 miles SE of Montrose, Colorado
•10.50 feet in diameter and feet long
•Rectangular shape with ? feet of cover

South Fork
•Project: Fryingpan-Arkansas
•13 miles W of Leadville, Colorado
•8.00 feet in diameter and 16,244 feet long
•Horseshoe shape with 2100 feet of cover

Southside
•Project: Collbran
•7 miles ESE of Collbran, Colorado
•6.50 feet in diameter and 2,388 feet long
•Horseshoe shape with ? feet of cover

West Canal No. 1 (UVP)
•Project: Uncompahgre Valley 1/23/12
•7 miles SSE of Montrose, Colorado
•6.83 feet in diameter and 1,800 feet long
•Rectangular shape with ? feet of cover

West Canal No. 2 (UVP)
•Project: Uncompahgre Valley 1/23/12
•5 miles SW of Montrose, Colorado
•? feet in diameter and ? feet long
•? shape with ? feet of cover

Colorado & New Mexico

Azotea
•Project: San Juan-Chama
•6 miles SW of Chama, Colorado & New Mexico
•10.92 feet in diameter and 67,010 feet long
•Circular shape with 1600 feet of cover

Idaho

Black Canyon Canal No. 1
•Project: Boise 12/2/35
•5 miles NE of Emmett, Idaho
•14.00 feet in diameter and 825 feet long
•Horseshoe shape with ? feet of cover

Black Canyon Canal No. 2
•Project: Boise 12/2/35
•3 miles S of Emmett, Idaho
•14.00 feet in diameter and 475 feet long
•Horseshoe shape with 100 feet of cover

Black Canyon Canal No. 2A
•Project: Boise 6/13/38
•3 miles S of Emmett, Idaho
•14.00 feet in diameter and 422 feet long
•Horseshoe shape with 71 feet of cover

Black Canyon Canal No. 3
•Project: Boise 7/27/36
•4 miles SW of Emmett, Idaho
•14.00 feet in diameter and 1,375 feet long
•Horseshoe shape with 236 feet of cover

Black Canyon Canal No. 4
•Project: Boise 7/27/36
•4 miles SW of Emmett, Idaho
•14.00 feet in diameter and 1,270 feet long
•Horseshoe shape with 160 feet of cover

Black Canyon Canal No. 5
•Project: Boise 7/27/36
•5 miles SW of Emmett, Idaho
•14.00 feet in diameter and 640 feet long
•Horseshoe shape with 105 feet of cover

Black Canyon Canal No. 6
•Project: Boise 7/27/36
•5 miles SW of Emmett, Idaho
•14.00 feet in diameter and 870 feet long
•Horseshoe shape with 253 feet of cover

Black Canyon Canal No. 7
•Project: Boise 12/2/35
•6 miles SW of Emmett, Idaho
•14.00 feet in diameter and 1,630 feet long
•Horseshoe shape with ? feet of cover

Black Canyon Canal No. 8
•Project: Boise 12/2/35
•13 miles WSW of Emmett, Idaho
•8.50 feet in diameter and 3,170 feet long
•Horseshoe shape with 65 feet of cover

Station Creek
•Project: Preston Bench
•7 miles NE of Preston, Idaho
•6.50 feet in diameter and 1,125 feet long
•Horseshoe shape with ? feet of cover

Montana

Helena Valley
•Project: Pick-Sloan Missouri Basin 11/27/56
•12 miles E of Helena, Montana
•7.00 feet in diameter and 13,985 feet long
•Horseshoe shape with 750 feet of cover

Huntley No. 1
•Project: Huntley 1/15/06
•1 mile SW of Huntley, Montana
•9.16 feet in diameter and 716 feet long
•Rectangular shape with ? feet of cover

Huntley No. 2
•Project: Huntley 1/15/06
•1 mile SW of Huntley, Montana
•9.20 feet in diameter and 1,548 feet long
•Rectangular shape with ? feet of cover

Huntley No. 3
•Project: Huntley 1/15/06
•1 mile SW of Huntley, Montana
•9.16 feet in diameter and 390 feet long
•Rectangular shape with ? feet of cover

Pishkun Reservoir Supply No. 1
•Project: Sun River 1/1/13
•17 miles SSW of Saypo, Montana
•11.50 feet in diameter and 621 feet long
•Horseshoe shape with ? feet of cover

Pishkun Reservoir Supply No. 2
•Project: Sun River 4/30/13
•12 miles S of Saypo, Montana
•12.00 feet in diameter and 1,003 feet long
•Horseshoe shape with 53 feet of cover

Pishkun Reservoir Supply No. 3
•Project: Sun River 4/30/13
•12 miles S of Saypo, Montana
•12.00 feet in diameter and 2,280 feet long
•Horseshoe shape with 110 feet of cover

Toston
•Project: Pick-Sloan Missouri Basin 8/5/52
•3 miles S of Toston, Montana
•6.50 feet in diameter and 2,044 feet long
•Horseshoe shape with ? feet of cover

Nebraska

Fort Laramie No. 3
•Project: North Plate 4/16/23
•7 miles WSW of Scottsbluff, Nebraska
•10.25 feet in diameter and 6,501 feet long
•Horseshoe shape with 230 feet of cover

Sherman Feeder
•Project: Pick-Sloan Missouri Basin
•6 miles N of Loup City, Nebraska
•11.50 feet in diameter and 2,053 feet long
•Circular shape with 150 feet of cover

Nevada

River Mountains
•Project: Southern Nevada Water
•5 miles NE of Henderson, Nevada
•10.10 feet in diameter and 19,970 feet long
•Circular shape with 650 feet of cover

Southern Nevada P P #1 Intake
•Project: Southern Nevada Water 6/18/68
•10 miles ENE of Boulder City, Nevada
•13.00 feet in diameter and 1,321 feet long
•Horseshoe shape with 516 feet of cover

Truckee
•Project: Truckee 7/15/03
•10 miles S of Wadsworth, Nevada
•12.33 feet in diameter and feet long
•Rectangular shape with ? feet of cover

New Mexico

Earth Canal No. 1
•Project: Tucumcari 11/16/39
•1 mile E of Conchas City, New Mexico
•11.60 feet in diameter and 2,500 feet long
•Horseshoe shape with ? feet of cover

Earth Canal No. 2
•Project: Tucumcari 11/16/39
•8 miles SE of Conchas City, New Mexico
•11.50 feet in diameter and 7,930 feet long
•Horseshoe shape with ? feet of cover

Earth Canal No. 3
• Project: Tucumcari 11/16/39
•11 miles SE of Conchas City, New Mexico
•11.50 feet in diameter and 9,650 feet long
•Horseshoe shape with ? feet of cover

Earth Canal No. 4
•Project: Tucumcari 10/6/42
•13 miles NW of Tucumcari, New Mexico
•11.50 feet in diameter and 7,087 feet long
•Horseshoe shape with 378 feet of cover

Earth Canal No. 5
•Project: Tucumcari 11/17/44
•1 mile S of Tucumcari, New Mexico
•11.50 feet in diameter and 3,053 feet long
•Horseshoe shape with 27 feet of cover

Navajo Dam Rt. Abut Drainage
•Project: Colorado River Storage 9/26/86
•22 miles E of Aztec, New Mexico
•9.00 feet in diameter and 1,175 feet long
•Horseshoe shape with 330 feet of cover

Navajo No. 1
•Project: Navajo Indian Irrigation
•22 miles E of Bloomfield, New Mexico
•18.00 feet in diameter and 10,078 feet long
•Circular shape with 320 feet of cover

Navajo No. 2
•Project: Navajo Indian Irrigation
•21 miles W of Aztec, New Mexico
•17.50 feet in diameter and 25,800 feet long
•Horseshoe shape with 780 feet of cover

Navajo No. 3
•Project: Navajo Indian Irrigation
•12 miles SE of Bloomfield, New Mexico
•18.00 feet in diameter and 15,264 feet long
•Circular shape with 1100 feet of cover

Navajo No. 3A
•Project: Navajo Indian Irrigation
•10 miles SE of Bloomfield, New Mexico
•18.00 feet in diameter and 3,312 feet long
•Circular shape with 250 feet of cover

Navajo No. 4
•Project: Navajo Indian Irrigation
•18 miles SE of Farmington, New Mexico
•17.50 feet in diameter and 4,999 feet long
•Horseshoe shape with 230 feet of cover

Navajo No. 5
•Project: Navajo Indian Irrigation
•8 miles S of Farmington, New Mexico
•10.50 feet in diameter and 7,437 feet long
•Circular shape with 160 feet of cover

Navajo Route 44 Crossing
•Project: Navajo Indian Irrigation
•6 miles SW of Bloomfield, New Mexico
•18.00 feet in diameter and 519 feet long
•Horseshoe shape with 102 feet of cover

North Dakota

McCluskey
•Project: Pick-Sloan Missouri Basin
•2 miles W of McClusky, North Dakota
•15.00 feet in diameter and 416 feet long
•Circular shape with 125 feet of cover

Oregon

Approach
•Project: Owyhee 12/23/31
•5 miles WSW of Adrian, Oregon
•12.25 feet in diameter and 440 feet long
•Horseshoe shape with 83 feet of cover

Cascade Divide
•Project: Rogue River Basin
•22 miles SE of Medford, Oregon
•6.00 feet in diameter and 2,100 feet long
•Circular shape with ? feet of cover

Deadwood
•Project: Rogue River Basin 7/2/56
•24 miles E of Medford, Oregon
•6.00 feet in diameter and 3,553 feet long
•Horseshoe shape with 125 feet of cover

Deschutes No. 1
•Project: Deschutes 1/31/44
•3 miles NW of Terrebonne, Oregon
•11.25 feet in diameter and 3,361 feet long
•Horseshoe shape with ? feet of cover

Deschutes No. 2
•Project: Deschutes 1/31/44
•3 miles NW of Terrebonne, Oregon
•11.25 feet in diameter and 3,443 feet long
•Horseshoe shape with ? feet of cover

Green Springs
•Project: Rogue River Basin
•21 miles SE of Medford, Oregon
•6.00 feet in diameter and 4,833 feet long
•Circular shape with ? feet of cover

Kingman Lateral
•Project: Owyhee 7/12/34
•5 miles WSW of Adrian, Oregon
•4.75 feet in diameter and 350 feet long
•Horseshoe shape with 67 feet of cover

Klamath Main Canal
•Project: Klamath 12/29/05
•1 mile NNE of Klamath Falls, Oregon
•14.38 feet in diameter and 3,100 feet long
•Rectangular shape with 112 feet of cover

North Canal No. 2
•Project: Owyhee 12/23/31
•8 miles SW of Adrian, Oregon
•14.00 feet in diameter and 489 feet long
•Horseshoe shape with 42 feet of cover

North Canal No. 3
•Project: Owyhee 12/23/31
•7 miles SW of Adrian, Oregon
•14.00 feet in diameter and 13,330 feet long
•Horseshoe shape with 90 feet of cover

North Canal No. 4
•Project: Owyhee 11/7/33
•7 miles NW of Adrian, Oregon
•11.75 feet in diameter and 1,990 feet long
•Horseshoe shape with 76 feet of cover

Owyhee No. 1
•Project: Owyhee 3/11/30
•9 miles SW of Adrian, Oregon
•16.58 feet in diameter and 18,723 feet long
•Horseshoe shape with 1200 feet of cover

Owyhee No. 5
•Project: Owyhee 3/11/30
•6 miles SW of Adrian, Oregon
•9.25 feet in diameter and 21,948 feet long
•15,312 feet shape with 900 feet of cover

South Canal Tunnel No. 6
•Project: Owyhee 1/7/35
•7 miles WNW of Homedale, Oregon
•8.25 feet in diameter and 1,040 feet long
•Horseshoe shape with 138 feet of cover

South Canal Tunnel No. 7
•Project: Owyhee 1/7/35
•7 miles W of Homedale, Oregon
•7.00 feet in diameter and 4,325 feet long
•Horseshoe shape with 188 feet of cover

Vale No. 1
•Project: Vale 6/8/28
•20 miles SW of Vale, Oregon
•10.50 feet in diameter and 2,150 feet long
•Horseshoe shape with 420 feet of cover

Vale No. 2
•Project: Vale 6/8/28
•1 mile N of Namorf, Oregon
•10.50 feet in diameter and 5,007 feet long
•Horseshoe shape with 448 feet of cover

Vale No. 3
•Project: Vale 6/8/28
•2 miles NE of Namorf, Oregon
•10.50 feet in diameter and 1,312 feet long
•Horseshoe shape with 106 feet of cover

Vale No. 4
•Project: Vale 6/14/29
•13 miles WSW of Vale, Oregon
•10.00 feet in diameter and 500 feet long
•Horseshoe shape with 76 feet of cover

Vale No. 5
•Project: Vale 6/14/29
•13 miles WSW of Vale, Oregon
•10.00 feet in diameter and 546 feet long
•Horseshoe shape with 66 feet of cover

Utah

Alpine
•Project: Central Utah
•8 miles NW of Provo, Utah
•7.50 feet in diameter and 1,825 feet long
•Horseshoe shape with 350 feet of cover

Alpine-Draper
•Project: Provo River 11/22/38
•2 miles SSE of Draper, Utah
•6.50 feet in diameter and 15,037 feet long
•8,798 feet shape with ? feet of cover

Currant
•Project: Central Utah
•39 miles W of Duchesne, Utah
•10.33 feet in diameter and 9,131 feet long
•Circular shape with 100 feet of cover

Duchesne
•Project: Provo River 8/21/40
•18 miles E of Kamas, Utah
•9.25 feet in diameter and 31,651 feet long
•Horseshoe shape with 2600 feet of cover

Ephraim
•Project: Sanpete 7/8/35
•6 miles ESE of Ephraim, Utah
•6.50 feet in diameter and 7,113 feet long
•Horseshoe shape with 545 feet of cover

Gateway
•Project: Weber Basin 11/13/52
•7 miles SE of Ogden, Utah
•9.33 feet in diameter and 17,203 feet long
•Horseshoe shape with ? feet of cover

Hades
•Project: Central Utah
•40 miles NW of Duchesne, Utah
•8.25 feet in diameter and 22,149 feet long
•Circular shape with 2150 feet of cover

Layout
•Project: Central Utah
•37 miles W of Duchesne, Utah
•10.33 feet in diameter and 17,355 feet long
•Circular shape with 120 feet of cover

Ogden Canyon
•Project: Ogden River
•2 miles NW of Ogden, Utah
•? feet in diameter and ? feet long
•? shape with ? feet of cover

Ogden-Brigham
•Project: Ogden River 4/18/35
•2 miles N of Ogden, Utah
•6.50 feet in diameter and 4,259 feet long
•Horseshoe shape with ? feet of cover

Olmsted
•Project: Provo River 11/22/38
•6 miles N of Provo, Utah
•6.50 feet in diameter and 3,614 feet long
•Horseshoe shape with ? feet of cover

Rhodes
•Project: Central Utah
•40 miles NW of Duchesne, Utah
•8.25 feet in diameter and 4,110 feet long
•Circular shape with 700 feet of cover

Salt Lake Aqueduct No. 1
•Project: Provo River 5/19/48
•7 miles NE of Orem, Utah
•6.50 feet in diameter and 994 feet long
•Horseshoe shape with 132 feet of cover

Salt Lake Aqueduct No. 2
•Project: Provo River 5/19/48
•7 miles NE of Orem, Utah
•6.50 feet in diameter and 490 feet long
 •Horseshoe shape with 108 feet of cover

Salt Lake Aqueduct No. 3
•Project: Provo River 5/19/48
•7 miles NE of Orem, Utah
•6.50 feet in diameter and 2,550 feet long
•Horseshoe shape with ? feet of cover

Soldier Creek Right Abutment Drainage
•Project: Central Utah
•35 miles W of Duchesne, Utah
•12.00 feet in diameter and 731 feet long
•Horseshoe shape with 140 feet of cover

Spring City
•Project: Sanpete 9/21/37
•12 miles NE of Ephraim, Utah
•5.50 feet in diameter and 4,907 feet long
•Horseshoe shape with ? feet of cover

Starvation
•Project: Central Utah
•4 miles N of Duchesne, Utah
•7.67 feet in diameter and 5,345 feet long
•Circular shape with 150 feet of cover

Stillwater, Completion Contract
•Project: Central Utah
•45 miles NW of Duchesne, Utah
•8.25 feet in diameter and 28,579 feet long
•Circular shape with 2900 feet of cover

Stillwater, Initial Contract
•Project: Central Utah
•45 miles NW of Duchesne, Utah
•8.25 feet in diameter and 13,849 feet long
•Circular shape with 2700 feet of cover

Strawberry
•Project: Strawberry Valley
•22 miles ESE of Provo, Utah
•8.50 feet in diameter and 18,600 feet long
•Rectangular shape with 1400 feet of cover

Strawberry Inlet Rehibitation (sic)
•Project: Central Utah 10/20/81
•22 miles E of Springville, Utah
•10.75 feet in diameter and 2,435 feet long
•Horseshoe shape with 185 feet of cover

Vat
•Project: Central Utah
•46 miles NW of Duchesne, Utah
•8.25 feet in diameter and 38,760 feet long
•Circular shape with 2400 feet of cover

Water Hollow
•Project: Central Utah
•27 miles SE of Heber City, Utah
•10.33 feet in diameter and 21,582 feet long
•Circular shape with 1420 feet of cover

Washington

Bacon
•Project: Columbia Basin 4/30/46
•1 mile S of Coulee City, Washington
•23.25 feet in diameter and 10,037 feet long
•Horseshoe shape with 215 feet of cover

Bacon #2
•Project: Columbia Basin
•1 mile S of Coulee City, Washington
•28.50 feet in diameter and 9,950 feet long
•Horseshoe shape with 260 feet of cover

Frenchman Hills
•Project: Columbia Basin 12/13/50
•20 miles S of Quincy, Washington
•14.00 feet in diameter and 9,280 feet long
•Horseshoe shape with 390 feet of cover

North Branch Canal No. 1
•Project: Yakima 12/6/27
•10 miles NW of Ellensburg, Washington
•11.71 feet in diameter and 1,686 feet long
•Horseshoe shape with 178 feet of cover

North Branch Canal No. 2
•Project: Yakima 12/6/27
•10 miles NW of Ellensburg, Washington
•11.71 feet in diameter and 1,025 feet long
•Horseshoe shape with 116 feet of cover

North Branch Canal No. 3
•Project: Yakima 12/6/27
•10 miles NW of Ellensburg, Washington
•11.70 feet in diameter and 2,276 feet long
•Horseshoe shape with 117 feet of cover

North Branch Canal No. 4
•Project: Yakima 8/9/29
•7 miles N of Ellensburg, Washington
•11.17 feet in diameter and 482 feet long
•Horseshoe shape with 51 feet of cover

North Branch Canal No. 5
•Project: Yakima 4/16/30
•12 miles ESE of Ellensburg, Washington
•6.58 feet in diameter and 3,470 feet long
•Horseshoe shape with 370 feet of cover

Rocky Point
•Project: Yakima 6/3/27
•10 miles SE of Cle Elum, Washington
•11.92 feet in diameter and 965 feet long
•Horseshoe shape with ? feet of cover

Snow Lake
•Project: Columbia Basin 3/1/38
•9 miles SW of Leavenworth, Washington
•7.00 feet in diameter and 2,502 feet long
•Rectangular shape with ? feet of cover

South Branch Canal No. 1
•Project: Yakima 6/3/27
•10 miles SE of Cle Elum, Washington
•6.25 feet in diameter and 2,000 feet long
•Horseshoe shape with 58 feet of cover

South Branch Canal No. 2
•Project: Yakima 8/7/28
•8 miles WNW of Ellensburg, Washington
•5.00 feet in diameter and 1,320 feet long
•Horseshoe shape with 110 feet of cover

Under C.M.&ST.P.Ry.
•Project: Yakima 2/10/28
•13 miles WNW of Cle Elum, Washington
•12.25 feet in diameter and 179 feet long
•Horseshoe shape with 21 feet of cover

Under Northern Pacific Ry.
•Project: Yakima 2/10/28
•14 miles WNW of Cle Elum, Washington
•12.25 feet in diameter and 305 feet long
•Horseshoe shape with 33 feet of cover

Yakima Ridge Canal No. 1
•Project: Yakima 12/3/35
•10 miles N of Yakima, Washington
•17.58 feet in diameter and 8,180 feet long
•Horseshoe shape with ? feet of cover

Yakima Ridge Canal No. 2
•Project: Yakima 12/3/35
•9 miles NNE of Yakima, Washington
•17.33 feet in diameter and 1,410 feet long
•Horseshoe shape with ? feet of cover

Yakima Ridge Canal No. 3
•Project: Yakima 12/3/35
•3 miles N of Yakima, Washington
•17.33 feet in diameter and 9,650 feet long
•Horseshoe shape with ? feet of cover

Yakima Ridge Canal No. 5
•Project: Yakima 2/9/38
•9 miles SE of Yakima, Washington
•13.75 feet in diameter and 3,988 feet long
•Horseshoe shape with ? feet of cover

Yakima Ridge Canal No. 7
•Project: Yakima 12/8/38
•12 miles SE of Yakima, Washington
•13.25 feet in diameter and 755 feet long
•Horseshoe shape with 83 feet of cover

Yakima Ridge Canal No. 8
•Project: Yakima 12/8/38
•12 miles SE of Yakima, Washington
•13.25 feet in diameter and 1,475 feet long
•Horseshoe shape with 116 feet of cover

Yakima River Crossing
•Project: Yakima 3/5/29
•9 miles SE of Cle Elum, Washington
•9.25 feet in diameter and 3,640 feet long
•Circular shape with 330 feet of cover

Wyoming

Casper Canal No. 1
•Project: Kendrick 3/7/34
•12 miles NW-W-SW of Casper, Wyoming
•14.00 feet in diameter and 2,810 feet long
•Horseshoe shape with 410 feet of cover

Casper Canal No. 2
•Project: Kendrick 3/7/34
•12 miles NW-W-SW of Casper, Wyoming
•14.00 feet in diameter and 4,400 feet long
•Horseshoe shape with 440 feet of cover

Casper Canal No. 3
•Project: Kendrick 11/25/35
•12 miles NW-W-SW of Casper, Wyoming
•14.00 feet in diameter and 1,200 feet long
•Horseshoe shape with 119 feet of cover

Casper Canal No. 4
•Project: Kendrick 11/25/35
•12 miles NW-W-SW of Casper, Wyoming
•14.00 feet in diameter and 2,000 feet long
•Horseshoe shape with 129 feet of cover

Casper Canal No. 5
•Project: Kendrick 11/25/35
•12 miles NW-W-SW of Casper, Wyoming
•13.75 feet in diameter and 1,605 feet long
•Horseshoe shape with 86 feet of cover

Casper Canal No. 6
•Project: Kendrick 11/25/35
•12 miles NW-W-SW of Casper, Wyoming
•13.75 feet in diameter and 5,460 feet long
•Horseshoe shape with 220 feet of cover

Corbett
•Project: Shoshone 9/6/05
•8 miles NE of Cody, Wyoming
•11.50 feet in diameter and 17,355 feet long
•Non-standard shape with 90 feet of cover

Fort Laramie No. 1
•Project: North Plate 5/22/16
•3 miles W of Fort Laramie, Wyoming
•14.00 feet in diameter and 2,700 feet long
•Horseshoe shape with ? feet of cover

Fort Laramie No. 2
•Project: North Plate 5/22/16
•2 miles SE of Fort Laramie, Wyoming
•14.00 feet in diameter and 2,150 feet long
•Horseshoe shape with ? feet of cover

Fremont Canyon Access
•Project: Pick-Sloan Missouri Basin 5/22/56
•35 miles SW of Casper, Wyoming
•16.00 feet in diameter and 1,692 feet long
•Modified Horseshoe shape with 250 feet of cover

Fremont Canyon Power Conduit
•Project: Pick-Sloan Missouri Basin 1/3/57
•35 miles SW of Casper, Wyoming
•18.00 feet in diameter and 16,055 feet long
•Circular shape with 135 feet of cover

Heart Mountain No. 1
•Project: Shoshone 3/2/38
•3 miles WSW of Cody, Wyoming
•11.00 feet in diameter and 894 feet long
•Horseshoe shape with 138 feet of cover

Heart Mountain No. 2
•Project: Shoshone 8/31/38
•12 miles N of Cody, Wyoming
•8.50 feet in diameter and 874 feet long
•Horseshoe shape with 92 feet of cover

Riverton
- Project: Riverton 7/7/48
- 20 miles NE of Riverton, Wyoming
- 7.50 feet in diameter and 2,832 feet long
- Horseshoe shape with ? feet of cover

Shoshone Canyon Conduit
- Project: Shoshone 12/5/35
- 6 miles WSW of Cody, Wyoming
- 12.00 feet in diameter and 13,786 feet long
- Horseshoe shape with ? feet of cover

Shoshone PP Access Road
- Project: Shoshone 12/29/49
- 8 miles WSW of Cody, Wyoming
- 13.00 feet in diameter and 184 feet long
- Rectangular with shape with ? feet of cover

Sluicing
- Project: Shoshone 9/6/05
- 8 miles NE of Cody, Wyoming
- ? feet in diameter and 335 feet long
- Horseshoe shape with 48 feet of cover

(*Source*: United States Bureau of Reclamation, on the WWW at http://www.usbr.gov/wcg/tunnels/tdata.html, 1997.)

Index

Index key: f = footnote; i = illustration and/or illustration caption.

A
Air Force, U.S. 21, 29-30, 31i-33i, 39, 55, 57, 63i, 94, 140i, 177i
Alaska 36i, 37, 37i, 77, 154, 158, 203, 226, 227-228
Albuquerque, New Mexico 29, 31i
Al Matthews Corp. 70
American Underground Construction Association 69-70
Arizona 13, 57-59, 78i, 226, 227-228
Army, U.S. 15, 21, 24, 25i, 26, 39, 40-42, 52-53, 57, 139, 176, 178-179, 181
Army Corps of Engineers, U.S. 34, 40-42, 40f-42f, 43i, 45-46, 45-46f, 47i, 49i-50i, 51, 63, 64f, 94-96, 98, 103, 106, 118, 174, 175f, 179, 179f, 180i
Army Missile Command, U.S. 130f, 139
Art Bell 19
Atlas Copco 70, 71f, 73
Auditory Cortex 17, 18i
Australia 151, 153, 170, 219f

B
Battelle Memorial Institute 105, 119
Bechtel 70, 105-107, 112, 136i
Bhutan 36-37, 183
Big Dig 136i-137i
Black Budget 53-55, 57, 61-62, 64, 94, 100-101, 128-129, 148, 179, 192, 216, 218, 220
Boeing Aerospace Co. 64, 64f, 87f, 89, 97f, 105, 113, 129f
Boston, Massachusetts 71, 71f, 136i-137i, 166, 166f, 168i, 169
Boyers, Pennsylvania 142

Brain Transmitter 17, 18i, 19
Bureau of Mines, U.S. 98, 148, 148f, 150i, 205-207, 209
Bureau of Reclamation, U.S. 69, 72, 77, 78, 78i, 79-80, 85i, 98, 226-253

C
Caissons 42, 44-46
California 77, 93, 127, 143-144, 148, 157, 160, 169-170, 190, 203, 205-206, 226, 228-230
Camp David, Maryland 26-27
Canada 36-37, 151, 153, 153f, 154, 154f, 155i, 156, 158, 204-205
Central Intelligence Agency (CIA) 15, 24, 25i, 26, 55, 55f, 56-57, 62f, 207, 218, 218f-219f, 220
Cheyenne Mountain, Colorado 35
Chile 151, 154, 154f
Chilled Water Plants 52-53
Chunnel 147f, 156, 156i, 157
Clementine 210-211
Cocaine 219f
Colorado 35, 58, 64, 65i, 129, 226, 231-237
Colorado School of Mines 98
Continental Shelf 144, 181, 190-191, 216
Cornwall, Pennsylvania 140i
Crooke, Curtis 208-210
Culpeper, Virginia 15

D
Decoupling Chamber 131-132
Deep Bases 51, 65i-66i, 87, 89
Defense Nuclear Agency, U.S. 64, 64f, 65i-66i, 87, 87f, 88i, 97f, 98, 129f
Department of Energy, U.S. 27-28, 30, 36i-38i, 63i, 72, 81, 84i-86i, 92f, 93f, 103, 106
Dreamland Radio Show 19
Drugs 16, 219f
Dulce, New Mexico 57-59, 93, 219f

Duscha, Lloyd A. 34, 35f, 178-179, 179f, 183

E
EG&G Reeco 70
England 35f, 147f, 151f, 156, 156i, 203
Executive Office of the President (EOP) 26

F
Federal Emergency Management Agency (FEMA, U.S. 15, 23
Federal Investigations Service, U.S. 142
Finland 151, 152i
France 147f, 156, 156i
Frontier-Kemper 70, 72,72f, 90

G
Genetic Engineering 15, 58, 93-94, 219, 220f
Genetic Research 91, 93-94
Genome Project 92, 93, 93f, 94
Gibraltar 203, 204i
Global Marine 208, 212
Glomar Challenger 212, 212f, 212i, 213-214
Glomar Explorer 206-207, 207f, 208, 208f, 209-212, 214
Grumman Corporation 105, 118-121

H
Halliburton Co. 145
Harza Engineering Co. 70, 99
Hawaii 203, 208
Heat Sinks 46f, 47i, 48, 49i-50i, 51
Hoover Dam 72, 80, 80f
Hughes, Howard 207, 209
Human Genome Project 92, 93, 93f, 94

I
Ice House 27-29
Idaho 226, 237-238
Invisible Government 54, 54f, 55, 179, 218
Irene 39-40

J
Jacobs Associates 70
Japan 114, 120, 122, 147, 147f, 151, 153, 153f-154f, 156-157, 160
Jicarilla Apache Reservation 58
JOIDES Resolution 213i, 214

K
Kiewit Construction 70
Kirtland Air Force Base 29-30, 31i, 39, 94
Korea, South 147, 147f
Kursk 145, 145f

L
Laytonsville, Maryland 15, 24
Little Creek, Virginia 170
Lock Tube 187i, 188-189, 189i, 190-193, 195, 197i, 199, 200
Long Beach, California 143-144
Los Alamos National Laboratories 27-29, 39, 81, 9-94
Lovat Tunnel Equipment, Inc. 70, 73, 100

M
Maglev Train 102-129 inclusive
Manson Construction Co. 164i
Manzano Underground Base 29, 31i-33i
Marine Corps, U.S. 57
Maryland 15, 23-24, 26-27
Massachusetts 71, 136i-137i, 166-169, 219f
McConnelsville, Ohio 177i
McLean, William B. 148, 148f
Mediterranean Sea 203
Mind Control 19, 34f, 218, 218f
Mines, Abandoned 141, 141f
Mining, Undersea 151, 151f, 152-154, 155i, 195, 198i, 204-205
Molita 160, 162i
Montana 77, 226, 238-239
Morrison-Knudsen 70, 90, 99,

255

105-106, 113

N
Narcotics 219, 219f
National Archives and Records Administration (NARA), U.S. 15
National Security Agency (NSA) 25-26, 29, 56
Naval Facilities Engineering Service Center (NFESC), U.S. 170f, 171, 172i-173i, 214f
Navy, British 145
Navy, U.S. 26, 29, 57, 143-145, 148, 164i, 170-171, 172-173i, 174, 174f, 179, 182-183, 184i, 186, 199i, 202-203, 204-206, 204i, 214-216
Nebraska 77, 226, 240
Nevada 63i, 64, 72, 77, 80-82, 83i, 84i, 88i, 127, 226, 240
New Jersey 95, 95f
New Mexico 27, 29, 31i, 39, 57-59, 72, 77, 81, 85, 93-94, 178, 226, 240-242
New York 93, 95, 95f, 136i
New York City 73, 73f, 74i, 80
New Zealand 151, 204
NORAD 35, 179
North Dakota 226, 242
North Sea 145, 151
Nuclear Decoupling 131-132
Nuclear Reactors 193, 195, 196, 199, 200, 202
Nuclear Waste 30, 72, 75, 81-83, 83i, 87, 89

O
Octopus 55-56
Olney, Maryland 15, 23
Oregon 72, 226, 242-245

P
Parsons Brinckerhoff 75, 75f, 90, 105-106, 119, 136i
Parsons Brinckerhoff Quade & Douglas, Inc. 70, 99, 136i
Passaic River Flood Protection Project, New Jersey 95, 95f

Pennsylvania 27, 140i, 142
Perini Corp. 70, 73
Port Hueneme, California 170
Prouty, Fletcher 24, 26, 55, 55f, 56, 62, 129
Puerto Rico 217

R
Retirement Operations Center, U.S. 142
Riggs Road, Maryland 24
Ripple Rock 158-160, 169
Robbins Co. 70-71, 71f, 89, 100-101, 146f
Rock-Site 182, 182f, 183, 184i, 186, 187i, 189-191, 196, 197i, 199i, 200-204, 204i, 213
Russia 143, 145, 145f, 171, 208

S
Salter, Robert 102, 102f, 103
San Clemente, California 203
San Clemente Island, California 203, 206
Sandia National Laboratories 39, 98
San Diego, California 160, 160f, 163f, 229-230
San Diego South Bay Outfall 160, 161i-165i, 169
Sea Mounts 159, 178, 197i, 199i, 201, 203, 204i
Seattle, Washington 84i, 164i
Secret Team 24, 55, 55f, 56, 62, 129, 179, 218
Sedona, Arizona 57-59
Seikan Tunnel, Japan 157, 157f, 169
Snettisham Project, Alaska 36i, 37, 37i-38i
Spie Batignolles 100-101
Submarines 143-144, 144f, 171, 183, 188, 191, 197i, 199, 199i, 202-203, 208f
Sugar Grove, West Virginia 26, 29
Superconducting Super Collider

(SSC) 79, 89-90, 90f

T
Taiwan 151
Texas 23, 23f, 81-82, 89-91, 91f
Transuranic Waste 85, 86i, 87
Traylor Bros. 71-72, 90, 99, 160f, 163f
Tunnel Boring Machine (TBM) 63i, 71, 73, 79, 82, 82f, 84i, 89, 96-97, 100-101, 146, 146f, 147f, 156i, 160, 160f, 163-164, 169, 193, 202, 206

U
Undersea Bases 57, 76, 143-146, 148, 179, 181-182, 187i, 191-193, 197i, 205-206, 214, 221
Undersea Mining 151, 151f, 152-154, 155i, 195, 198i, 204-205
Underwater Construction Teams (UCT), U.S. Navy 170, 170f
United States National Committee on Tunneling Technology (USNC/TT) 96, 97, 97f, 98-99, 146f
U.S. Steel 142
Utah 64, 65i, 68i, 226, 245-248

V
Van Dolah, Robert W. 148, 148f, 149, 149f, 150i
Virginia 15, 24-26, 25i, 41, 41f, 170, 170f

W
Warrenton Training Center 24-26, 25i
Warrenton, Virginia 15, 24, 25-26, 25i
Washington (State of) 71, 77, 84i, 89, 164, 181, 226, 248-251
Washington, DC 24, 34, 55, 179
Waxahatchie, Texas 81-82, 89-90
West Virginia 29
Waste Isolation Pilot Plant (WIPP) 85, 85f, 86i, 87, 87f, 89

Wirth Maschinen- und Bohr-geräte, GmbH 70, 73, 100
Wotan 164i
World Bank 142
Wyoming 226, 251-253

Y
Yucca Mountain Exploratory Studies Facility (ESF) 81-82, 83f, 83i-85, 87, 89

STRANGE SCIENCE

UNDERGROUND BASES & TUNNELS
What is the Government Trying to Hide?
by Richard Sauder, Ph.D.
Working from government documents and corporate records, Sauder has compiled an impressive book that digs below the surface of the military's super-secret underground! Go behind the scenes into little-known corners of the public record and discover how corporate America has worked hand-in-glove with the Pentagon for decades, dreaming about, planning, and actually constructing, secret underground bases. This book includes chapters on the locations of the bases, the tunneling technology, various military designs for underground bases, nuclear testing & underground bases, abductions, needles & implants, military involvement in "alien" cattle mutilations, more. 50 page photo & map insert.
201 PAGES. 6x9 PAPERBACK. ILLUSTRATED. $15.95. CODE: UGB

KUNDALINI TALES
by Richard Sauder, Ph.D.
Underground Bases and Tunnels author Richard Sauder's second book on his personal experiences and provocative research into spontaneous spiritual awakening, out-of-body journeys, encounters with secretive governmental powers, daylight sightings of UFOs, and more. Sauder continues his studies of underground bases with new information on the occult underpinnings of the U.S. space program. The book also contains a breakthrough section that examines actual U.S. patents for devices that manipulate minds and thoughts from a remote distance. Included are chapters on the secret space program and a 130-page appendix of patents and schematic diagrams of secret technology and mind control devices.
296 PAGES. 7x10 PAPERBACK. ILLUSTRATED. BIBLIOGRAPHY. $14.95. CODE: KTAL

LOST SCIENCE
by Gerry Vassilatos
Secrets of Cold War Technology author Vassilatos on the remarkable lives, astounding discoveries, and incredible inventions of such famous people as Nikola Tesla, Dr. Royal Rife, T.T. Brown, and T. Henry Moray. Read about the aura research of Baron Karl von Reichenbach, the wireless technology of Antonio Meucci, the controlled fusion devices of Philo Farnsworth, the earth battery of Nathan Stubblefield, and more. What were the twisted intrigues which surrounded the often deliberate attempts to stop this technology? Vassilatos claims that we are living hundreds of years behind our intended level of technology and we must recapture this "lost science."
304 PAGES. 6x9 PAPERBACK. ILLUSTRATED. BIBLIOGRAPHY. $16.95. CODE: LOS

THE TIME TRAVEL HANDBOOK
A Manual of Practical Teleportation & Time Travel
edited by David Hatcher Childress
In the tradition of *The Anti-Gravity Handbook* and *The Free-Energy Device Handbook*, science and UFO author David Hatcher Childress takes us into the weird world of time travel and teleportation. Not just a whacked-out look at science fiction, this book is an authoritative chronicling of real-life time travel experiments, teleportation devices and more. *The Time Travel Handbook* takes the reader beyond the government experiments and deep into the uncharted territory of early time travellers such as Nikola Tesla and Guglielmo Marconi and their alleged time travel experiments, as well as the Wilson Brothers of EMI and their connection to the Philadelphia Experiment—the U.S. Navy's forays into invisibility, time travel, and teleportation. Childress looks into the claims of time travelling individuals, and investigates the unusual claim that the pyramids on Mars were built in the future and sent back in time. A highly visual, large format book, with patents, photos and schematics. Be the first on your block to build your own time travel device!
316 PAGES. 7x10 PAPERBACK. ILLUSTRATED. $16.95. CODE: TTH

MAPS OF THE ANCIENT SEA KINGS
Evidence of Advanced Civilization in the Ice Age
by Charles H. Hapgood
Charles Hapgood's classic 1966 book on ancient maps produces concrete evidence of an advanced world-wide civilization existing many thousands of years before ancient Egypt. He has found the evidence in the Piri Reis Map that shows Antarctica, the Hadji Ahmed map, the Oronteus Finaeus and other amazing maps. Hapgood concluded that these maps were made from more ancient maps from the various ancient archives around the world, now lost. Not only were these unknown people more advanced in mapmaking than any people prior to the 18th century, it appears they mapped all the continents. The Americas were mapped thousands of years before Columbus. Antarctica was mapped when its coasts were free of ice.
316 PAGES. 7x10 PAPERBACK. ILLUSTRATED. BIBLIOGRAPHY & INDEX. $19.95. CODE: MASK

PATH OF THE POLE
Cataclysmic Pole Shift Geology
by Charles Hapgood
Maps of the Ancient Sea Kings author Hapgood's classic book *Path of the Pole* is back in print! Hapgood researched Antarctica, ancient maps and the geological record to conclude that the Earth's crust has slipped in the inner core many times in the past, changing the position of the pole. *Path of the Pole* discusses the various "pole shifts" in Earth's past, giving evidence for each one, and moves on to possible future pole shifts. Packed with illustrations, this is the sourcebook for many other books on cataclysms and pole shifts.
356 PAGES. 6x9 PAPERBACK. ILLUSTRATED. $16.95. CODE: POP.

24 hour credit card orders—call: 815-253-6390 fax: 815-253-6300
email: auphq@frontiernet.net www.adventuresunlimitedpress.com www.wexclub.com

ANTI-GRAVITY

ANTI-GRAVITY

THE COSMIC MATRIX
Piece For A Jig-Saw
Part 2

Leonard G. Cramp

COSMIC MATRIX
Piece for a Jig-Saw, Part Two
by Leonard G. Cramp

Leonard G. Cramp, a British aerospace engineer, wrote his first book *Space Gravity and the Flying Saucer* in 1954. *Cosmic Matrix* is the long-awaited sequel to his 1966 book *UFOs & Anti-Gravity: Piece for a Jig-Saw.* Cramp has had a long history of examining UFO phenomena and has concluded that UFOs use the highest possible aeronautic science to move in the way they do. Cramp examines anti-gravity effects and theorizes that this super-science used by the craft—described in detail in the book—can lift mankind into a new level of technology, transportation and understanding of the universe. The book takes a close look at gravity control, time travel, and the interlocking web of energy between all planets in our solar system with Leonard's unique technical diagrams. A fantastic voyage into the present and future!
364 PAGES. 6x9 PAPERBACK. ILLUSTRATED. BIBLIOGRAPHY. $16.00. CODE: CMX

UFOS AND ANTI-GRAVITY
Piece For A Jig-Saw
by Leonard G. Cramp

UFOS AND ANTI-GRAVITY:
PIECE FOR A JIG-SAW
by Leonard G. Cramp

Leonard G. Cramp's 1966 classic book on flying saucer propulsion and suppressed technology is a highly technical look at the UFO phenomena by a trained scientist. Cramp first introduces the idea of 'anti-gravity' and introduces us to the various theories of gravitation. He then examines the technology necessary to build a flying saucer and examines in great detail the technical aspects of such a craft. Cramp's book is a wealth of material and diagrams on flying saucers, anti-gravity, suppressed technology, G-fields and UFOs. Chapters include Crossroads of Aerodymanics, Aerodynamic Saucers, Limitations of Rocketry, Gravitation and the Ether, Gravitational Spaceships, G-Field Lift Effects, The Bi-Field Theory, VTOL and Hovercraft, Analysis of UFO photos, more.
388 PAGES. 6x9 PAPERBACK. ILLUSTRATED. $16.95. CODE: UAG

THE HARMONIC CONQUEST OF SPACE
BRUCE CATHIE

THE HARMONIC CONQUEST OF SPACE
by Captain Bruce Cathie

Chapters include: Mathematics of the World Grid; the Harmonics of Hiroshima and Nagasaki; Harmonic Transmission and Receiving; the Link Between Human Brain Waves; the Cavity Resonance between the Earth; the Ionosphere and Gravity; Edgar Cayce—the Harmonics of the Subconscious; Stonehenge; the Harmonics of the Moon; the Pyramids of Mars; Nikola Tesla's Electric Car; the Robert Adams Pulsed Electric Motor Generator; Harmonic Clues to the Unified Field; and more. Also included are tables showing the harmonic relations between the earth's magnetic field, the speed of light, and anti-gravity/gravity acceleration at different points on the earth's surface. New chapters in this edition on the giant stone spheres of Costa Rica, Atomic Tests and Volcanic Activity, and a chapter on Ayers Rock analysed with Stone Mountain, Georgia.
248 PAGES. 6x9 PAPERBACK. ILLUSTRATED. BIBLIOGRAPHY. $16.95. CODE: HCS

THE INVESTIGATION INTO THE WORLD ENERGY GRID
THE ENERGY GRID
HARMONIC 695
THE PULSE OF THE UNIVERSE

BRUCE L. CATHIE

THE ENERGY GRID
Harmonic 695, The Pulse of the Universe
by Captain Bruce Cathie.

This is the breakthrough book that explores the incredible potential of the Energy Grid and the Earth's Unified Field all around us. Cathie's first book, *Harmonic 33*, was published in 1968 when he was a commercial pilot in New Zealand. Since then, Captain Bruce Cathie has been the premier investigator into the amazing potential of the infinite energy that surrounds our planet every microsecond. Cathie investigates the Harmonics of Light and how the Energy Grid is created. In this amazing book are chapters on UFO Propulsion, Nikola Tesla, Unified Equations, the Mysterious Aerials, Pythagoras & the Grid, Nuclear Detonation and the Grid, Maps of the Ancients, an Australian Stonehenge examined, more.
255 PAGES. 6x9 TRADEPAPER. ILLUSTRATED. $15.95. CODE: TEG

THE BRIDGE TO INFINITY
Harmonic 371244
by Captain Bruce Cathie

...IDGE ...NFINITY HARMON...

Cathie has popularized the concept that the earth is crisscrossed by an electromagnetic grid system that can be used for anti-gravity, free energy, levitation and more. The book includes a new analysis of the harmonic nature of reality, acoustic levitation, pyramid power, harmonic receiver towers and UFO propulsion. It concludes that today's scientists have at their command a fantastic store of knowledge with which to advance the welfare of the human race.
204 PAGES. 6x9 TRADEPAPER. ILLUSTRATED. $14.95. CODE: BTF

Man-Made UFOS
1944-1994
50 Years of Suppression

MAN-MADE UFOS 1944—1994
Fifty Years of Suppression
by Renato Vesco & David Hatcher Childress

A comprehensive look at the early "flying saucer" technology of Nazi Germany and the genesis of man-made UFOs. This book takes us from the work of captured German scientists to escaped battalions of Germans, secret communities in South America and Antarctica to todays state-of-the-art "Dreamland" flying machines. Heavily illustrated, this astonishing book blows the lid off the "government UFO conspiracy" and explains with technical diagrams the technology involved. Examined in detail are secret underground airfields and factories; German secret weapons; "suction" aircraft; the origin of NASA; gyroscopic stabilizers and engines; the secret Marconi aircraft factory in South America; and more. Introduction by W.A. Harbinson, author of the Dell novels *GENESIS* and *REVELATION.*
318 PAGES. 6x9 PAPERBACK. ILLUSTRATED. INDEX & FOOTNOTES. $18.95. CODE: MMU

24 hour credit card orders—call: 815-253-6390 fax: 815-253-6300

email: auphq@frontiernet.net www.adventuresunlimitedpress.com www.wexclub.com

FREE ENERGY SYSTEMS

LOST SCIENCE
by Gerry Vassilatos
Rediscover the legendary names of suppressed scientific revolution—remarkable lives, astounding discoveries, and incredible inventions which would have produced a world of wonder. How did the aura research of Baron Karl von Reichenbach prove the vitalistic theory and frighten the greatest minds of Germany? How did the physiophone and wireless of Antonio Meucci predate both Bell and Marconi by decades? How does the earth battery technology of Nathan Stubblefield portend an unsuspected energy revolution? How did the geoaetheric engines of Nikola Tesla threaten the establishment of a fuel-dependent America? The microscopes and virus-destroying ray machines of Dr. Royal Rife provided the solution for every world-threatening disease. Why did the FDA and AMA together condemn this great man to Federal Prison? The static crashes on telephone lines enabled Dr. T. Henry Moray to discover the reality of radiant space energy. Was the mysterious "Swedish stone," the powerful mineral which Dr. Moray discovered, the very first historical instance in which stellar power was recognized and secured on earth? Why did the Air Force initially fund the gravitational warp research and warp-cloaking devices of T. Townsend Brown and then reject it? When the controlled fusion devices of Philo Farnsworth achieved the "break-even" point in 1967 the FUSOR project was abruptly cancelled by ITT. What were the twisted intrigues which surrounded these deliberate convolutions of history? Each chapter is a biographic treasure. Ours is a world living hundreds of years behind its intended stage of development. Complete knowledge of its loss is the key to recapturing this wonder technology.
304 PAGES. 6x9 PAPERBACK. ILLUSTRATED. BIBLIOGRAPHY. $16.95. CODE: LOS

SECRETS OF COLD WAR TECHNOLOGY
Project HAARP and Beyond
by Gerry Vassilatos
Vassilatos reveals that "Death Ray" technology has been secretly researched and developed since the turn of the century. Included are chapters on such inventors and their devices as H.C. Vion, the developer of auroral energy receivers; Dr. Selim Lemstrom's pre-Tesla experiments; the early beam weapons of Grindell-Mathews, Ulivi, Turpain and others; John Hettenger and his early beam power systems. Learn about Project Argus, Project Teak and Project Orange; EMP experiments in the 60s; why the Air Force directed the construction of a huge Ionospheric "backscatter" telemetry system across the Pacific just after WWII; why Raytheon has collected every patent relevant to HAARP over the past few years; more.
250 PAGES. 6x9 PAPERBACK. ILLUSTRATED. $15.95. CODE: SCWT

THE TIME TRAVEL HANDBOOK
A Manual of Practical Teleportation & Time Travel
edited by David Hatcher Childress
In the tradition of *The Anti-Gravity Handbook* and *The Free-Energy Device Handbook*, science and UFO author David Hatcher Childress takes us into the weird world of time travel and teleportation. Not just a whacked-out look at science fiction, this book is an authoritative chronicling of real-life time travel experiments, teleportation devices and more. *The Time Travel Handbook* takes the reader beyond the government experiments and deep into the uncharted territory of early time travellers such as Nikola Tesla and Guglielmo Marconi and their alleged time travel experiments, as well as the Wilson Brothers of EMI and their connection to the Philadelphia Experiment—the U.S. Navy's forays into invisibility, time travel, and teleportation. Childress looks into the claims of time travelling individuals, and investigates the unusual claim that the pyramids on Mars were built in the future and sent back in time. A highly visual, large format book, with patents, photos and schematics. Be the first on your block to build your own time travel device!
316 PAGES. 7x10 PAPERBACK. ILLUSTRATED. $16.95. CODE: TTH

THE TESLA PAPERS
Nikola Tesla on Free Energy & Wireless Transmission of Power
by Nikola Tesla, edited by David Hatcher Childress
In the tradition of *The Fantastic Inventions of Nikola Tesla, The Anti-Gravity Handbook* and *The Free-Energy Device Handbook*, science and UFO author David Hatcher Childress takes us into the incredible world of Nikola Tesla and his amazing inventions. Tesla's rare article "The Problem of Increasing Human Energy with Special Reference to the Harnessing of the Sun's Energy" is included. This lengthy article was originally published in the June 1900 issue of *The Century Illustrated Monthly Magazine* and it was the outline for Tesla's master blueprint for the world. Tesla's fantastic vision of the future, including wireless power, anti-gravity, free energy and highly advanced solar power. Also included are some of the papers, patents and material collected on Tesla at the Colorado Springs Tesla Symposiums, including papers on:
•The Secret History of Wireless Transmission •Tesla and the Magnifying Transmitter
•Design and Construction of a Half-Wave Tesla Coil •Electrostatics: A Key to Free Energy
•Progress in Zero-Point Energy Research •Electromagnetic Energy from Antennas to Atoms
•Tesla's Particle Beam Technology •Fundamental Excitatory Modes of the Earth-Ionosphere Cavity
325 PAGES. 8x10 PAPERBACK. ILLUSTRATED. $16.95. CODE: TTP

THE FANTASTIC INVENTIONS OF NIKOLA TESLA
Nikola Tesla with additional material by David Hatcher Childress
This book is a readable compendium of patents, diagrams, photos and explanations of the many incredible inventions of the originator of the modern era of electrification. In Tesla's own words are such topics as wireless transmission of power, death rays, and radio-controlled airships. In addition, rare material on German bases in Antarctica and South America, and a secret city built at a remote jungle site in South America by one of Tesla's students, Guglielmo Marconi. Marconi's secret group claims to have built flying saucers in the 1940s and to have gone to Mars in the early 1950s! Incredible photos of these Tesla craft are included. The Ancient Atlantean system of broadcasting energy through a grid system of obelisks and pyramids is discussed, and a fascinating concept comes out of one chapter: that Egyptian engineers had to wear protective metal head-shields while in these power plants, hence the Egyptian Pharoah's head covering as well as the Face on Mars!
•His plan to transmit free electricity into the atmosphere. •How electrical devices would work using only small antennas. •Why unlimited power could be utilized anywhere on earth. •How radio and radar technology can be used as death-ray weapons in Star Wars. •Includes an appendix of Supreme Court documents on dismantling his free energy towers. •Tesla's Death Rays, Ozone generators, and more…
342 PAGES. 6x9 PAPERBACK. ILLUSTRATED. $16.95. CODE: FINT

24 hour credit card orders—call: 815-253-6390 fax: 815-253-6300
email: auphq@frontiernet.net www.adventuresunlimitedpress.com www.wexclub.com

LOST CITIES

LOST CITIES OF ATLANTIS, ANCIENT EUROPE & THE MEDITERRANEAN
by David Hatcher Childress

Atlantis! The legendary lost continent comes under the close scrutiny of maverick archaeologist David Hatcher Childress in this six book in the internationally popular *Lost Cities* series. Childress takes the reader in search of sunken cities in the Mediterranean; acr the Atlas Mountains in search of Atlantean ruins; to remote islands in search of megalithic ruins; to meet living legends and see societies. From Ireland to Turkey, Morocco to Eastern Europe, and around the remote islands of the Mediterranean and Atlan Childress takes the reader on an astonishing quest for mankind's past. Ancient technology, cataclysms, megalithic construction, civilizations and devastating wars of the past are all explored in this book. Childress challenges the skeptics and proves that gr civilizations not only existed in the past, but the modern world and its problems are reflections of the ancient world of Atlantis.
524 PAGES. 6x9 PAPERBACK. ILLUSTRATED WITH 100S OF MAPS, PHOTOS AND DIAGRAMS. BIB OGRAPHY & INDEX. $16.95. CODE: MED

LOST CITIES OF CHINA, CENTRAL INDIA & ASIA
by David Hatcher Childress

Like a real life "Indiana Jones," maverick archaeologist David Childress takes the reader on an incredible adventure across some the world's oldest and most remote countries in search of lost cities and ancient mysteries. Discover ancient cities in the Go Desert; hear fantastic tales of lost continents, vanished civilizations and secret societies bent on ruling the world; visit forgotten monasteries in forbidding snow-capped mountains with strange tunnels to mysterious subterranean cities!
A unique combination of far-out exploration and practical travel advice, it will astound and delight the experi- enced traveler or the armchair voyager.
429 PAGES. 6x9 PAPERBACK. ILLUSTRATED. FOOTNOTES & BIBLIOGRAPHY. $14.95. CODE: CHI

LOST CITIES OF ANCIENT LEMURIA & THE PACIFIC
by David Hatcher Childress

Was there once a continent in the Pacific? Called Lemuria or Pacifica by geologists, Mu or Pan by the mystics, there is now ample mythological, geological and archaeological evidence to "prove" that an ad- vanced and ancient civilization once lived in the central Pacific. Maverick archaeologist and explorer David Hatcher Childress combs the Indian Ocean, Australia and the Pacific in search of the surprising truth about mankind's past. Contains photos of the underwater city on Pohnpei; explanations on how the statues were levitated from around Easter Island in a clockwise vortex movement; tales of disappearing islands; Egyptians in Australia; and more.
379 PAGES. 6x9 PAPERBACK. ILLUSTRATED. FOOTNOTES & BIBLIOGRAPHY. $14.95. CODE: LEN

ANCIENT TONGA
& the Lost City of Mu'a
by David Hatcher Childress

Lost Cities series author Childress takes us to the south sea islands of Tonga, Rarotonga, Samoa and Fiji to investigate the megalithic ruins on these beautiful islands. The great empire of the Polynesians, centered on Tonga and the ancient city of Mu'a, is revealed with old photos, drawings and maps. Chapters in this book are on the Lost City of Mu'a and its many megalithic pyramids, the Ha'amonga Trilithon and ancient Polynesian astronomy, Samoa and the search for the lost land of Havai'iki, Fiji and its wars with Tonga, Rarotonga's megalithic road, and Polynesian cosmology. Material on Egyptians in the Pacific, earth changes, the fortified moat around Mu'a, lost roads, more.
218 PAGES. 6x9 PAPERBACK. ILLUSTRATED. COLOR PHOTOS. BIBLIOG- RAPHY. $15.95. CODE: TONG

ANCIENT MICRONESIA
& the Lost City of Nan Madol
by David Hatcher Childress

Micronesia, a vast archipelago of islands west of Hawaii and south of Japan, contains some of the most amazing megalithic ruins in the world. Part of our *Lost Cities* series, this volume explores the incredible confor mations on various Micronesian islands, especially the fantastic and little-known ruins of Nan Madol on Pohnpei Island. The huge canal city of Nan Madol contains over 250 million tons of basalt columns over an 11 square-mile area of artificial islands. Much of the huge city is submerged, and underwater structures can be found to an estimated 80 feet. Island legends claim that the basalt rocks, weighing up to 50 tons, were magically levitated into place by the powerful forefathers Other ruins in Micronesia that are profiled show include the Latte Stones of the Marianas, the menhirs of Palau, the megalithic canal city on Kosrae Island, megaliths on Guam, and more.
256 PAGES. 6x9 PAPERBACK. ILLUSTRATED. INCLUDES A COLOR PHOTO SECTION. BIBLIOGRAPHY $16.95. CODE: AMIC

LOST CITIES

TECHNOLOGY OF THE GODS
The Incredible Sciences of the Ancients
by David Hatcher Childress

Popular *Lost Cities* author David Hatcher Childress takes us into the amazing world of ancient technology, from computers in antiquity to the "flying machines of the gods." Childress looks at the technology that was allegedly used in Atlantis and the theory that the Great Pyramid of Egypt was originally a gigantic power station. He examines tales of ancient flight and the technology that it involved; how the ancients used electricity; megalithic building techniques; the use of crystal lenses and the fire from the gods; evidence of various high tech weapons in the past, including atomic weapons; ancient metallurgy and heavy machinery; the role of modern inventors such as Nikola Tesla in bringing ancient technology back into modern use; impossible artifacts; and more.
356 PAGES. 6x9 PAPERBACK. ILLUSTRATED. BIBLIOGRAPHY. $16.95. CODE: TGOD

VIMANA AIRCRAFT OF ANCIENT INDIA & ATLANTIS
by David Hatcher Childress, introduction by Ivan T. Sanderson

Did the ancients have the technology of flight? In this incredible volume on ancient India, authentic Indian texts such as the *Ramayana* and the *Mahabharata* are used to prove that ancient aircraft were in use more than four thousand years ago. Included in this book is the entire Fourth Century BC manuscript *Vimaanika Shastra* by the ancient author Maharishi Bharadwaaja, translated into English by the Mysore Sanskrit professor G.R. Josyer. Also included are chapters on Atlantean technology, the incredible Rama Empire of India and the devastating wars that destroyed it. Also an entire chapter on mercury vortex propulsion and mercury gyros, the power source described in the ancient Indian texts. Not to be missed by those interested in ancient civilizations or the UFO enigma.
334 PAGES. 6x9 PAPERBACK. RARE PHOTOGRAPHS, MAPS AND DRAWINGS. $15.95. CODE: VAA

LOST CONTINENTS & THE HOLLOW EARTH
I Remember Lemuria and the Shaver Mystery
by David Hatcher Childress & Richard Shaver

Lost Continents & the Hollow Earth is Childress' thorough examination of the early hollow earth stories of Richard Shaver and the fascination that fringe fantasy subjects such as lost continents and the hollow earth have had for the American public. Shaver's rare 1948 book *I Remember Lemuria* is reprinted in its entirety, and the book is packed with illustrations from Ray Palmer's *Amazing Stories* magazine of the 1940s. Palmer and Shaver told of tunnels running through the earth—tunnels inhabited by the Deros and Teros, humanoids from an ancient spacefaring race that had inhabited the earth, eventually going underground, hundreds of thousands of years ago. Childress discusses the famous hollow earth books and delves deep into whatever reality may be behind the stories of tunnels in the earth. Operation High Jump to Antarctica in 1947 and Admiral Byrd's bizarre statements, tunnel systems in South America and Tibet, the underground world of Agartha, the belief of UFOs coming from the South Pole, more.
344 PAGES. 6x9 PAPERBACK. ILLUSTRATED. $16.95. CODE: LCHE

LOST CITIES OF NORTH & CENTRAL AMERICA
by David Hatcher Childress

Down the back roads from coast to coast, maverick archaeologist and adventurer David Hatcher Childress goes deep into unknown America. With this incredible book, you will search for lost Mayan cities and books of gold, discover an ancient canal system in Arizona, climb gigantic pyramids in the Midwest, explore megalithic monuments in New England, and join the astonishing quest for lost cities throughout North America. From the war-torn jungles of Guatemala, Nicaragua and Honduras to the deserts, mountains and fields of Mexico, Canada, and the U.S.A., Childress takes the reader in search of sunken ruins, Viking forts, strange tunnel systems, living dinosaurs, early Chinese explorers, and fantastic lost treasure. Packed with both early and current maps, photos and illustrations.
590 PAGES. 6x9 PAPERBACK. ILLUSTRATED. FOOTNOTES & BIBLIOGRAPHY. $14.95. CODE: NCA

LOST CITIES & ANCIENT MYSTERIES OF SOUTH AMERICA
by David Hatcher Childress

Rogue adventurer and maverick archaeologist David Hatcher Childress takes the reader on unforgettable journeys deep into deadly jungles, high up on windswept mountains and across scorching deserts in search of lost civilizations and ancient mysteries. Travel with David and explore stone cities high in mountain forests and hear fantastic tales of Inca treasure, living dinosaurs, and a mysterious tunnel system. Whether he is hopping freight trains, searching for secret cities, or just dealing with the daily problems of food, money, and romance, the author keeps the reader spellbound. Includes both early and current maps, photos, and illustrations, and plenty of advice for the explorer planning his or her own journey of discovery.
381 PAGES. 6x9 PAPERBACK. ILLUSTRATED. FOOTNOTES & BIBLIOGRAPHY. $14.95. CODE: SAM

LOST CITIES & ANCIENT MYSTERIES OF AFRICA & ARABIA
by David Hatcher Childress

Across ancient deserts, dusty plains and steaming jungles, maverick archaeologist David Childress continues his world-wide quest for lost cities and ancient mysteries. Join him as he discovers forbidden cities in the Empty Quarter of Arabia; "Atlantean" ruins in Egypt and the Kalahari desert; a mysterious, ancient empire in the Sahara; and more. This is the tale of an extraordinary life on the road: across war-torn countries, Childress searches for King Solomon's Mines, living dinosaurs, the Ark of the Covenant and the solutions to some of the fantastic mysteries of the past.
423 PAGES. 6x9 PAPERBACK. ILLUSTRATED. FOOTNOTES & BIBLIOGRAPHY. $14.95. CODE: AFA

One Adventure Place
P.O. Box 74
Kempton, Illinois 60946
United States of America
Tel.: 815-253-6390 • Fax: 815-253-6300
Email: auphq@frontiernet.net
http://www.adventuresunlimitedpress.com
or www.wexclub.com/aup

ORDERING INSTRUCTIONS

✓ Remit by USD$ Check, Money Order or Credit Card
✓ Visa, Master Card, Discover & AmEx Accepted
✓ Prices May Change Without Notice
✓ 10% Discount for 3 or more Items

SHIPPING CHARGES

United States

✓ Postal Book Rate { $3.00 First Item
50¢ Each Additional Item
✓ Priority Mail { $4.00 First Item
$2.00 Each Additional Item
✓ UPS { $5.00 First Item
$1.50 Each Additional Item
NOTE: UPS Delivery Available to Mainland USA Only

Canada

✓ Postal Book Rate { $4.00 First Item
$1.00 Each Additional Item
✓ Postal Air Mail { $6.00 First Item
$2.00 Each Additional Item
✓ Personal Checks or Bank Drafts MUST BE
USD$ and Drawn on a US Bank
✓ Canadian Postal Money Orders OK
✓ Payment MUST BE USD$

All Other Countries

✓ Surface Delivery { $7.00 First Item
$2.00 Each Additional Item
✓ Postal Air Mail { $13.00 First Item
$8.00 Each Additional Item
✓ Payment MUST BE USD$
✓ Checks and Money Orders MUST BE USD$
and Drawn on a US Bank or branch.
✓ Add $5.00 for Air Mail Subscription to
Future Adventures Unlimited Catalogs

SPECIAL NOTES

✓ RETAILERS: Standard Discounts Available
✓ BACKORDERS: We Backorder all Out-of-
Stock Items Unless Otherwise Requested
✓ PRO FORMA INVOICES: Available on Request
✓ VIDEOS: NTSC Mode Only. Replacement only.
✓ For PAL mode videos contact our other offices:

European Office:
Adventures Unlimited, Panewaal 22,
Enkhuizen, 1600 AA, The Netherlands
http://www.adventuresunlimited.nl
Check Us Out Online at:
www.adventuresunlimitedpress.com

Please check: ☑

☐ This is my first order ☐ I have ordered before ☐ This is a new address

Name
Address
City
State/Province _____ Postal Code _____
Country
Phone day _____ Evening _____
Fax

Item Code	Item Description	Price	Qty	Total

Please check: ☑

☐ Postal-Surface
☐ Postal-Air Mail (Priority in USA)
☐ UPS (Mainland USA only)

Subtotal ➜	
Less Discount-10% for 3 or more items ➜	
Balance ➜	
Illinois Residents 6.25% Sales Tax ➜	
Previous Credit ➜	
Shipping ➜	
Total (check/MO in USD$ only) ➜	

☐ Visa/MasterCard/Discover/Amex

Card Number
Expiration Date

10% Discount When You Order 3 or More Items!

Comments & Suggestions	Share Our Catalog with a Friend